A·D
ART AND DESIGN

EDITORIAL OFFICES:
42 LEINSTER GARDENS, LONDON W2 3AN
TEL: 071-402 2141 FAX: 071-723 9540

HOUSE EDITOR: Nicola Hodges
EDITORIAL TEAM: Ramona Khambatta,
Katherine MacInnes
ART EDITOR: Andrea Bettella
CHIEF DESIGNER: Mario Bettella
DESIGNER: Gina Williamson

SUBSCRIPTION OFFICES:
UK: VCH PUBLISHERS (UK) LTD
8 WELLINGTON COURT, WELLINGTON STREET
CAMBRIDGE CB1 1HZ
TEL: (0223) 321111 FAX: (0223) 313321

USA AND CANADA: VCH PUBLISHERS INC
303 NW 12TH AVENUE DEERFIELD BEACH,
FLORIDA 33442-1788 USA
TEL: (305) 428-5566 / (800) 367-8249
FAX: (305) 428-8201

ALL OTHER COUNTRIES:
VCH VERLAGSGESELLSCHAFT MBH
BOSCHSTRASSE 12, POSTFACH 101161
69451 WEINHEIM
FEDERAL REPUBLIC OF GERMANY
TEL: 06201 606 148 FAX: 06201 606 184

CONTENTS

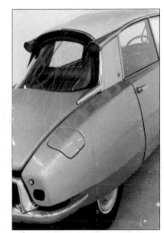

Gabriel Orozco, *The DS*,
1993, surtured car (Marian
Goodman, New York)

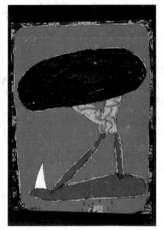

Ofelia Rodriquez, *Dreaming
of a crying Island*, 1990, oil
drawing, 56x75cm

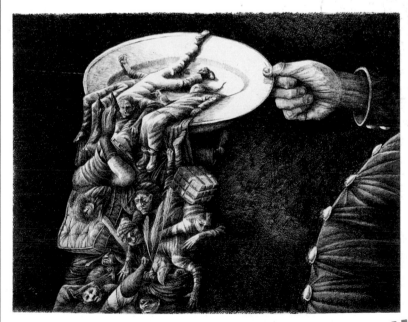

Marcelo Mayorga, *Untitled*,
1993, ink on paper,
50x65cm, University of
Essex Collection

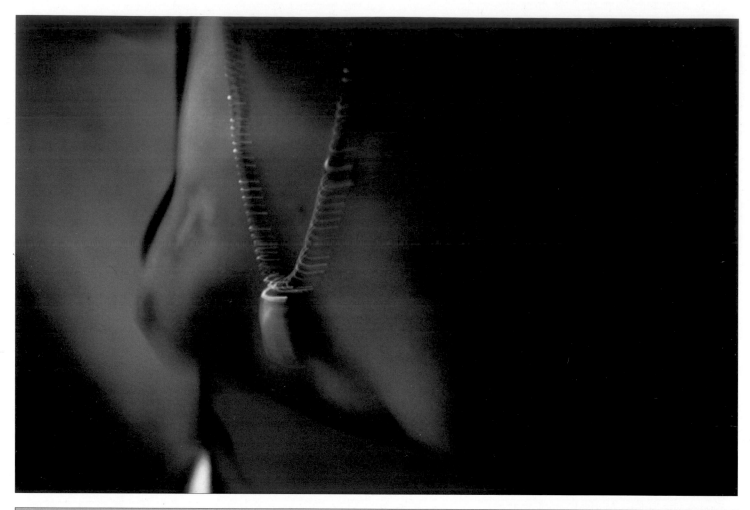

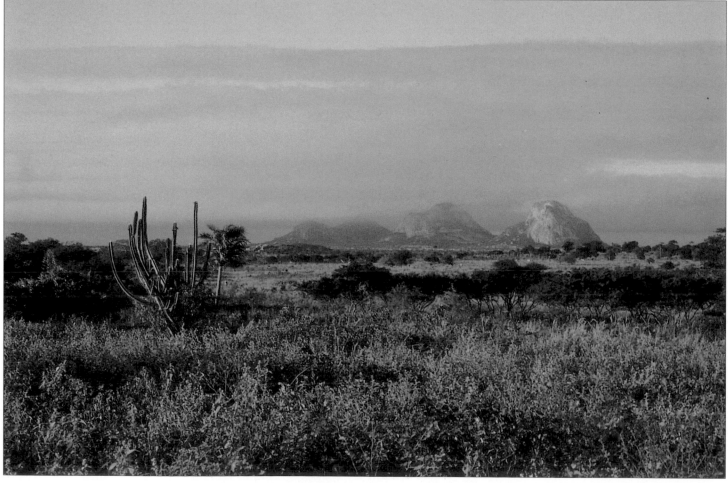

FESTIVAL OF BAHIA

A HIDDEN VIEW

Amanda Hopkinson

A 'hidden view' is the look of the insider, whose presence can safely be ignored. A view that is almost impossible for a visitor to achieve. It is also a view that is most often kept hidden, perhaps because it is in the interior of the country, off the beaten track of its coasts and cities. Or because it's of a way of life lived according to its own norms, perhaps for a long while in clandestinity, something with a reason for being separate, if not secret. The vision, therefore, depends on who views, what is viewed, and the relationship between the two.

How it's received is determined by you, the viewers. There is no single way of reading these images, many of them mysterious to our ways of seeing, none of them seen here in Britain before. Whether created by a born *baiano* or a foreigner who has, through the years, been adopted by this unique region of northeastern Brazil, each view is taken from the inside. Each aspect illuminates something beyond the tourist beat of beaches, markets, colonial squares and Carnival sambas. In Anna Mariani's case this has literally meant reiterated journeys into the interior, documenting the sparse scrubland of the backwoods and the scattered houses, still oddly designed according to the tradition of early Dutch settlers and painted with a blend of pastel delicacy and robust humour. Just as the Brazilian literary classic *Rebellion in the Backlands* lent inspiration to her fascination with the interior, so her work lends a fresh power to a recording of Euclides da Cunha – or Mario Vargas Llosa who based his *War of Worlds* on the same backlands, the same possessed visionary.

Miguel Rio Branco is an established photographer and film-maker, an unusually un-photo journalistic member of the Magnum agency. His flawless sense of colour, whether in subtle shades of monochrome or in vivid off primary colours, owes much to his dual career as a painter. Increasingly, he exhibits large-scale painting alongside his often abstract photographic images.

At the same time he has frequently taken a shrewd look at groups often marginalised by the rest of society: boxers at a gym in downtown Rio; street children around the Candelaria church where the 1993 killings took place; the whores of the colonial quarter of Pelourinho, Salvador, the capital of the state of Bahia. His 'hidden view' is that of someone whose presence has become an accepted part of the environment, one that in turn endows a caught corner of cloth or the shadow of a lintel with as much meaning as a carefully-recorded portrait.

Mario Cravo Neto is a portraitist with an historical memory. While Brazilians are generally loathe to divide individuals into 'black' or 'white' – and often laugh at attempts to do so, since we're all varying shades between – there's an obvious reason why Bahia has also been known as 'little Africa'. In the course of over three centuries (Brazil being the last country to formally abolish slavery in 1888), up to ten million blacks were displaced from their countries of origin. Their subsequent history is built into the structure of the city they largely built themselves, with its wealth of gilded baroque churches and convents, the picturesque narrow houses with their wide wooden gates and ornate balconies. The very name 'Pelourinho' at the centre of Salvador city, means 'pillory' or 'place of punishment' for those slaves determined to rebel or run away.

Cravo Neto's image of a naked man hung upside down is a collective memory of that time. 'Collective' also because he works in collaboration with his subjects, so that together a doubly-powerful portrait is created. Alongside collective memory there is the personal: the man who is now a housepainter was a fisherman, relishing the heavy slither of cool wet sea-mackerel down his back. The mingling of memory with a mind to the future is there in the portrait of a friend with AIDS, eyes looking inwards, pressed shut by a metal sculpture, anticipating the coins placed there after death. Finally, there are those memories at once collective and personal, part of a continuing tradition referred to by Cravo Neto's mentor, Pierre Verger, when he writes: '. . . the slave ships transported across the Atlantic not only the bodies of captives . . . but also their personalities, their ways of behaviour, as well as their beliefs'.

These beliefs, specifically in the form of the Afro Brazilian religion of *candomblee,* are the springboard for Cravo Neto's most imaginative portraits. They are also the substance of Verger's own work as an ethnographer and photographer, now going back over 60 years. Having started as a photojournalist in the early 1930s, in the hope that the work would lead him to travel, Verger discovered that the place and time of our birth is

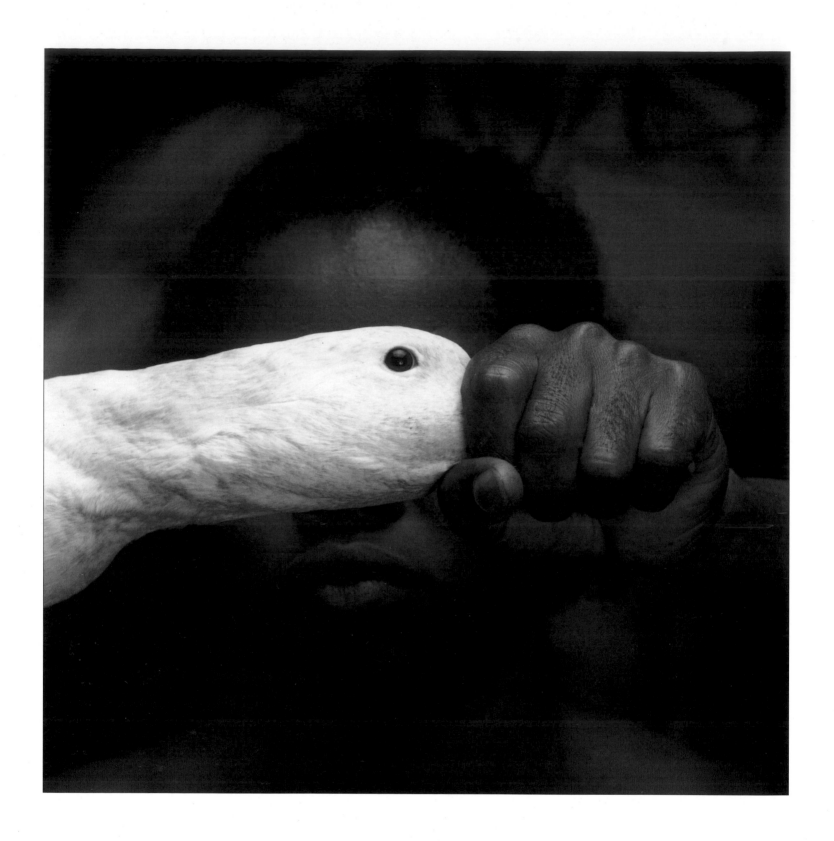

a matter of complete happenstance. Although European in origin (he did not discover his German and Belgian roots until recently, having always assumed he was 'merely' French), he has led a chameleon existence in an astonishing variety of countries and cultures. Nonetheless his spiritual home is with the religions of West Africa, whose adherents he has faithfully – lovingly – recorded both there and in Brazil. That renders

him, he believes, a particular kind of a 'messenger' between the two, in which photography has been but one instrument of communication.

Carybé is another foreigner, of Verger's generation, who arrived at Salvador de Bahia from Buenos Aires in 1950 – and found himself unable to leave. His artistry ranges across the spectrum of sculpture, carving, oils, watercolours and sketches and is likewise rooted in the African

ABOVE: Mario Cravo Neto

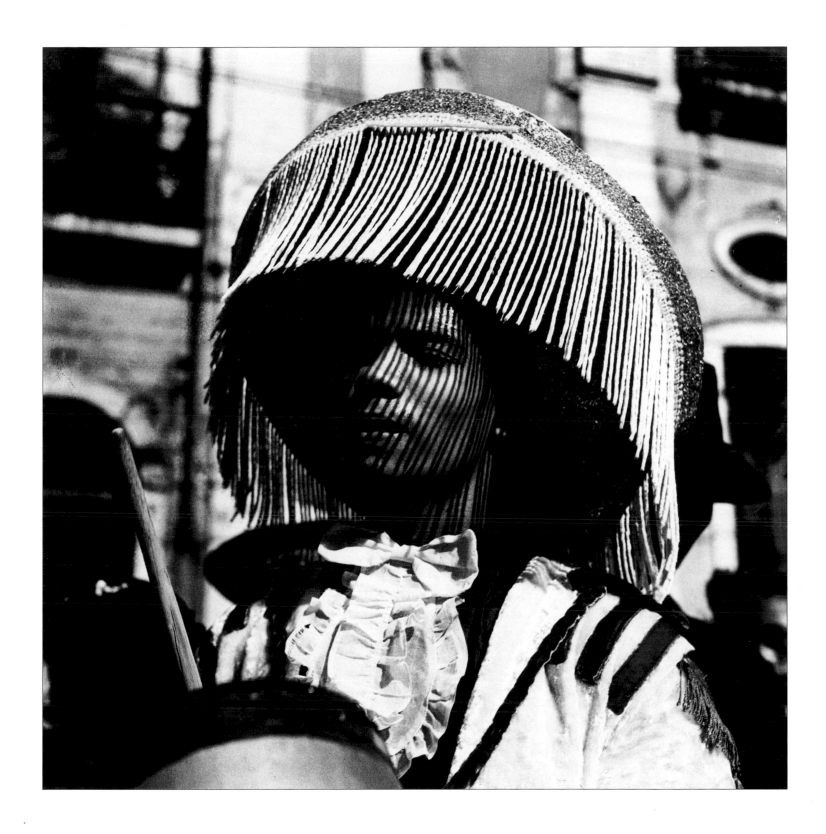

belief-system that itself took such fertile root in this region of vast plantations and hidden wildernesses. His eye is not that of a dispassionate observer but of a committed initiate able to communicate to the rest of us what we might otherwise not have the eyes to see. After all, it's too easy to visit Bahia's quaint museums and unspoilt beaches without cause to wonder at what might be hidden from view.

This text is an extract from the preface of A Hidden View: Images of Bahia, Brazil, *edited and translated by Amanda Hopkinson, Frontline/Brazilian Contemporary Arts, 1994, 112pp, b/w and colour ills, PB £12.99. The Barbican exhibition 'Images of Bahia' curated by Amanda Hopkinson is part of the 1994 Festival of Bahia.*

ABOVE: Pierre Verger, carnival group called Mexican Embassy

SIRON FRANCO

The work of Brazilian artist Siron Franco has always engaged with issues of the environment. His interest was aroused by the destruction that contemporary technology had visited upon the natural environment of the Planalto Central, a large plateau that dominates the state of Goiás, his birthplace.

In the tradition of other Latin American narrative artists, however abstract his paintings may appear, they represent his feelings and opinions on the world around him. He has chosen to address environmental rather than political themes since military rule has technically gone in Brazil, however whether consciously or unconsciously many of his narratives are inextricably linked with politics. For example, the 'Fur series' started in 1989 addressed the moral issue of using fur to demonstrate wealth. The word for 'fur' is the same as the word for skin in Portuguese, therefore when said art buyers said, 'I want a Siron "Fur"', they were effectively saying 'I want Siron's skin'. This resulted in the paradoxical situation that the people Siron Franco was criticising were the people that bought the fur paintings. Siron is wary of being taken over by one theme and he gradually reduced the amount of space the fur took up in his picture.

Charles Cosac, a collector of Siron Franco's work, says that he is suspicious of aesthetically pleasing work. He is notorious for altering paintings after they have been bought. Charles wanted to photograph the painting which represented the ubiquitous crossed telephone lines in Brazil for the exhibition flyer. However Siron had it at home and wanted to make it less appealing so he told Charles that he had painted 'Cannibal' in fluorescent blue paint across the top. Charles not only objected to alteration but to the relevance of this word to the work. Franco said that although they don't have any real cannibals in Brazil, they do with respect to capitalism.

One of the most interesting paintings in this exhibition is the self portrait painted especially for the Durini Gallery event. He paints layer upon layer. Often the original picture bears little resemblance to the final work. The circle on the right began as the round end of a key which Franco has found recently to be a recurring theme. It has now been transformed into a womb and the self portrait has been altered dramatically from a large face onto a smaller head adopting a reticent expression. The canvas has been turned as it has been painted and is thus equally coherent any way up. Siron 'painted all his worries' into the canvas in order that they could be absorbed and then by painting a black square over them he left them in the wood and the cloth. 'Turn off the colours hide the passion. Use the object to eliminate violence from life in a magical way'. On the right the brightly coloured squares are deliberately reminiscent of traditional Brazilian fabric patterning.

Messages is an ordered concentration of other motifs that have prevailed at times in his work. The heart motif was designed for the 'Anniversary of the Discovery of Brazil'. Franco loves Brazil and has great faith in the power of humanity and the strength of compassion amongst his fellow countrymen. Franco's repetitive use of numbers recalls significant dates and expresses his interest in the mathematical study of light. His use of his own hand prints has enabled fake Siron Franco's to be easily detected. He stresses that he is an artist before he is a story teller or 'reporter' but that he feels that it is important to express the issues he has chosen to champion. His picture of two faces behind bars does not depict 'political prisoners' as one might imagine but the work in fact started as two Siamese twins and developed into a comment on the mental cage in which he feels people in Brazil live. *Katherine MacInnes*

3 May – 31 May 1994, Durini Gallery and the Brazilian Embassy, London

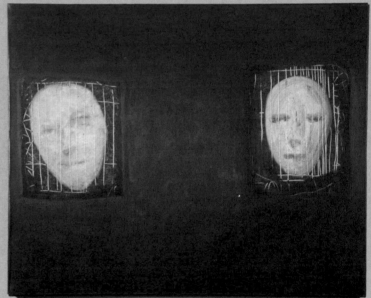

FROM ABOVE: Self-portrait, *1994, oil, 134.5x154.5cm;* Faces behind bars, *1994, oil, 90x110cm;* Messages, *1994, oil, 130x110cm;* Zip on skin, *1994, oil, 130x110cm (Durini Gallery, London)*

LATIN AMERICAN WOMEN ARTISTS

Women artists from seven different countries demonstrate the wide variety of styles and techniques that have been used to capture the essence of Latin America. Exhibitors include Rita Bonfim and Maria Thereza Negreiros (Brazil), Alicia Carletti and Antonia Guzman (Argentina), Margarita Lozano and Ofelia Rodriguez (Colombia), Julia Navarrete (Peru), Beatriz Sanchez (Venezuela), Carmen Valbuena and Bernarda Zegers (Chile). As Valerie Fraser says in her introduction to the catalogue: 'There is no common thread to this work, no single identifiable "women's vision", but there are recurrent concerns and perspectives that are in turn linked to issues of gender and cultural identity in Latin America'. Negreiros' work is especially motivated by environmental and ecological issues, Carletti's and Lozano's works are driven respectively by the recurrent themes of sexuality and feminity. Parra's paintings find their inspiration in a continuous evocation of the history and roots of the Mexican nation and Rodriguez draws on elements of popular objects found in daily life in her native Colombia. *8 June – 30 July, 1994, Durini Gallery, London*

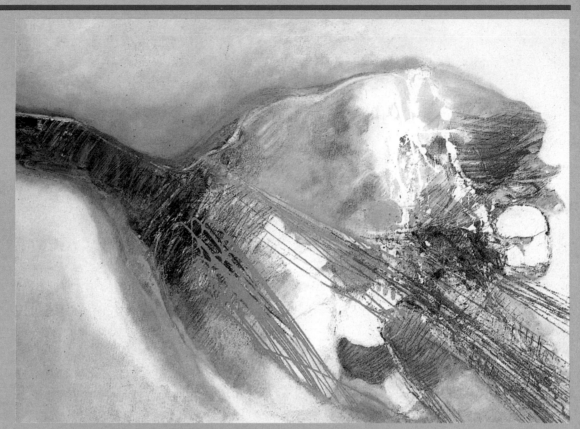

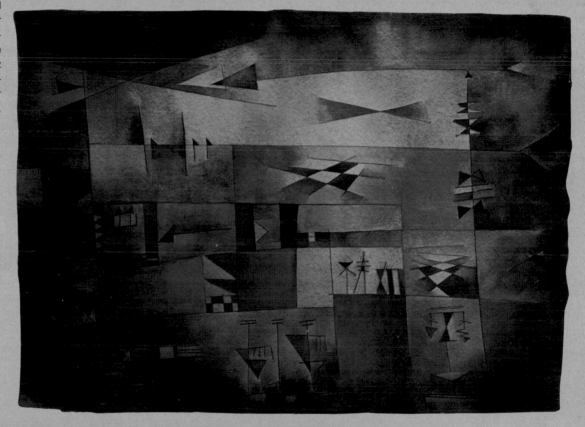

FROM ABOVE: Beatriz Sanchez, Je cherche à être une rose, *oil, 70x95cm; Antonia Guzman*, Campo, *1993, watercolour, 46x63cm (Durini Gallery, London)*

JUAN DAVILA

'Juan Davila, from Santiago de Chile, has lived in Australia for 20 years. Davila interrogates identity – what it means to be a Chilean, a Latin American from the Pacific rim, an emigrant, an artist, a homosexual. All terms, as far as he is concerned are loaded, and their very imposition must be regarded with mistrust. To call Davila a "political" artist would also be to diminish him; perhaps we might regard him instead as a transvestite. "I am not a man", he has said, "I impersonate one". His work, then, is a kind of *travesty*.

In Davila's work, everything is available, from the art historical fragment to the dictator's rump. When, in his painting, high culture slums with kitsch, and folk memories jostle alongside disturbing scenes from a pornographic comic book, and a character from the paintings of Fernando Botero meets a transvestite dragged-up to look like Frida Kahlo, such events do not take place merely to entertain or to shock. Although the cross-cultural quotations, parodies, jokes and histrionic regurgitations in Davila's work might be seen as a consumately leftist "post-modernism", the artist has said that it is more like "bad cooking": everything is contaminated, and it is a meal prepared as much for his enemies as for his friends.' *Adrian Searle from* Unbound, *exhib cat, South Bank Centre, London, 1994.*

His first solo exhibition in the UK, at the Chisenhale Gallery, focuses on the character of Juanito Laguna, a Chilean folk-hero, with whom the artist clearly identifies. According to Davila, Laguna, once an innocent has become the embodiment of duplicity and corruption. He is an anarchist, a transvestite, the ultimate colonial returning to wreak havoc in an ordered world of established values. *'UnBound', Hayward Gallery 3 March – 30 May 1994. Chisenhale Gallery, London, November-December 1994*

FROM ABOVE: Utopia, *1988, oil and collage on canvas, 180x1050cm, installed at the Hayward Gallery;* 3-D Chilean cultural policy, *1993, jet spray on vinyl, 300x500cm (Chisenhale Gallery, London)*

GABRIEL OROZCO

The Mexican artist, Gabriel Orozco explores the familiar through chance encounters. In contrast to the decadence of consumerism, Orozco's work comes back to the root question of production. His repetitive use of found objects stems, not from fetishism, but rather from the premise that there is no justification for adding any more objects, much less any personal production, to an already over-saturated universe.

In the *Galeries Magazine* (January 1994) Jérôme Sans says that Orozco reminds us that things, in the contemporary world, are above all instruments of consciousness. Knowledge is acquired through direct contact, without any prior exercise of reason. In a constant posture of availability 'on the watch' for whatever might arise from the landscapes of reality, Orozco lets the tiny, normally unnoticed gesture of everyday life serve as triggers for his experiments. These experiments are poetic juxtapositions or confrontations whose origins lie in surrealism or the new English sculpture: but they stand apart from these sources by playing a game of false leads into contemporary sculpture's formal and materiological repertory.

Sans concludes that 'In today's top-speed, rush-job atmosphere, Orozco attempts to lend a new temporality to the objects of the world, and to vision as well. He wants to give time some time again. To give the time of vision its time of rest, a clearing for those poetic instants. It's a way of facing eternity'. These elements of social realism have been seen as evidence that Orozco was influenced by the muralists' philosophy to which his father, also an artist, subscribed. On the contrary, Orozco's understatement seems to studiously avoid the bold muscularity, colour and drama of that tradition. *'Epic and the Everyday', June-August, 1994, Hayward Gallery, London*

FROM ABOVE: The DS, 1993, surtured car: metal, leather, coated fabric, 140x480x114cm; Cats and Watermelons, 1992, C Print, 32.4x47.6cm (Marian Goodman Gallery, New York)

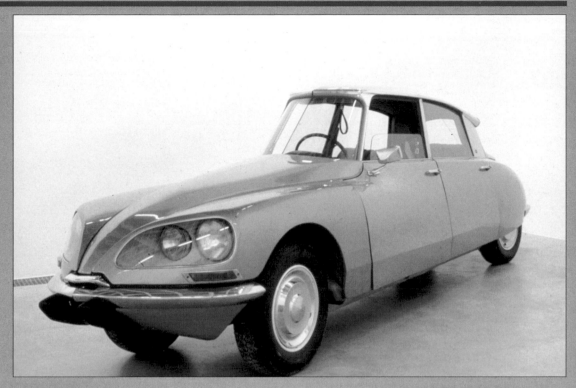

news *exhibitions*

MARY-ANNE MARTIN
Interviewed by Anna Ray-Jones

As an independent gallery owner in New York Mary-Anne Martin has pioneered exhibitions by masters like Tamayo, Rivera, Kahlo and Matta and has sought to elevate the position of Latin American art to the global stature she believes it deserves. She continues to be a sympathetic catalyst for many younger artists and has given first US exhibitions to painters such as Nahum B Zenil, Elena Climent and Alfredo Castaneda. Art & Design recently interviewed her in the midst of a highly successful show of Latino surrealists.

Anna Ray-Jones Can you comment on American interest in Latin American art? It seems to be a passion that has waxed and waned. Why is that?

Mary-Anne Martin Politics! The socialism of the 1930s brought Americans into solidarity with such countries as Mexico. Under Roosevelt's WPA (Work Progress Administration) program many American artists travelled there to study the work of the Muralists. Likewise, many Mexican artists such as Rivera were invited to work here – there was a lot of cross-fertilisation. During the 40s the war in Europe made Mexico a travel preference for many Americans. It was also a time of a great deal of Pan-American feeling. I know that IBM organised a major exhibition of art from 79 countries during this period, which included art works from every Latin American country where they had offices. But with the advent of the cold war the door suddenly slammed shut. It was the 1950s and McCarthyism was rife, given the political climate in the USA and the fear of communism, it became less chic to have a Diego Rivera on your wall. Latin American art was pretty much relegated to the closet. Fortunately, a lot of academic research on Latin American art that was begun in the 80s has now been published. Hayden Herrera's thesis on Frida Kahlo appeared as a commercial book and captured the imagination of the American public. Because of that biography many people became fascinated by Kahlo. She was relatively unknown before, except as the wife of Diego Rivera. But the book gave her work more visibility and in doing so it stimulated curiosity about other Latino artists.

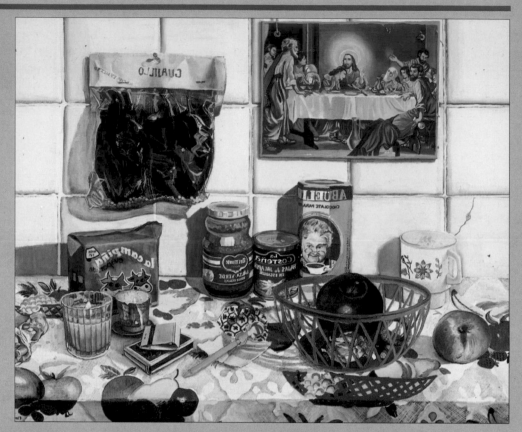

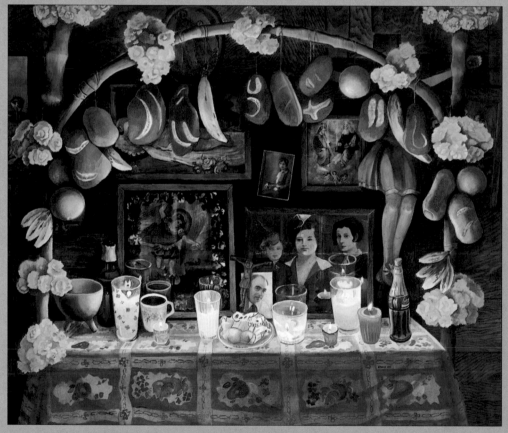

Elena Climent, FROM ABOVE: Cocina amarilla, *oil on canvas laid down on board, 1991, 46x61cm;* Altar de muertos con ancestros, *oil, 1991, 117x137cm (Mary-Anne Martin Fine Arts, New York)*

A R-J Do you think that America and Europe has viewed Latin American art as 'naif'? Do we bring a bias to such art?

M-A M What you're describing was extremely prevalent in 1982 and was an attitude I was up against when I first started this gallery. I would send out a press release describing the work of some very intellectual Argentinian painter living in Paris and the reaction of the press was that this must be someone who paints cactus and burros! It was an uninformed view, but in the 12 years I've been running my gallery things have changed radically. I've always found it remarkable that Diego Rivera, who was an excellent Cubist, living in Paris during the height of the Cubist period, was never included in any of the shows of those artists. His dealer then also represented Matisse and Picasso and he had many important shows at a relatively young age. It was on returning to Mexico that he found his authenticity, his 'Mexicanness'. In terms of our bias towards Latin American art? There is a lot of revisionism everywhere. The 80s created many questions, the 90s are trying to produce some answers. I don't where we'll be on this by the Millennium. I do know things are never going to be the same.

A R-J Many of the nations your artists belong to are or have been ruled by corrupt and repressive regimes. How can these artists exist and produce in such political climates?

M-A M Many fine Argentinian artists during the days of the Junta simply left and moved to Paris. I know of a very talented artist living in Panama, Isabel de Obaldia, who stayed through all kinds of terrible difficulties, painted and had many exhibitions. She produced paintings that were political but disguised her feelings in the imagery. It was never blatant but you could see she was protesting through her art. She refused to leave and always claimed she wanted to see how the political situation would end – she wanted to see it through. I know of another painter, Antonio Amaral from Brazil. He painted, during a period of great political upheaval, huge still life images of fruit with forks driven forcefully into their pulp or bananas tied up with rope. He was actually making reference to the oppression around him. The works are now highly collectible because of their

political intent. As an artist one is faced with two choices, stay and work subversively under the regime or go into exile – both are painful. People have had to make great sacrifices. There is inevitably a change in the art when many of these artists move to another country. You remove yourself from the influences that have nurtured the work, you're not able to continue in the wellspring of your own culture. Often, painters in these situations look to memory and nostalgia for inspiration. On a more positive basis many Latin American artists actually leave their countries for the sole purpose of having access and creative exchange with their counterparts in Europe and the USA. Unlike the fate of certain Latin American writers, the political regimes we're discussing seem to leave artists in peace. Several of these governments actually appreciate the visual arts and often artists are treated very well. For example, in Mexico legitimate artists may satisfy their taxes by using their paintings as payment – for the fair market value. Consequently, the country has a huge inventory of art provided by many of the nation's finest artists which they circulate in regional and local museums. Another painter I've showed is Nahum Zenil who is an Indian from Vera Cruz. He was a school teacher until the age of 40 when he decided to devote himself to painting. He's painted an excellent self-portrait that contains the image of the sacred heart and the Virgin of Guadeloupe literally sewn into the background. The painting narrates his personal consecration to the Virgin and how he wishes to devote himself to his new profession. He is, of course, part of the Indiana tradition of Mexico and very religious. Another artist, Elena Climent, grew up with an agnostic father born in Spain and an American Jewish mother in Mexico but she defines herself as totally Mexican. She paints what she sees there – a marvellous hybrid society of religious imagery, folk imagery and Catholic tradition. She's fascinated with altars and the art of arrangement. It's common, even among the poorest Mexicans, to attempt to beautify one's surroundings with improvised decorations, using whatever they can find to hand, and her work reflects this. One painting I love very much that she has constructed or painted is an altar of the dead. In Mexico on the Day of the Dead

everyone sits outside and arranges food for their deceased relatives and waits for their souls to come down and partake. If you look closely at the painting you can see a crucifix, beer bottles, her Spanish father, her Jewish ancestors – it's all mixed together.

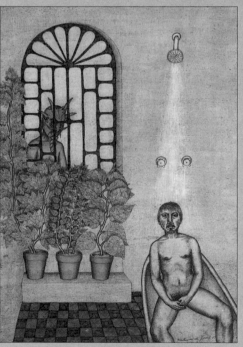

FROM ABOVE: Alfredo Castaneda, The Rich Young Man, *1985, oil, 80x60cm; Nahum Zenil,* In the Bath, *mixed media on paper, 1987, 52x36cm (Mary-Anne Martin Fine Arts, New York)*

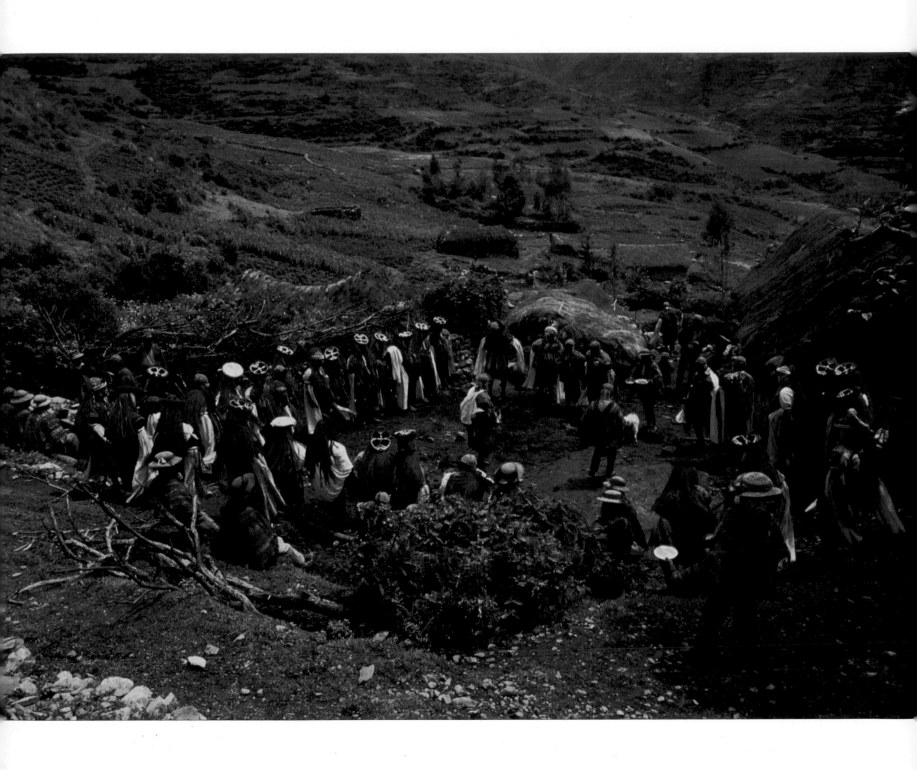

THE NAVEL OF THE EARTH
Max Milligan

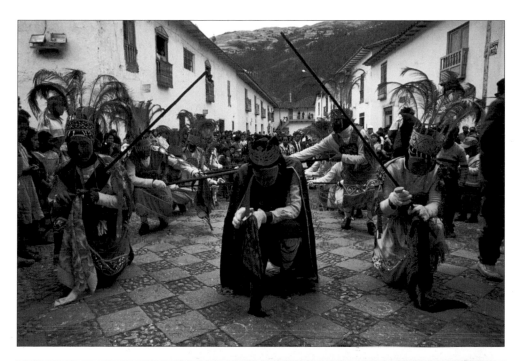

Peru is a celebration of colour and light and diverse extremes. Georgia O'Keeffe's early work was inspired by her visit to Peru, 'The earth is the reddest and the sky the bluest I have ever seen'.

British photographer Max Milligan, made the old Inca capital, Cuzco his home for over four years. Cuzco can be literally translated as 'The Navel of the Earth' (also the title of his book in progress). Some of his images are of a documentary nature revealing his training in film while others are more enigmatic, demonstrating his increased interest in abstract painting and the structural potential of photography.

The surrounding landscape is an extraordinary concentration of geographical extremes, so that in a matter of 14 hours one can drive through eight distinct climatic zones, from icy glaciers to tropical rainforest. The Sacred Valley is a fertile area amongst barren high plains and cloud forest. The Incas considered it sacred because although Cuzco was above the tree line, the valley provided them with luxury crops as varied as the land, from peaches, coffee and avocados at 9,000 feet, down to the jungle delicacies of pineapples, papaya and mangos.

The Incas are renowned for their engineering and architectural feats, for their cyclopean walls and phenomenal aqueducts. They also moulded the landscape itself. Curving huge swathes from the mountain sides to build monumental terraces, each

FROM ABOVE: Masked dancers
in the festival of Paucartambo;
Machu Picchu; OPPOSITE:
Quechua festival

XIII

one perfectly irrigated. Their knowledge enabled them to straighten a meandering river into a 3.3km canal that still stands 500 years later.

Milligan believes their masonry to be their finest art form – the magnificent examples of textiles, ceramics and gold within their empire generally belonging to pre-Inca cultures. 'Walking alongside pristine Inca stonework, it is difficult to believe that an aesthetic effect was not deliberate, for example a number of the nodules used to drag the vast stones, (the Incas had no wheel) are left in place, a conscious effort to create pleasing forms'. Some of these nodules cast shadows into niches, shapes or signals of forgotten significance. Their understanding of the Cosmos, the elements and seasons are instilled in many of their works. The Upper Moon Temple at Machu Picchu is one example. On the summer solstice the full moon rises over forested peaks to illuminate the main altar within the cave.

The culture of modern Peru is a continuous flux and fusion between Spanish and Inca, Catholic and pre-Christian, the New World and the Old, and the festivals of the high Andes are perfect symbolic microcosms of this turmoil. On one level they are an excuse for drunken celebrations, a temporary chance to forget the harsh living conditions in the barren highlands – on other levels they are a deeply religious focus for the year in the community.

Two festivals are illustrated here. The first is a rural affair which involves the young Quechua men who run around the boundary of their commu-

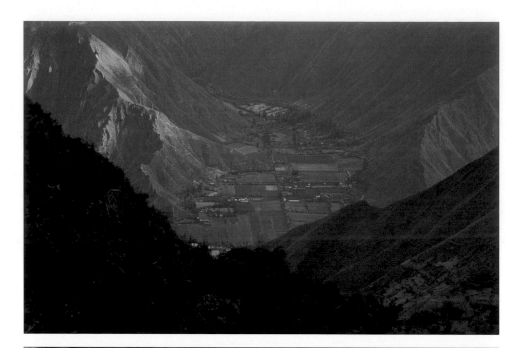

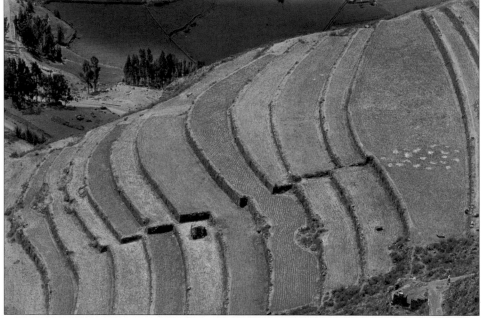

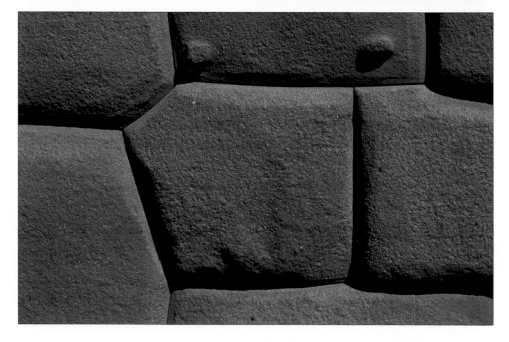

FROM ABOVE: 'The navel of the world'; Inca terracing; Inca masonry

nity area, as if to bond its disparate elements. This is a physical feat in itself when you consider the steep rugged terrain. At each village they are given soup and tea.

In Paucartambo, an ancient trading town between the mountains and jungle, the fiesta of the Virgin Carmen takes place every July. This festival was introduced by the 17th-century descendants of the conquistadors, but over several hundred years the ritual costumes and dances have been taken over by the Quechua people and become a satire and quasi-pagan ritual. For four days the town descends into apparent anarchy. Groups of dancers parade around, each with their own distinct music, dance and intricate costumes. There are the devils with their animal masks, the Ucucus in their multicoloured balaclavas, messengers between the living and the dead and the Chunchos in feathered headdresses and net masks with their palm wood bows, who represent the jungle Indians who were never conquered, they form the Virgin's personal bodyguard. The climax of the festival is the 'war', fires of straw are lit in the main square and dancers jump through them exploding the embers. Bamboo towers loaded with fireworks explode at random and oranges are pelted into the crowd with slings (the traditional Inca weapon). On the last day the Virgin is brought out of the church and each group Kneels before her; the Devils, cowering and moaning on the rooftops, cover their faces and hide. Thus order and harmony are restored for the coming year. *Katherine MacInnes*

FROM ABOVE: a timeless 'Inca' face; group of revellers; dancers dressed as devils. Max Milligan has been sponsored by Olympus and Kodak.

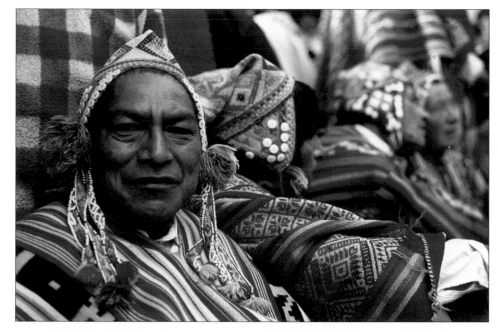

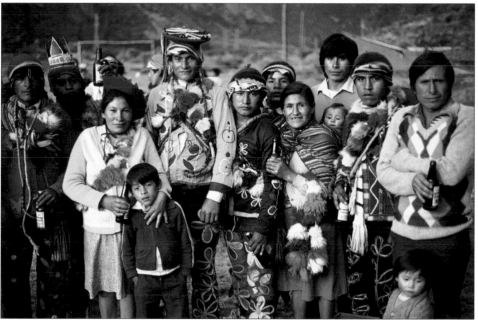

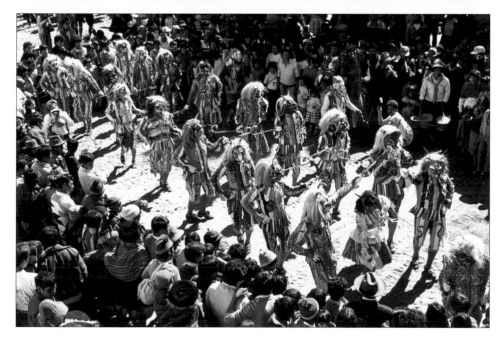

OUT OF THE DUMP

Around three and a half thousand people live eat and work in the Guatemala city rubbish dump. The majority are children. Every year poverty pushes thousands of people from their rural villages to the overpopulated cities in search of a better life. The dump is the end of the line for families already suffering severe poverty, repression and violence.

For the children of the dump much of life is spent digging through the refuse or guarding sacks of rubbish while their parents work. The ones who can be spared attend school, but 64 per cent of all Guatemalan children drop out of the 1st grade.

In 1991 American photographer and journalist Nancy McGirr gave cameras to eight children (ranging from six to 12 years old) who live with their families and thousands of others in Guatemala City's municipal dump. The result is 'Out of the Dump' an exhibition of honest pictures capturing the everyday lives of a community full of life and hope.

For Gladiz Jimenez, Llunior Ramos, Adelso Ordoñez, Miriam Esquivel, Benito Santos, Marta and Rosario López and Rember Ramirez, photography has become a new and powerful voice allowing them to document and interpret life around them – their environment, living and working conditions, family violence and drug abuse and even their dreams of the future.

'Using photography inspires the children: exposing them to dreams and the idea that there are options in life – contradicting the prevailing philosophy that one lives, works and ultimately gets tossed in the dump when they die.' *Nancy McGirr Photographers' Gallery, London, 7-18 June 1994*

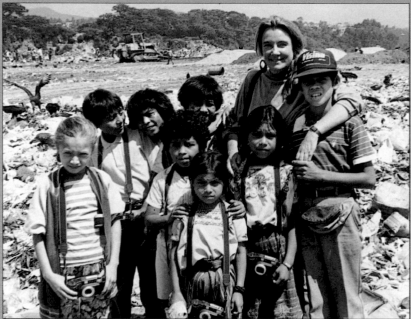

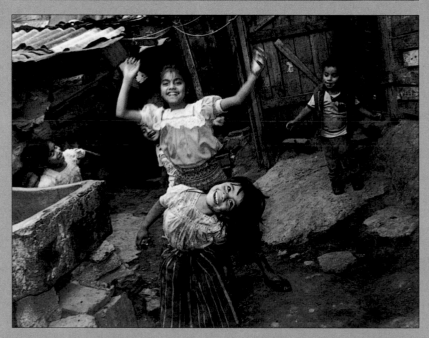

FROM ABOVE: Benito Santos, My sister shoots the thief, 1993 © Out of the Dump; Doug Farah, The Photographers; Rosario López, Dancing in our alley, 1991 © Out of the Dump

SECRETS OF THE SHAMAN
Plants and Medicinal Uses, Botanical Paintings by Sophia Louise Joseph

The Ecuadorian Oriente is an area in the north west of the country that is no larger than Alabama but as many as 12 thousand species of plants are estimated to grow there, roughly five per cent of all the plant species on earth. World-wide awareness of the invaluable properties of Amazonian medicinal plants has been stimulated recently, largely due to the threat of destruction through development. Enticed by the oil rich terrain, petroleum companies have bought and developed large areas of the land. The Oriente constitutes perhaps two per cent of the land mass of the Amazon basin but since the river's headwaters originate there, it plays an inordinately large role in the basin's ecology. The vast amount of toxic waste and repetitive oil pipe leaks have inflicted untold damage on this delicate environment. However, Ecuador depends on oil for half its revenue so the Ecuadorian Government accepted an offer by the oil companies to take charge of the health and education of the indigenous Ecuadorian tribes, among them the Huaorani. This anachronistic patriarchal approach has undermined the Huaorani culture since, historically the they have passed their knowledge of the medicinal properties of jungle plants from generation to generation through an oral tradition. Recently, however they have felt that their culture is sufficiently threatened to take the unprecedented step of recording their knowledge of the jungle in a more concrete form. The Huaorani approached an international

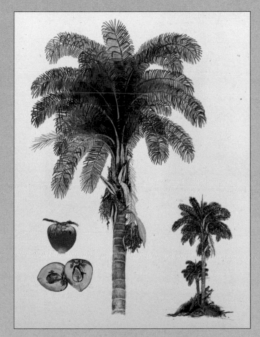

organisation to help them achieve this goal. A pictorial representation was thought to be the most effective means of communicating this information and the artist Sophia Louise Joseph was asked to help. Joseph was guided by both the Huaorani and the Quechua people and by botanists, environmentalists and ethnologists from various international associations. Since the aim of this project was to encourage recognition, she abandoned her more abstract technique for an uncompromisingly realistic approach, four examples of which are shown here.

The first is called BROWNEA *ariza* LEGUMINOSAE. Garetahue. H (in Huaorani) Cruz Caspi. Q (in Quechua). It regulates menstruation and the synthetic copy is a widely used contraceptive in the developed world. The dosage is all important. Too much of this can cause sterility. In despair at the invasion of their lands and the correspondingly bleak future for the next generation, one Amazonian tribe in Peru decided by mutual agreement to give their women too much in order to sterilise them and prevent continuation. Like many Amazonian plants the Brownea defends itself against being eaten. The new leaves look brown, moth-eaten, old and withered and only when they become tough do they look green and enticing.

The BACTRIS *gasipaes* PALMAE Dagenka (H) Chontaduro (Q) is a symbol of abundance and well being since it is a staple food. Unlike other forest fruits which require much effort to find a small amount of edible flesh, this 'Chonta palm' provides a large amount of easily accessible food. Each Chonta palm is owned by a family and although they will share its fruit, strangers are forbidden to harvest it. The wood of the Chonta palm is reinforced with black wiry strips along its length. This makes it suitable for load bearing

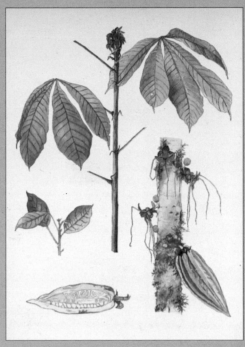

in construction. The shafts of spears are also made out of this wood and the spines on the surface of the trunk are used as spikes for blow-guns necessary for their nomadic, hunter gather way of life. The third image represents the HERRANIA *nitida* STERCULIACEAE. Boginkahue (H) Cambiac (Q) which can cure snake bites and has an edible fruit rather like a cucumber. Both the fruit and the flower grow directly out of the three meter thick tree trunk, a common feature In the jungle. Finally CROTON *lechlert*. EUPHOR-BIACEAE. Kungijue (H) Sangue de drago (Q). The sap from this tree is known as Dragon's Blood. It is dark red, viscious and dries quickly. It can be used to sterilise open wounds and to seal them from further infection, essential in the rainforest. Although the sap is poisionous, small drops of it can be swallowed to cure stomach ulcers. This plant is becoming increasingly important since research has proved that it might be an essentail link in the quest for a cure for cancer.

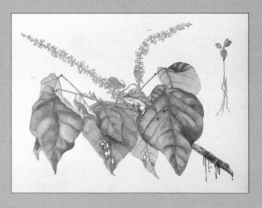

Chelsea Physic Garden, June 1994

PETER RANDALL-PAGE Sculptures and Drawings 1977-92, text by Charles Hall, Reed's Wharf Gallery, 1994, 24pp, colour ills, PB £5
The work of Peter Randall-Page seems to project an almost spiritual feeling both through form and context. Indeed in an accompanying booklet which publishes a conversation between the artist and Tessa Jackson, he reveals that he believes that 'a sense of rightness in form has an intrinsic value for human beings'. One of his best known works is *Dartmoor Granite* which he selected to echo the shape of other rocks in the stream of the River Teign where it was to be placed. His incisions frequently emphasise the organic nature of the rock, comprised of animal and vegetable as well as mineral. Randall-Page aims to make 'ultimate objects that are utterly irreducible' to invoke the timelessness of an ancient carving. Wenlock Priory is hosting the exhibition from June 94 until it moves to the recently-opened Reed's Wharf Gallery in London in the autumn.

SALVADOR DALÍ: the early years, South Bank Centre, 1994, 248pp, colour ills, PB £17.95
Salvador Dalí was such a remarkable character, such a showman that exhibitions have traditionally found it difficult to separate the man from his work. This catalogue examines the early years of his work from his teenage years in Figueres, Catalonia; through his years in Madrid as a rebellious student and friend of the poet Federico García Lorca and the film-maker Luis Buñuel to the fully fledged Surrealist whose first exhibition in Paris in 1929 made such an impact. As well as containing the roots of Dalí's later ideas, these early works show the ambitious and prodigiously gifted young artist experimenting with a variety of styles ranging through Neo-Impressionism, Symbolism, Cubism, Futurism to a kind of Mediterranean classicism before finding his own style. Dalí was almost as active with the pen as with the brush and many of his early writings are published here for the first time.

INSTALLATION ART introduced by Nicolas de Oliveira, Nicola Oxley and Michael Petry, Thames and Hudson, 1994, 209pp, colour ills, HB £28
Installation is a rich art form, often heroic in scale, sometimes witty and subversive, usually impermanent. It is made up of multiple histories including architecture and Performance Art. By crossing the frontiers between different disciplines, installation is able to question their individual autonomy and their relevance to the contemporary context. Michael Archer traces the history of installation art from Duchamp's first ready-made through the Pop tableaux of Kienholz, Oldonburg, Kaprow and Dine to more recent developments such as Land Art and Process Art. This volume chronicles the development of installation through artists such as Christian Marclay's floor carpeted with LPs and Jenny Holzer's pulsating LED screens with their enigmatic messages, to Lothar Baumgarten's haunting memorial to Native American tribes and Hiroshi Teshigahara's tranquil tunnels of bamboo.

LIFE INTO ART Isadora Duncan and Her World, foreword by Agnes de Mille, WW Norton & Company, 1993, 198pp, b/w ills, HB £25
The mother of Modern Dance and a pioneering feminist, Isadora Duncan was one of the first international superstars. She was an independent thinker and activist and she changed the course of society, theatre and dance. She did not think; she felt and her improvised choreographies, where she abandoned herself to heightened emotions at moments of stress, were her most famous. She championed freedom in dance and borrowed freely from rigid vocabularies such as the graceful movements of classical Greek dance. Her rejection of rigidity pervaded her life outside the theatre and her outrageous non-conformity is often commented on in relation to the emancipation of women. Although photography was not sufficiently advanced to capture the fleeting movements of Isadora's dance, artists of the time including Gordon Craig and Abraham Walkowitz have captured the new scope of dramatic movement which she had made possible.

GOYA Truth and Fantasy by Juliet Wilson-Bareau and Manuela B Mena Marqués, Yale University Press, 1994, 384pp, colour ills, Cloth £40/PB £19.95
The exhibition for which this catalogue was prepared encompasses a wide range of subjects and these exceptional works include the surviving oil paintings produced by Goya for the Royal Tapestry Factory. These were translated by weavers into decorative hangings for the royal palaces. It is here that the artist brings his own personal vision of Spanish life and customs to his painting. From 1770 to 1820 he produced sketches for some of his major religious work while intermittently working on a series of portraits including self portraits of the 1790s and lively miniature portraits painted on copper of Goya's family. After 1800, enlightened liberals, including many of his friends, were imprisoned or exiled and Goya expressed his anxieties and foreboding in small scenes of violence, prison scenes and executions.

THE IMPRESSIONIST GARDEN by Derek Fell, Francis Lincoln, 1994, 144pp, colour ills, HB £20
The impressionist painters not only pioneered new concepts in painting but also championed a new style of gardening. Some – like Monet, Renoir and Cézanne – did so in gardens they owned and cultivated – using plants like paint to colour the landscape; others – like Van Gogh – discovered stimulating companion plantings in the gardens they painted. Although Monet's garden is the most visited in the world he was secretive about his gardening philosophy and never disclosed the methods he used. This book suggests that he achieved the shimmering glittering effect by using white flowers with loose, airy flower clusters taking inspiration from Japanese gardens to create his own water garden masterpiece. The leaf tunnels and dramatic foliage contrasts used by Cézanne in Provence and the wildflowers and oat grasses beneath the ancient olive groves of Renoir's garden go some way towards explaining their respective attitudes to art. Van Gogh never had a garden of his own but he painted many and wrote letters to his sister recommending colour harmonies and suggesting specific plants for her to grow.

CHRISTIAN BOLTANSKI by Lynn Gumpert, Flammarion, 1994, 182pp, colour ills, HB £20

Using media as diverse as newspaper clippings, used clothes, bare light bulbs, rusty biscuit tins, found snapshots and flickering shadows, Christian Boltanski has created a substantial body of work out of such insubstantial objects that represent the preoccupations that continue to haunt him – the way photographs can lie, nostalgia for a childhood that must disappear, parodies on the idea of collecting, the presence of death, memory and forgetting. Boltanski often works from the narrative of his own life story – both actual and reinvented – evoked through resonant collections of objects and photographs. Boltanski uses similar techniques to explore events external to his autobiography. Humour is also an integral part of Boltanski's work which has the unsettling ability to be both merry and morbid.

WALL TO WALL introduced by Maureen Paley, 1994, 110pp, colour ills, PB £18.95

This exhibition, at the Serpentine, London and Southampton and Leeds City Arts Galleries, shows the work of 20 artists from Europe and America who have been commissioned to create new work, using the floors, walls, windows and ceilings of three galleries. Whilst neither strictly painting nor sculpture, the work incorporates elements of both. Maureen Paley sees the walls as embodiments of the history of a gallery and feels that the site-specific nature of these works releases some of that energy. Different interpretations include that of the American artist Robert Barry, one of the founders of conceptual art, who paints words at odd angles on the walls, evoking specific emotions and states of mind. The Dutch artist Lily van der Stokker paints clouds of colour with deliberately naive expressions from the 'have a nice day' culture. Ernst Caramelle is Viennese and draws directly on to the window which links inside and outside. David Tremlett uses pigment in architectural sites often working on a grand scale while Craig Wood's work involves drilling holes directly into the surface of the wall.

PICASSO: Sculptor/Painter, Tate Gallery, 1994, 295pp, colour ills, PB £19.95

This exhibition explores in detail for the first time the relationship between Picasso's sculpture and painting – while he is acknowledged as one of the great revolutionary modern painters it is less widely appreciated that he was possibly even more revolutionary and influential as a sculptor.

In his Cubist constructions of 1912-14 he introduced a totally new way of making sculpture by the assembly of disparate elements – a kind of three-dimensional collage. At the same time he established that a work can be made of ordinary everyday materials rather than the traditional ones of bronze and carved stone or wood. The effects of these innovations have been far-reaching, their progeny ranging from Russian Constructivism and the tradition of pure abstract constructed sculpture that came out of it, to Carl André's notorious 'bricks' and the multifarious forms of assembled art, from the Dada movement onwards, that incorporate real materials and objects as part of the work.

DECONSTRUCTION AND THE VISUAL ARTS Art, Media, Architecture edited by Peter Brunette and David Wills, Cambridge University Press, 1994, 315pp, b/w ills, HB £37.50/PB £13.95

Critiques of Jacques Derrida's philosophy feature throughout this book. The main aim is to analyse the relevance of such ideas of deconstruction to the visual and media arts and to architecture. These essays explore the full range of his analyses, from 'Of Grammatology' and 'The Truth in Painting' to recent discussions on photography and drawing. They are modelled on the variety of critical approaches that he has encouraged from critiques of the foundations of our thinking and disciplinary demarcation to creative and experimental readings visual 'texts'. They represent some innovative ideas, which present important challenges to existing disciplinary orthodoxies. The book also features a recent interview with Derrida concerning the visual and spatial arts

UNBOUND Possibilities in Painting, text by Adrian Searle, South Bank Centre, 1994, 120pp, colour ills, PB £9.95

Painters today find themselves curiously liberated, a state which the latest Hayward Gallery exhibition attempts to exemplify. Painting was declared redundant at the advent of photography nearly 150 years ago. It has survived partly by defining its own position ever more closely and partly by virtue of the continuing influence of the painted image on every other kind of visual representation. As a result painting is best seen not in opposition, but in relation, to other contemporary art forms like sculpture, photography and installation. Quarrels which vexed earlier artistic generations – among them those of abstraction versus figuration, or invention versus observation – seem in their dogmatic posturing to have little to do with the wealth of creative intelligence that characterises art today.

THE LOW COUNTRIES Arts and Society in Flanders and The Netherlands, Flemish-Netherlands Foundation 'Stichting Ons Erfdeel', 1993, 319pp, colour ills, PB £50

This Yearbook for 1993-94, includes articles by British, American, Dutch and Flemish contributors who survey the living contemporary culture of the Low Countries as well as their cultural heritage. Hans Ibelings reviews recent architecture in Rotterdam looking particularly at JJP Oud's housing complex in Spangen and the Van Nelle coffee Factory by Brinkman and Van der Vlugt.

EM Uhlenbeck feels that since the Netherlands is a Dutch-speaking country surrounded by language communities where three of the major modern languages are spoken the 'Threat of Language Death' is very real. He works from the premise that linguistic variety is rapidly being eroded due to far-reaching political and social changes, which have caused a dramatic acceleration of this dying out process.

Karel Porteman studies emblem literature where pictorial and verbal communication is achieved through engravings which illustrate the moral and political narratives of the time

PATRONAGE IN RENAISSANCE ITALY From 1400 to the Early Sixteenth Century, Mary Hollingsworth, John Murray, 372pp, b/w ills, HB £25

This is the first comprehensive study of patrons in the Italian quattrocento. It will be of great interest to art historians and their students and to lovers of Renaissance art and civilisation. At the start of the fifteenth century the patron, not the artist, was seen as the creator and he carefully controlled both subject and medium. In a competitive and violent age, image and ostentation were essential statements of power. Buildings, bronze or tapestry were much more eloquent statements than the cheaper marble or fresco. The artistic quality that concerns us was less important than perceived cost. The arts in any case were just part of a pattern of conspicuous expenditure which would have included for instance holy relics, manuscripts and jewels – all of which had the added advantage that they were portable and could be used as collateral for bank loans. Since Christian teaching frowned on wealth and power, money had also to be spent on religious endowments made in expiation. But here too the patron was in control, and used the arts and other means to express religious belief, not aesthetic sensibility. Thus artists in the Early Renaissance were employed as craftsmen. Only late in the century did their relations with patrons start to adopt a pattern we might recognise today. This book, which also discusses the important differences between mercantile republics like Florence and Venice, the princely states such as Naples and Milan, and the papal court in Rome, is essential for a full understanding of why the works of this seminal period take the forms they do.

BOYD WEBB, Introduced by Greg Hilty, Harris Museum and Art Gallery, 56pp, colour ills, PB Price NB
This catalogue looks at the work that appeared in the exhibition 'Boyd Webb– Recent Work' which is touring to various venues in England, Scotland and Northern Ireland during 1994. Greg Hilty describes Boyd Webb's work as that which is capable of inducing both 'elation and panic. Self-con-

tented in their otherworldliness and ambiguity, they nevertheless set alarm bells ringing in our heads. Though these bells warn of impending global catastrophe, they are triggered by the deepest, most atavistic associations. In recent works both humankind as a species, and men and women as individuals, are reduced through a kind of high-speed biological regression to their crudest embodiments, engaged in a never-ending and desperate search for fruition. We cannot help asking, as we did when faced with the artist's earlier work, whether such preposterous activity can be deemed to have a purpose. The poetic, experimental universe Webb conjures up is governed, like our own world, by conditions which are at once self-perpetuating and self-defeating: stasis and migration, growth and decay, life and death'.

ART in the age of mass media, John Walker, Pluto Press, 200pp, b/w ills, PB £11.95, HB £35
Until the mid 19th century, architecture, painting and sculpture were the three principal visual arts of Europe. These arts flourished because they received substantial patronage. Today the situation is very different: our culture is not dominated by the fine arts but by the mass media. Changes brought about by the industrial revolution, by the development of a capitalist economic system, and by the emergence of an urban, consumer society, have irrevocably altered the social context in which fine arts operate. Architecture, it should be acknowledged, has been far less affected by these changes than painting and sculpture. Machines have played a crucial role in the social and technological transformation. Until the advent of colour photography and printing, for example, painters enjoyed a virtual monopoly over the production of coloured images. Now millions of high-quality colour images and millions of copies of those images, can be simply and rapidly generated by the use of the camera and the printing machine. The art of painting has not died out as a result but, arguably there has been a decline in its status and power; its social functions have also altered. This book asks what

the response of fine artists to the mass media has been and whether there is any vital social role left.

JOHN CAGE composition in retrospect, Exact Change, 1994, 171pp, PB £10.99
In his introduction to the Norton Lectures, John Cage explained that the physical form of his writing effected the text. 'Like acrostics, mesostics are written in the conventional way horizontally, but at the same time they follow a vertical rule, down the middle not down the edge as in an acrostic, a string which spells a word or name, not necessarily connected with what is being written, though it may be . . . In the writing of the wing words, the horizontal text, the letters of the vertical string help me out of sentimentality. I have something to do, a puzzle to solve. This way of responding makes me feel in this respect one with the Japanese people, who formerly, I once learned, turned their letter writing in the writing of poems.'

SOME WENT MAD, SOME RAN AWAY, edited by Andrea Schlieker, Serpentine Gallery, 50pp, colour ills, PB Price NA
The artists represented in this exhibition include, Johannes Albers, Ashley Bickerton, Sophie Calle, Angus Fairhurst, Michael Joaquin Grey, Marcus Harvey, Michael Joo, Abigail Lane, Robert Peacock, Alexis Rockman, Jane Simpson, Andreas Slominski, Kiki Smith, Hiroshi Sugimoto and finally the man who selected them, Damien Hirst. This is the first time he has curated an exhibition for a publicly funded space and in his opinion, curating, selecting, is another form of art. The 15 artists come from England, Germany, France and the United States, whilst not representing a homogeneous group, their work is rooted in a common sensibility defiantly opposing the current climate of conservatism. The exhibition appears first at the Serpentine Gallery, London and then tours to Nordic Arts Centre, Helsinki, the Kunstverein, Hanover, ending up at the Museum of Contemporary Art, Chicago at the beginning of 1995. In its fusion of the viscera and the lyrical this exhibition triggers a variety of responses from shock to amazement to laughter. It has been

described as 'provocative, curious, disquieting' and indeed in this diversity it reflects the experience of living. Richard Shone says, in an informative catalogue essay, that this is a manifestation of the 'urge to bring order to chaos which has existed as a fundamental human motivation throughout history'.

ART NOUVEAU by Alastair Duncan, Thames and Hudson, World of Art Series, 1994, 216pp, colour and b/w ills, PB £6.95

Art Nouveau was a movement not a style, one that evolved differently in different countries in the late 19th century, with the single purpose of defeating the established order within the applied and fine arts. Its broad sweep encompasses the linear austerity of Mackintosh and the floral profusions of Emile Gallé and Louis Majorelle. Alistair Duncan claims that resistance to the Victorian preoccupation with a cluttered eclecticism produced concepts of modern interior design through which Art Nouveau advanced one of its own causes, that of neat and coherent settings for the home. Art Nouveau's solution was to synchronise every element of a room. Duncan credits Willliam Morris as the designer to which Art Nouveau owed its single greatest debt. Although like Ruskin he did not always practise what he preached it was what he preached, namely that mass-production meant soulless products, that triggered the philosophy of Art Nouveau.

THE MEXICAN MURALISTS, Europalia 93, 205pp, colour ills, PB £56

This exhibition of the Mexican Muralists concentrated on the 'Big Three', José Clemente Orozco, Diego Rivera, David Alfaro Siqueiros. The movement is widely regarded as Latin America's most important contribution to 20th-century art. Internationally much of primitive art is in the form of murals but it was considered to be genuinely indigenous in Mexico on the introduction of communism. In 1992 Siqueiros drafted a manifesto in the name of the union of craftsmen, painter and sculptors in which he set forth the revolutionary premises of the movement – ' To the Indian race, humiliated for centuries; to soldiers made executioners by the praetorians; to workers and peasants scourged by the greed of the rich; to intellectuals uncorrupted by the bourgeoisie . . . The art of the Mexican people is the most important and vital spiritual manifestation in the world today, and its Indian traditions lie at its very heart . . . We believe that any work of art which is alien or contrary to popular taste is bourgeois and should disappear because it perverts the aesthetic of our race'. This attitude, or some may say misinformed arrogance, was responsible for preventing any artistic spontaneity or outside input, for several years. For all their desire not to use outside influences and to present a common style the muralists each sought his own way to bring off a synthesis between the Indian traditions and modern art resorting to the monumentalism of the Italian Renaissance or European Romanticism and modern Expressionism and Realism. Indeed, Diego Riviera had spent some years in Paris where he flirted with Cubism and for inspiration, he looked more to the masters of the Italian Renaissance than to his contemporaries. Robert Hoozee claims that 'when all was said and done, the only common (but valuable) denominator was a great swell of humanitarian feeling'. *Museum voor Schone Kunsten, Ghent, September 25 – December 12, 1993*

FRIDA KAHLO La Casa Azul, Europalia 93, 220pp, texts in French, colour ills, PB £40

Frida Kahlo was one of the first major female artists to break away from the male-dominated tradition of painting and invent a truly female iconography. Her portrayal of her own suffering, through an accident which left her unable to bear children, is a uniquely female self-exploration. Small, intimate, introverted canvases, they contrast strikingly with the flamboyant murals of her husband, the celebrated Diego Rivera and inspired great acclaim especially from the Surrealists. Her work, like Diego's was part of a renaissance in Mexican art utilising the pre-Columbian traditions, popular religious art and celebrating the vibrancy of Mexican culture. Frida herself dressed almost exclusively in exquisite Tehuana robes, as seen in the portraits by her friends, and in the self portraits which became a principal vehicle for her own work.

Including essays on the Mexican votive paintings from which she derived so much inspiration and also the radical circle of people who surrounded her and Diego, this book includes colour plates of all her major works and sketches. The section on the Casa Azul evokes the image of the house where Frida Kahlo was born and where she died through the objects and materials she surrounded herself with adding to a very complete portrait of a unique and vibrant woman. *Museum Paleis Lange Voorhout, Den Haag, 28th September – 21 November 1993*

REGARDS DE FEMMES with essays by Linda Nochlin and Edward Sullivan, Europalia, 137 pages, colour ills, texts in French, PB £35

Marginalised twice by the history of modernism, first geographically, by operating outside the Western European and North American axis, and secondly on account of their gender, the work of many of the artists in this book was little known outside Mexico until the feminist reevaluation of art history in the 60s and early 70s. As Linda Nochlin writes 'Why when I ask myself to cite the name of two or three Mexican painters in 1968 do I immediately think of Rivera and Orozco in place of Kahlo or Varo? Why again if I ask myself to cite two of the most important painters in the 20th century do I respond by thinking of Picasso and Matisse and not Rivera and Orozco, whose ambition and production were comparable?' Including work in all media by Tina Modotti, Frida Kahlo, Remedios Varo, Leonora Carrington, Marie José Paz and many others this book reviews the fundamental role played by women in the history of creative production in Mexico. The images themselves provide ample proof of the eloquence, inexhaustible vitality and originality which marks out their work. *Exhibition 15 October – 1st December 1993, Liege Musée d'art Moderne.*

Europalia's distributers in England: Art Book International, Stewarts Court 220 Stewarts Road, London SW8 44D. Tel 071 7201503

A HISTORY OF AFRICAN-AMERI-CAN ART From 1792 to the Present by Romare Bearden & Harry Henderson, Pantheon Books, New York, 1994, 42 pages, b/w and colour ills, HB £ 59.50 (available in the UK from the Atrium Bookshop, Cork St, London 071 495 0073)

'At Mr Mclean's, Watch-Maker, near the Town-House, is a Negro Man whose extraordinary Genius has been assisted by one of the best Masters in London; he takes Faces at lower Rates. Specimens of his Performances may be seen at said Place . . .' *The Massachusetts Gazette, 7 January, 1773.*

Thus read the notice from the first American portraitist to advertise his skin colour and his talents in the slave economy of the New World colonies. Such an advertisement contradicted the slaveholder's view that African-Americans were incapable of art, and served to warn off prejudice. The identity of the artist has never been established. He is one of the unknown, ephemeral figures that wander the pages of an important and essential history of Black American artists. The authors, Romare Bearden and Harry Henderson who compiled this landmark conspectus, have made valiant efforts to give a past to the invisible, to excavate from beneath the weighty burden of racism and biased scholarship, a whole area of American art long hidden.

For instance, Barbara Novak's *American Paintings of the Nineteenth Century* makes no mention of the landscape painter, Robert M Bannister, who won the Centennial Exposition Award of 1876, or Henry Ossawa Tanner, a former student of Thomas Eakins, who was once dragged by his fellow students into the streets of Philadelphia where he was tied to his easel in a mock crucifixion for asserting as a Negro man that he 'painted too'.

It was Paris that saved his humiliated soul and his art. There, he developed a style that reflected a mystical searching in which radiant light played a symbolic role. His work soon won the prizes of the Paris Salon, honours previously achieved by very few Americans. Tanner found himself an ac-claimed peer of John Singer Sargent and James McNeill Whistler.

The attempt to create a first history of African-American artists grew out of a request in 1965 from the Museum of Modern Art to Romare Bearden that he talk with a group of black students on the history and development of Black American artists. He found that he could put together a few scanty notes on only a dozen artists before his own generation. His concern about this situation led to discussions with his co-author, Henderson, which set them both on a path of ground-breaking research to correct a wilful void in American history. Apart from a few itinerant immigrants trained in Europe, painting in early America was the province of artisans, part-time 'face-painters' who would paint portraits with the sitter reposed in better clothes than they could afford. Among these were sign and banner painters, varnishers, house painters, mechanics, even tailors and black artisans. What is known of the latter is largely limited to the advertisements of their abilities, their obscurity and their history so painfully intertwined with slavery.

The period of abolition generated a departure point for the increase of African-American artists. The Civil War compelled their migration to northern cities and the civil right to create, the route of the black artist had been grudgingly opened. This is keenly echoed in the efforts of the authors during the preparation of this book. Their task made more difficult by the lack of simple but vital information that had gone unrecorded – the lives and art they were seeking to describe had lain in shadow for so long. The sources usually considered prime by art historians – letters, diaries, dealer's records – were almost non-existent. By sheer persistence they would uncover one significant factual stone and find another beneath it – individual breakthroughs in training, in concepts, in identity, in subject matter, colour and style. The stimulation of friendships, teachers, social and political conditions. The story begins with the debated racial identity of the enigmatic Joshua Johnston, (possibly a slave once owned by a white artist in Baltimore in 1817 and potentially the first African-American to produce a highly distinguished body of work), through the 19th century to the 1920s and more migration from the south by blacks, the arrival of jazz and a black Renaissance in the visual arts. Despite the growing energy mounting among artists in this period, the long tendrils of racism were hard to loosen. It was a time when spirited Augusta Savage emerged as a talented young sculptor from Cooper Union. She also won an opportunity to further her studies abroad but was denied the prize because of her race. She stayed to fight the discrimination and eventually became a prominent artist and leader of the Harlem Community Art Center, the largest project of Roosevelt's Works Progress Administration. (The WPA program aided the development of hundreds of African-American artists.)

Henderson and Bearden continue their journey through the emergence of African-American artists during the depression. They examine the work of self-taught painters such as Clementine Hunter whose vision encompasses black life on the old Melrose plantation in Louisiana and sculptor Edgar Patience of Wilkes-Barre, Pennsylvania, who carved miners in coal. They survey the place and focus of art departments in black colleges and draw us close across the post-war period and the flowering of the civil rights movement to where we are now. Today, African-American artists, although they still contend with prejudice, participate in every aesthetic development in the USA. However, the present does not bring closure but more the question of how much further do we need our eyes opened? For the history of these artists is far from complete. Romare Bearden died in 1988, after the foundations of this brave book were in place. Henderson continued on with the massive work. Both agree that they have sketched little more than an outline and washed away some old varnish that has contributed to the denial of recognition for African-American artists and their rightful place in American art. It is a denial that lays waste to spirit and vision and deprives us of what Arthur A Schomburg called 'the full story of human collaboration and interdependence'.

Anna Ray-Jones

A HISTORY OF AFRICAN–AMERICAN ARTISTS

From 1792 to the Present

ROMARE BEARDEN & HARRY HENDERSON

*I*n the decade of the Beatles and the moon landing, cybernetics and megacities, Archigram — Peter Cook, Ron Herron, Warren Chalk and Dennis Compton — invented new artefacts and situations that threatened the discipline of architecture itself: Walking Cities, Plug-in Universities and 'Suits that are Homes'. At once poetic and technological, utopian and grounded in social need, their projects embodied the avant-garde architecture of the 1960s. Presented here is a compact history of the work that influenced a whole generation of architects. It includes their best-known schemes and draws together for the first time articles on a wide variety of contemporary subjects allowing a new generation to discover their vision of a sophisticated humanity and a refined technology working in harmony to make a better world.

PB £18.95 1-85490-376-4
125 x 145 mm, 448 pages
400 illustrations, 60 in colour
July 1994

*S*tarting with his first commissions in the early 70s, the artistic output of Brian Clarke has been extraordinary in its creative range, scope of projects, and international appeal. His unique and thorough knowledge of drawings, paintings, gilding, mosaic, calligraphy, heraldry, tapestries, and stained glass has led him to see various concepts of artistic mediums as essential and integrated parts of a unified architectural structure.

Applying his many talents to a number of architectural challenges, including set designs for the ballet and concerts, his designs can be seen around the world in England, Germany, Spain, France, Japan, Saudi Arabia, Qatar, and the United States.

His design projects, frequently in stained glass, are in private homes; The New Synagogue in Darmstadt, Germany; Lake Sagami Country Club in Yamanashi, Japan; assorted shopping centres, corporations, and restaurants; Stansted Airport in England; stage sets for Paul McCartney's World Tour and for a tribute to Rudolf Nureyev; and the Stuttgart museum of Natural History, Germany.

PB £19.95 1 85490 343 8
305 x 252mm, 128 pages
over 100 colour illustrations
September 1994

An Art & Design Monograph

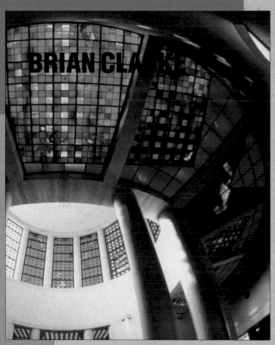

Further information can be obtained from Academy Group Ltd 071 402 2141

ACME, A LONDON ARTISTS' CHARITY NOW IN ITS 21ST ANNIVERSARY YEAR IS FUNDRAISING FOR A NEW STUDIO PROJECT

ACME will provide low-cost combined living and studio space for young professional artists in a new **freehold development** of an ex-industrial building in the East End of London.

ACME, the leading British studio development agency, **has already** helped over **2,000 artists with cheap space in studios located** in over half a million square foot **of temporary leasehold property**.

Included amongst these artists are Rachel Whiteread, Grenville Davey and Richard Deacon (recent Turner Prizewinners) and Shirazeh Houshiary, Fiona Rae, Tony Bevan, Helen Chadwick and Sean Scully.

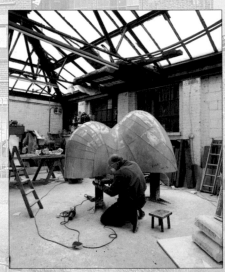

Rachel Whiteread, the recent Turner Prize winner, says: 'I have had an ACME studio since first leaving college. The new live/work project will satisfy many of the young developing artists' needs, providing security with both inexpensive accommodation and work space.'

Richard Deacon, another Turner Prizewinner, says: 'I can only applaud and encourage ACME's creativity and zeal in an area fundamental to the creative life of artists.'

Nicholas Serota, Director of the Tate Gallery, also supports the scheme: 'ACME's success in providing accommodation and working space for artists in London over the past 20 years cannot be over emphasised. Without ACME's involvement many working artists would not have been able to find adequate living or working space in the capital.'

ACME keeps a register of over 650 London based artists currently seeking studios and provides a nationwide advisory service. If you would like to support this project please write for further information to: David Panton and Jonathan Harvey, Directors, ACME, 44 Copperfield Road, London E3 4RR. Tel 081 981 6811 Fax 081 983 0567.

FROM ABOVE: Rachel Whiteread; Richard Deacon; Simon Edmundson; BACKGROUND: Carpenters Road studio complex seen across the River Lea (Stratford)

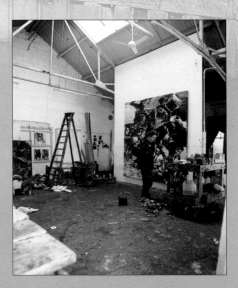

NEW ART
FROM LATIN AMERICA

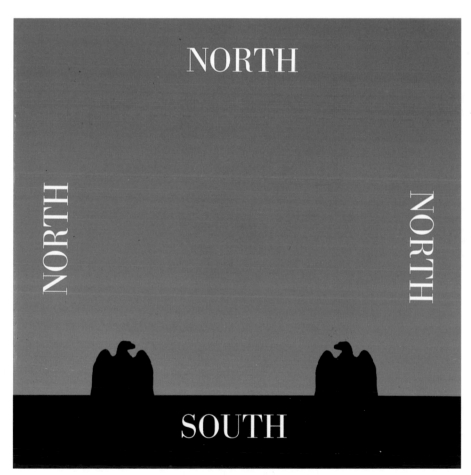

Alfredo Jaar, North and South, *1991*

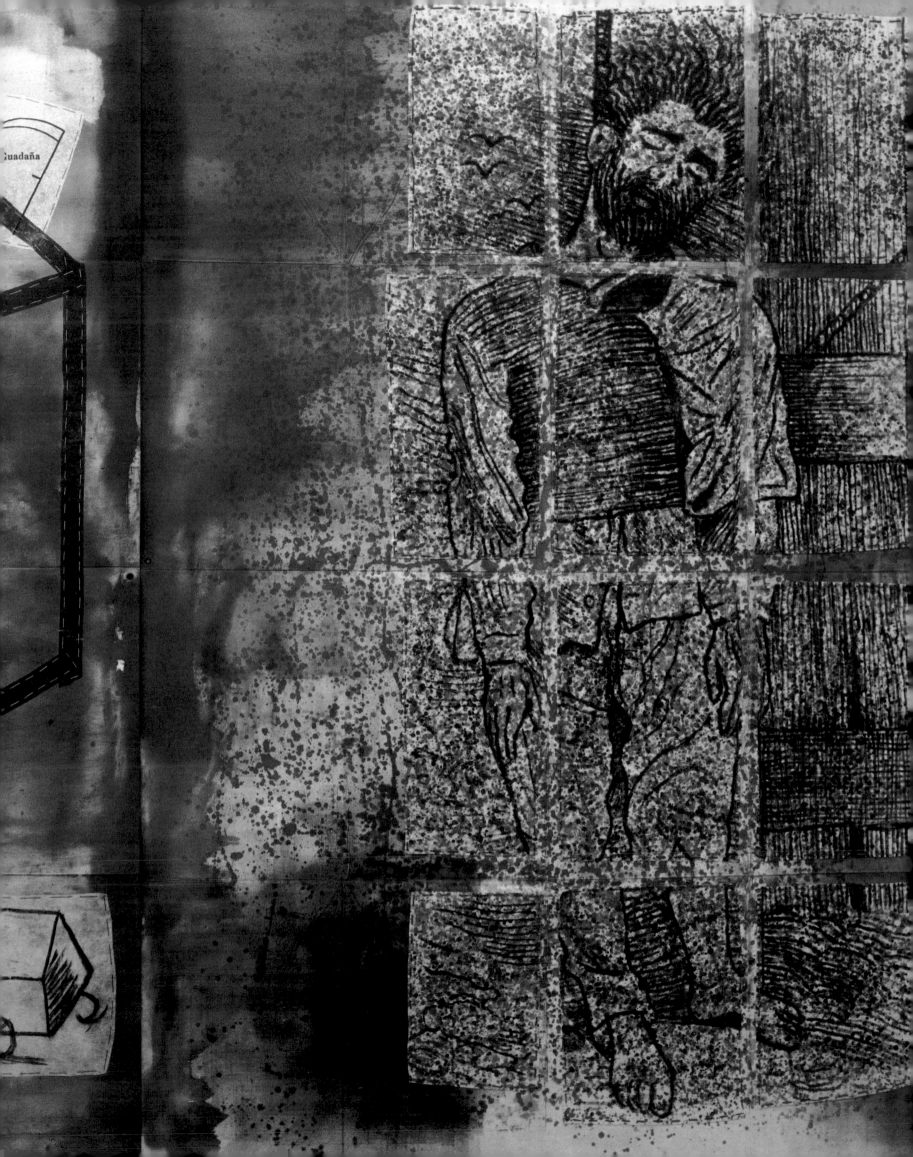

Art & Design

NEW ART
FROM LATIN AMERICA
EXPANDING THE CONTINENT

OPPOSITE: Eugenio Dittborn, If Left to its Own Devices, Airmail Painting No 75, *1988-89, detail reproduced in full on page 80;*
ABOVE: Tunga, Jardins de Mandâgoras, *1993, detail reproduced in full on page 93, University of Essex Collection, donated by Charles Cosac*

A.R. ACADEMY EDITIONS • LONDON

Acknowledgements

We would especially like to thank Oriana Baddeley for agreeing to guest-edit this special issue of *Art & Design* on Latin American Art. She would like to acknowledge the support of Camberwell College of Arts' research project on cultural dissemination.

Images courtesy the following: **Metaphor: The Energy for Beginning** *pp18-25* Diego Reboredo Ferrari; **Interview with Saulo Moreno** *pp26-33* the artist, photos David Lavender; **Difference and Representation in the Work of Alfredo Jaar** *pp34-43* the artist; **Two South American Artists** *pp44-51, 44-47* Arturo Duclos, *pp48-51* Jorge Macchi, photos Rodrigo Rojar; **The Amazonian Paintings of Maria Thereza Negreiros** *pp52-61, pp52, 54, 55-59, 61* the artist; **Art from Argentina** *pp62-65* Museum of Modern Art, Oxford; **Interview with Ofelia Rodriguez** *pp66-75* the artist, photos Simon Robertson; **Eugenio Dittborn: Travels on the Picture Plane** *pp76-83* the artist; **Ricardo Cinalli** *pp84-89* the artist; **Putting Latin American Art on the Map** *pp90-96* photos Alan Dench.

Notes on Contributors
Oriana Baddeley is Senior Lecturer in the History of Art and Design at Camberwell College of Arts and co-author with Valerie Fraser of *Drawing the Line: Art and Cultural Identity in Contemporary Latin America*, Verso, 1989, she is currently working on a book on Mexican Art and is also compiling an anthology of theoretical writings on art and multiculturalism; **Nikos Papastergiadis** is a lecturer in the department of Sociology at the University of Manchester who writes regularly for *Third Text* and is the author of *Modernity as Exile: The Stranger in John Berger's Writing*, Manchester University, 1993; **Chloë Sayer** is the author of several books on Mexico, including *Arts and Crafts of Mexico* (1990) and *Traditional Architecture of Mexico* (1993). She co-curated the recent exhibition 'The Skeleton at the Feast: The Day of the Dead in Mexico' at the Museum of Mankind, and lectures widely on Mexican culture; **Jon Bird** lives in London and is Reader in Visual Culture at Middlesex University, he teaches Theoretical and Critical Studies on the Curating Course at the Royal College of Art and is co-editor of *Mapping Futures* (1993) and *Traveller's Tales* (1994), both published by Routledge; **Mario Flecha** was born in Buenos Aires and now lives in London, he was the director of the Mario Flecha Gallery from 1987-93, after which he has undertaken freelance curating and has been the publisher of *Untitled* magazine, a publication which examines contemporary art; **Valerie Fraser** lectures on the art and architecture of Latin America and Spain at the University of Essex, her publications include *The Architecture of Conquest: Building in the Viceroyalty of Peru 1535-1635*, Cambridge University Press, 1990 and with Oriana Baddeley, *Drawing the Line: Art and Cultural Identity in Contemporary Latin America*, Verso, 1989; **David Elliott** is a cultural historian whose main academic interest is in the visual culture of Germany, Russia, Japan and Mexico during the 19th and 20th centuries, he has been the Director of the Museum of Modern Art in Oxford since 1976, at present he is researching contemporary art within the developing world and is completing a book entitled *Through the Looking Glass: The Roots of Realism in Modern Art*; **Jane Pavitt** is Senior Lecturer in the History of Decorative Arts at Camberwell College of Arts (The London Institute), she is currently working on a book on the architecture of Prague for Manchester University Press; **Sean Cubitt** is Reader in Video and Media Studies at The Liverpool John Moore's University, his books include *Videography: Video Media as Art and Culture* and *Timeshift: On Video Culture*, he is also on the editorial board of *Screen* and *Third Text*; **Edward Lucie-Smith** is an art-historian specialising in the 20th century, his most recent titles include *20th-Century Latin-American Art* and *Race, Sex and Gender in Contemporary Art*, soon to be published is *Frink: A Portrait*, a book of interviews with the leading sculptor, who died in 1993; **Gabriel Perez-Barreiro** is currently studying for a PhD on Constructivism in Argentina at the University of Essex, where he is also the Curatorial Advisor at the Collection of Latin American Art.

COVER: Maria Thereza Negreiros, Great Current, Modules 1 & 2, 1993, from the Amazónica *series, oil on canvas, each 180x180cm*
INSIDE FRONT AND BACK COVERS: María Fernanda Cardoso, Tusas de Maíz, 1989

HOUSE EDITOR: Nicola Hodges EDITORIAL: Ramona Khambatta
ART EDITOR: Andrea Bettella CHIEF DESIGNER: Mario Bettella DESIGNER: Gina Williamson

First published in Great Britain in 1994 by *Art & Design* an imprint of the
ACADEMY GROUP LTD, 42 LEINSTER GARDENS, LONDON W2 3AN
MEMBER OF THE VCH PUBLISHING GROUP

ISBN: 1 85490 220 2

Art & Design Profile 36 is published as part of *Art & Design* Vol 9 7/8 1994
Art & Design Magazine is published six times a year and is available by subscription

Printed and bound in Italy

Contents

Diego Reboredo Ferrari, Reflection *(detail), 1991*

ART & DESIGN PROFILE No 37

NEW ART FROM LATIN AMERICA
EXPANDING THE CONTINENT
Guest Edited by Oriana Baddeley

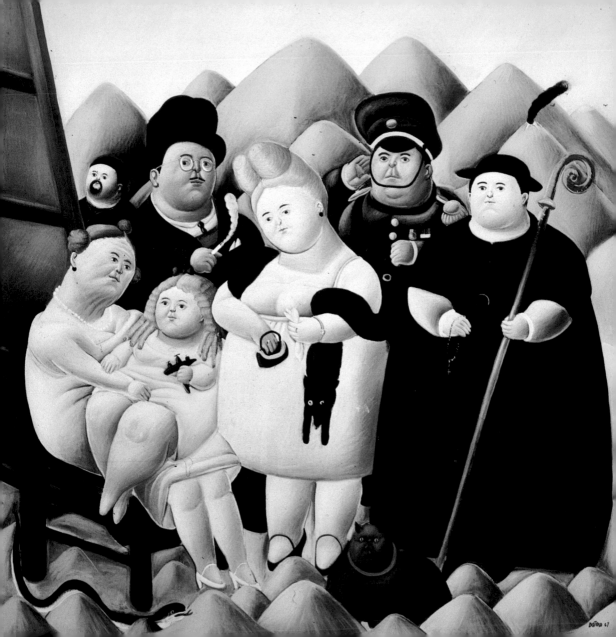

INTRODUCTION

ORIANA BADDELEY

Over the last few years 'Latin American art' has become an internationally recognised phenomenon, and numerous articles, books and exhibitions have attempted to give definition to the diverse cultural output of this complex political and geographic entity.[1] However, while the categorisation of a 'Latin American Art' has focused international attention on artists who previously had been known only on a national level, it has for many artists become a problematic term.[2]

After all ,what shared characteristics can be seen to unite such disparate realities as those of, for example, Belize and Argentina? What distinguishes the work of 'Latin American' artists from that produced within a declaredly 'international' art world? Apart from simple geography, what use does the denial of national identities serve? Venezuelans are just as convinced of their difference to Colombians as the British are of theirs to the French. There is as much ambivalence and contradiction within 'Latin American' as a cultural definition as within the term 'European' culture, which, when applied, usually obscures far more than it reveals. The fact is that the term 'Latin American' emerged from, and continues to refer to, a posited set of political and idealised values. It expresses a unity that gains its ultimate meaning only in opposition. On one level the term serves to link a group of primarily Spanish (and Portuguese) speaking nations, brought together by their shared experience of colonial history and relationship to the economic structures of world markets . On a second level it defines what is *not* North America, that exotic world 'south of the border, down Mexico way' and beyond. This oppositional aspect is intrinsic to the categorisation of a 'Latin American art' and while embraced by some has also come to be viewed by many as a dangerous ghettoisation, an exclusion from the world of 'mainstream' art.[3]

To put this current debate into perspective it is important to recognise some of the ways in which the traditional readings of modern art are related to contemporary definitions of mainstream art.

Within the context of Modernism, nation and geography were seen as extraneous to its defining criteria. Modernity defined itself as universal,[3] yet remained the prerogative of a contained cultural grouping. At its most restrictive 'Modern' art was seen to be produced by a collection of male artists working somewhere between Paris and New York. A few artists from Latin American countries, such as Roberto Matta, Joachim Torres-Garcia and Wifredo Lam entered into the pantheon of Modernism but the bulk of the world's artists were consigned to a shadowy universe where modernity could only be achieved through replication. Art such as that of the Mexican muralists; Diego Rivera, David Siqueiros and José Clemente Orozco, which asserted its difference to the dominant aesthetic was seen as marginal to the concerns of 'Modern' art.

For many years the dominant international perception of a Latin American aesthetic devolved from that of the regions popular art forms. These traditions were seen to represent an authentic manifestation of place and culture; an aesthetic with a continuous and unselfconscious connection to its past, produced by anonymous artisans outside of the fine art traditions of Europe.[4] The corollary of this external appreciation of the popular was the sense that the practice of the taught, selfconscious artist working *within* a fine art context was somehow less authentic.[5] Many of the artists who manifested elements of the popular within their aesthetic also gained an international reputation as 'Latin American'. The two most prominent of such artists, Frida Kahlo and Fernando Botero (who are respectively the most financially valued dead and living representatives of Latin American art) are frequently underrated as *artists* while being lauded as representing the authentic spirit of Latin America. Younger generations of artists have had to deal with this problematic notion of the authenticity of the popular, either by interweaving its aesthetic with that of the fine art tradition, as in the work of an artist such as German Venegas, or by direct confrontation as in the installations of Amalia Mesa-Bains[6] or the performance pieces of Guillermo Gomez-Peña.[7] Even in the miniature scale and 'craft-like' intimacy of José Antonio Suarez's embroidered prints this play upon the expectations of the popular is evident.

The choice of such a theme, however, does not delimit the parameters of aesthetics possible within a Latin American context. To make

OPPOSITE: Fernando Botero, The Presidential Family, *1967, collection of The Museum of Modern Art, New York, Gift of Warren D Benedek; ABOVE: Sydia Reyes, Zig Zag tiempo, 1992, soldered iron, collection of the artist*

such a demand would be as ridiculous as to assert that landscape was the only authentically British art form. Work such as the technologically sophisticated installations of Alfredo Jaar or the urban sculptures of Sydia Reyes or Fabiola Sequera cannot be deemed as 'un-Latin American'. What one must do to make sense of a categorisation such as Latin American is to return again to the idea of opposition, and question those expectations of difference, of otherness, implicit in such a term. The urban versus the rural, technology versus nature, reason versus emotion, the private versus the political, art versus craft; all such oppositions are reflected in the traditional expectations of Latin Americaness. They reflect primarily on a world of unequal expectations, a set of power relationships descended from colonialism and perpetuated by the economic systems of the later 20th century. In a world veering between homogeneity and fragmentation, the Latin American context offers a model of how to cope with a multiplicity of pasts, ethnicities and social orders.

In bringing together the diverse and often differing perspectives represented by the artists and writers within this edition, the aim has been to disrupt too easy a definition of the phenomenon of 'Latin American art', while giving voice to the themes and concerns of a creative practice emerging from a selfconsciously hybrid context. A practice emerging, not from a hermetically sealed cultural unit, but from an awareness of art as a dialogue between the past and the present, the individual and society, the known and the unknown.

NOTES

1 Many exhibitions have been held internationally over the last decade, among the most notable were 'Art of the Fantastic', Indianapolis Museum of Art (1987), the Hayward Gallery's 'Art in Latin America' (1989), MOMA's 'Latin American Art 1911-1968', (1993) all of which were accompanied by extensive and erudite catalogues, particularly Dawn Ades's catalogue to the Hayward show. My own book, co-authored with Valerie Fraser *Drawing the Line: Art & Cultural Identity in Contemporary Latin America*, Verso, 1989, discussed shared themes and concerns within contemporary Latin American art. More recently (1993), Thames & Hudson have brought out *Latin American Art of the Twentieth Century* by Edward Lucie-Smith as part of their 'World of Art' series.

2 This position emerges particularly strongly in Guy Brett's *Transcontinental*, Verso, 1990, which accompanied the exhibition of the same title at the Ikon Gallery, Birmingham & Cornerhouse, Manchester. It was also apparent in the fascinating exhibition 'Ante America' (1992), held at the Biblioteca Luis-Angel Arango in Bogota, Colombia. The catalogue articles of this exhibition (by among others Gerardo Mosquera, Carolina Ponce de Leon & Rachel Weiss) are of particular interest.

3 Nelly Richard's article 'Postmodernism and Perifery', *Third Text*, 2 Winter 1987/88, remains essential reading on this subject.

4 Chloë Sayer's interview with Saulo Moreno and Jane Pavitt's with Ofelia Rodriguez, pp26-33, explore this complex and problematic area.

5 See *Drawing the Line* (op cit), chapter 5, 'Forms of Authenticity'.

6 In taking the Virgin of Guadalupe as her theme in the installation *Queen of the Waters* (1992), Mesa-Bains plays not just with the expectations of the popular but with a figure of iconic significance within the history of Latin American Independence movements. For an account of the importance of Guadelupe see Jacques Lafaye, *Quetzal-coatl and Guadalupe*, University of Chicago Press, 1976.

7 In this joint performance with Coco Fusco, the links between the mediums of performance and installation art and the traditions of displaying 'other' ethnicities were explored. Handbills provided historical data on the 'display' of colonised peoples as amusements for European audiences. In making this point the artists were also subverting the assumption that 'modern' practices bore no relationship to the art of 'marginalised' cultures.

OPPOSITE, FROM ABOVE: Amalia Mesa-Bains, Queen of the Water, Mother of the Land of the Dead; Homenaje to Tonantzin/Guadalupe, *1992; Guillermo Gómez-Peña and Coco Fusco*, Aborigines in the Western World, *Edge 92; Fabiola Sequera*, El gran ciempiés, *1990; LEFT: José Clemente Orozco*, Birth of the Modern Age; *RIGHT: German Venegas Pérez*, Mártires, *collection Fundación Cultural Televisa-Centro Cultural, Mexico*

ENGENDERING NEW WORLDS: ALLEGORIES OF RAPE AND RECONCILIATION

ORIANA BADDELEY

The need to discuss the nature of the Latin American context, to deal with the disjunctions and incongruities of a post-colonial culture has become one of the most readily recognisable characteristics of 20th-century art from Latin America. Complex metaphors and symbolic languages have developed to define the interdependency of European and Latin American cultures, to offer some sort of explanation for the hybrid nature of Latin America. Within this category of cultural production, traditions of allegory have formed an important element. Allegory as a discursive medium is part of the heritage of Catholic evangelisation but also remains part of the visual vocabulary of many contemporary practitioners. In some ways the Renaissance appropriation of the classical past, from which many of our uses of allegory descend, was itself a model of cultural 'interaction'. As a model, it also puts an interesting gloss on the definitions of originality and replication so frequently of interest to artists working outside of the defined mainstream. Re-using and re-ordering the visual languages of a distant culture to the needs of a different time and place cannot be seen as specific to Latin America but rather as symptomatic of an awareness of cultural multiplicity.

1992-1492

In the wake of 1992's quincentennial of the 'encounter', attention has been focused anew on the point of contact between Europe and what Europeans called the 'New World'. To many artists, such as Maria Sagradini, the event served to highlight the continuing contradictions and inequality of this relationship. However, from whichever of the numerous complex and often conflicting perspectives adopted towards this historical moment,[1] the quincentennial was a reminder of the essentially hybrid nature of Latin American culture.

Neither indigenous, nor European, Latin American culture has been balanced between a sense of belonging and of exclusion since the 'encounter'. The visualising of this finely poised relationship has traditionally encompassed the recognition of both conflict and power, a tipping of the scales in the direction of one ideological camp or the other. The art of the region's diverse constituencies determined that whichever visual

language was adopted it would carry a set of meanings beyond that of the artists' personal aesthetic. From the very first moments of contact between the two worlds; the power of visual languages to speak to the continent's different constituent cultures – the Spanish, the indigenous and the ever increasing 'mestizo' – was acknowledged. At the same time, the differing traditions of representation and symbolism remained recognisably culturally specific. In the period after the Mexican Revolution, a highly rhetorical stand was taken to the notion of interdependency, as artists such as the muralists attempted to construct what they saw as a new, assertively anti-colonial art form.[2] For many contemporary artists, however, the notion of both conflict and affiliation goes deeper than the rights and wrongs of colonialism.

The Rape of America

Traditionally, the encounter is discussed in ostensibly sexual terms. The eroticised Indian nude greeting the arrival of the Spanish conqueror with equanimity, represents a long standing tradition of allegorical renderings of the colonial enterprise in the Americas. In a work such as Jan van de Straet's engraving from *c*1600 of *Vespucci Discovering America*, the naked fertile America is quite literally discovered by the explorer Vespucci; the clothed, civilised European, Vespucci, bringing technology and knowledge to the available, desirable but primitive Americas.

This fantasy of colonial relations, intersecting as it does with traditional gender roles – Woman/passive v Man/active; Woman/Nature v Man/Technology – has functioned as a powerful metaphor within Latin American culture. In one form or other this gendering of the 'Encounter' appears in many different Latin American contexts as an explanation of the hybrid nature of the post-colonial culture; the Indian mother taken by force by the European father, giving birth to the 'illegitimate', mixed race, 'mestizo', culture of Latin America.

The most famous version of this allegory of cultural origins is that of the Spanish conqueror Hérnan Cortes and his Indian interpreter/mistress, Malinche. From the 16th century on, the realities of Mexican colonial culture could be visualised via this relationship. The problematic

OPPOSITE: Maria Sagradini, Made in Uraguay (detail of installation), collection of the artist, 1991; ABOVE: Jan van der Straet, Vespucci Discovering America, c1600

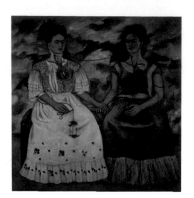

figure of Malinche, half collaborator, half victim, manifests the ambivalent inter-relationship of the conquered to the conqueror. In Antonio Ruiz's intricate, small painting, *The Dream of Malinche* (1939), Malinche's sleeping body metamorphoses into a microcosm of colonial Mexico. Traditionally, she is both pitied and despised but nonetheless she embodies the territories of the colonised. She forms part of the complex amalgam of allegorical Indian women referred to by Octavio Paz in his seminal discussion of the Mexican psyche *The Labyrinth of Solitude* (1950).[3] In this work Paz links the figure of Malinche to that of the 'chingada', a raped and beaten mother of popular slang, and discusses the cultural ramifications of the collective mother/victim/nation Image.

It is this allegory of injured 'motherland' that is frequently referred to in the work of Frida Kahlo, who elides the notion of personal injury with that of the collective trauma of colonisation.[4] In *The Two Fridas* (1939), Kahlo depicts herself as the allegorical body of Mexico, literally split into two, yet interdependent; the injured infertile colonial body gaining strength from that of the strong fertile Indian woman. This Indian woman is not the compromised and despised 'mother' Malinche, but Kahlo's iconic image of the inviolate spirit of the Americas, the Tehuana.[5]

In the period after the Mexican Revolution, the Tehuana came to represent an assertively post-colonial culture, the fertile un-bowed body, closer in spirit to the 'Amazons' of 16th-century travellers' tales. She existed in direct opposition to the image of the brutalised Indian woman, raped by the European colonisers. She represented a pride in the indigenous past and a denial of cultural dependency. This glorification of the 'un-raped' Indian woman emerged simultaneously to the appropriation of the visual languages of popular art into the construction of an oppositional culture to that of the Eurocentric high art tradition.

In Diego Rivera's *Dream of a Sunday Afternoon in the Alameda Park*, the artist produced a work which constituted a personal manifesto for a new art.[6] Rivera paints himself as a child (the art of the revolutionary future) nursed by the Tehuana (Kahlo) but parented by the 'popular' (in the form of the printer José Guadelupe Posada and his most famous creation, the skeletal lady 'La Caterina'). This allegorical 'family' is used to lay claim to a set of cultural values that conformed to Rivera's anti-colonialist aspirations. Past conflicts epitomised by the skeletal yet living figure of the Caterina, are seen as engendering a new, more positive future.

Contemporary Mexican artists appear highly conscious of the work of their predecessors and the use of allegory remains an important tool, but the mood has radically changed. Rivera's use of the popular and the indigenous to represent the dynamics of national identity is savagely inverted in Julio Galan's *Tehuana* (1990). Here the familiar costume of the Tehuana becomes an empty, bitter reminder of the hollowness of nationalist rhetoric. The blank gap for the face beckons like a fairground painting, waiting to be filled by any passing visitor, still a reference to the popular, but evoking a more random, less controllable force. Galan's is a world where 'authentic identity' has become something to buy at a souvenir shop. This is not so much a transformation of the allegorical body of the Tehuana, as a knowing rejection of the traditions of visualising the 'Latin American' identity. In this play upon the traditions of asserting a 'purer' identity, Galan attempts to escape the endlessly polarised positions of the gendered allegories of cultural interaction.

In a similarly bleak vein, Enrique Chagoya's *LA-K-LA-K* (1987), takes Posada's 'La Caterina' and unites her with a skeletal Mickey Mouse in a parody of Rivera's *Alameda . . .* self-portrait. The 'mother' culture claimed by Rivera has the bleak emptiness of Galan's *Tehuana*, the 'new art of the revolution', the sterility of Disney. Here again we are forced to recognise the mass marketing of the notion of authenticity, the impossibility of the 'pure' inviolate culture.

The battle seems no longer to be the simpler rejection of colonial culture espoused by the generation of Diego Rivera and the proponents of nationalist cultures within Latin America. The stark blacks and whites of Rivera's more jingoistic 'good Indians /bad Spaniards' have blurred to grey. To put it simply, the definition of what is imposed and what is inherited in cultural terms has shifted. Colonialism is not denied but clearly defined criteria of cultural identity are replaced by a series of questions.

Guilt and Reconciliation

The 'encounter/Rape/conquest' and its ensuing progeny, so often a theme within Latin American art, remains more than just a reference to a distant if crucial moment in history; it also becomes an allegorical reworking of the problematic position of the Latin American artist to the visual languages of a Eurocentric 'high art' tradition.

This tradition of the 'great artist' as the signifier of civilisation has itself been a focus of attention during the 1980s, an intrinsic part of the selfconscious games of post-modernism. However, in the work of Latin American artists, such as Alberto Gironella or Alejandro Colunga, these references are given an added meaning.

The roots of Latin America's colonial past grow from the same soil as Spain's 'golden age of painting'; for every Columbus, Cortes and

Pissaro there was also Titian, El Greco and Velàzquez.[7] As representative of Spanish culture at one of the most dramatic points in colonial history, the work of these 'Great Masters' takes on an added political dimension within a Latin American context.

In Colunga's *The Marriage of Chamuco & La Llorona*, the deliberately 'El Grecoesque' style of the artist's earlier work is present if subdued, while the theme is again that of hybrid identity. As with Chagoya, this work parodies the claims of the earlier generation and denies the notion of a transcendent culture emerging from the ashes of colonialism. Instead we are shown a 'family' of the insane and the vicious; Chamuco, the Christian devil imported by the Spaniards; and La Llorona, the 'Weeping Woman', a figure descended from an Aztec death goddess whose annual festival represents the trauma of conquest. This is not just the injured Chingada but an altogether more dangerous and uncontrollable 'mother' figure, who is said to roam the streets at night stealing children to revenge the loss of her own murdered offspring. Colunga's dark allegory points to the shared heritage of horror, a sort of 'a curse on all your houses'. There is no heroic victim, just a legacy of pain and cruelty.

The assigning of blame is also deliberately avoided by Alberto Gironella. His numerous reworkings of Velàzquez's *Queen Mariana* dissect and reconstitute the body of this colonial queen, transforming aggressor into victim.[8] In *Queen of Yokes*, the ghost of the Velàzquez portrait fights with the vitality of the collage of popular references, as if trapped forever within the wrong painting. In inverting the traditions of the male/Spanish/coloniser allegory, Gironella also humanises the notion of power, focusing on more subtle notions of freedom and oppression. The Spanish Queen becomes as much a victim of her birth and her particular historical moment as Malinche.

While in Mexico the point of contact between the 'old world' and the 'new', and the metaphorical debate surrounding that moment has a continuing relevance, it is obvious that the conditions of the present have changed. Within other parts of Latin America the relationship to the history of colonialism has not always been so vociferous and yet this move towards a less polarised position is equally evident.

In a work such as *El Compromiso* (1982) by the Uruguayan painter José Gamarra, the scene is set in a fantasy coastline jungle *somewhere in Latin America*. The style of the painting is deliberately 'old master' with only its scale alerting the observer to its 'modernity'. In this far away un-reachable place the representatives of indigenous and colonial world views are locked in violent conflict. The priest cuts the throat of

the feathered serpent while the native child stares unconcerned at a pet parrot. As an audience we are not asked to judge or take sides, we merely observe the progress of history. We cannot judge events taking place in a world created by writers and explorers, this lush jungle painted Rousseau-like by Gamarra from his studio in Paris.[9] For Gamarra, the past is indeed another country, a place where injury and cruelty co-exist with hope and innocence. His Latin America is an Eden-like paradise on the point of corruption; the conquest a sort of 'fall of man'. Yet the event is inevitable and offered in explanation of the chaos and hurt of the present times, a distant starting point. This point is made not just by the subject matter but by the manipulation of the traditions of representing the unknown. Gamarra's bitter sweet Utopias evoke the Latin America of European fantasy, it is a place without tangible existence yet is somehow familiar.

This same sense of familiarity pervades the work of the Argentine Miguel D'Arienzo. In his *La Conquista* (1992), the violence of the 'encounter' is only passingly referred to in the figure of the Indian child aiming his bow at the distracted *conquistador*. Even this reference is ambivalent: is this an attack or are we observing the antics of some indigenous Cupid, whose magic arrow will turn the heart of the homesick Spaniard towards the Indian woman who gazes so solemnly at the spectator? 'See what is about to happen', she seems to say as we are confronted with the amoral inevitability of history. D'Arienzo's work is not, however, about Latin America's colonial past in any direct sense. Even more strongly than in Gamarra's work we are asked not to assign blame. The Spaniard arrives almost like Ulysses on the island of Circe, he is about to forget his past to lose himself in his 'new world'. In this sense D'Arienzo's work is all about memory and loss, his characters as they move from painting to painting (and many of his works pick up on the same characters), act out semi-forgotten moments in a past they no longer recall. Did they once belong to Titian or Goya? Was that gesture once played out in a painting by Velàzquez or Tintoretto? Like a company of provincial players performing *The Tempest* in the Pampas, they act out a narrative, the meaning of which they have forgotten, while the lines and parts remain and are reconstituted into a new set of meanings. For D'Arienzo this seems to be the crux of the matter – that within replication there is also a re-ordering, a re-constituting of meaning which makes the alien, familiar; the distant, close.

The allegorical nature of D'Arienzo's work is made even more evident in his *Rape of America* acting as it does as a conceptual counterpiece to the more traditional 'Rape of Europa' theme.

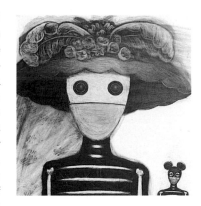

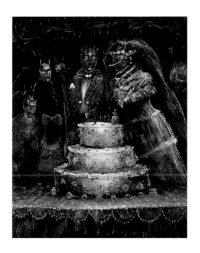

FROM ABOVE: Enrique Chagoya, LA-K-LA-K, 1987; Alejandro Colunga, The Marriage of Chamuco and La Llorona, 1984, collection of Guillermo Sepulveda, Monterrey; OVERLEAF: Diego Rivera, Dream of a Sunday Afternoon in the Alameda Park, 1947-48 (originally Hotel del Prado, Mexico City)

13

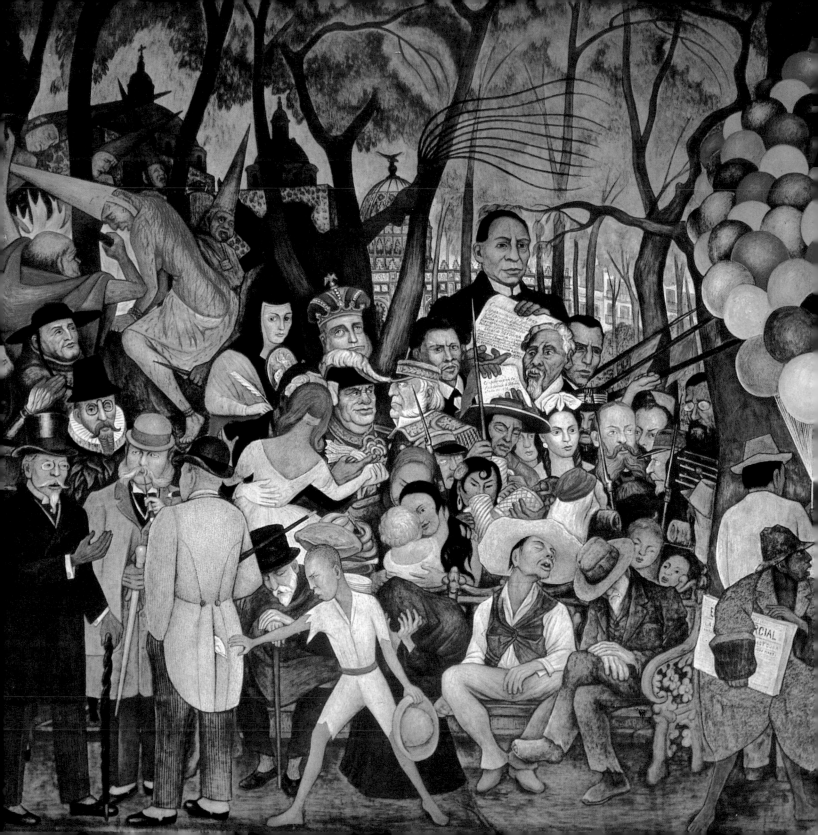

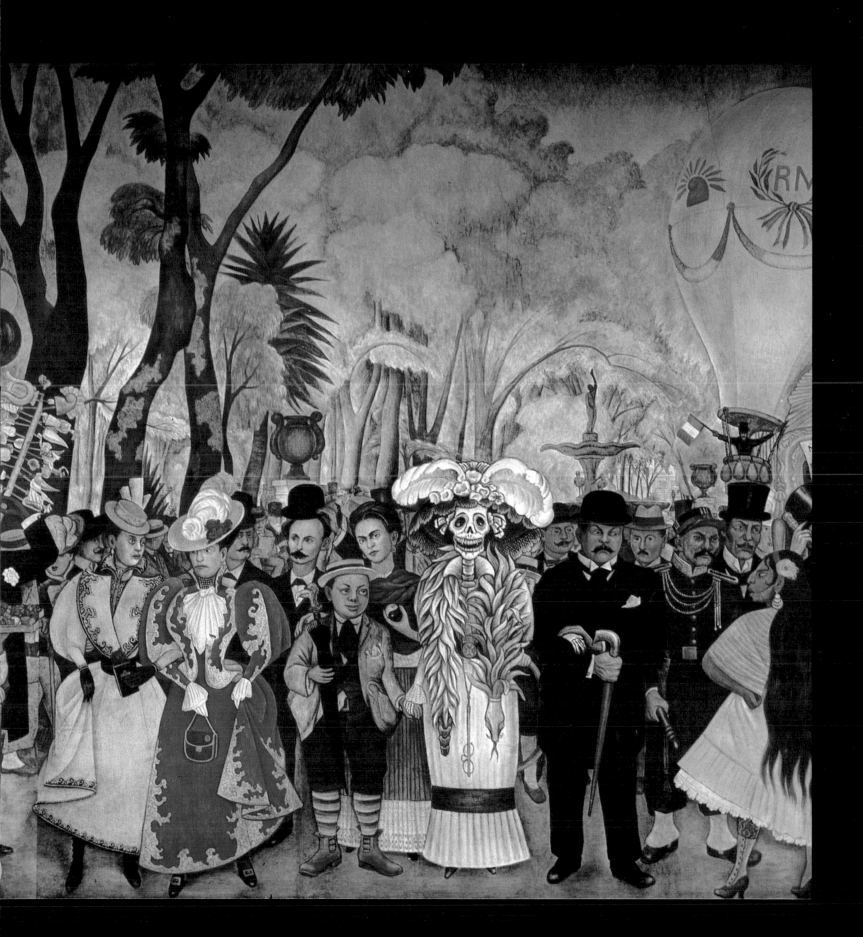

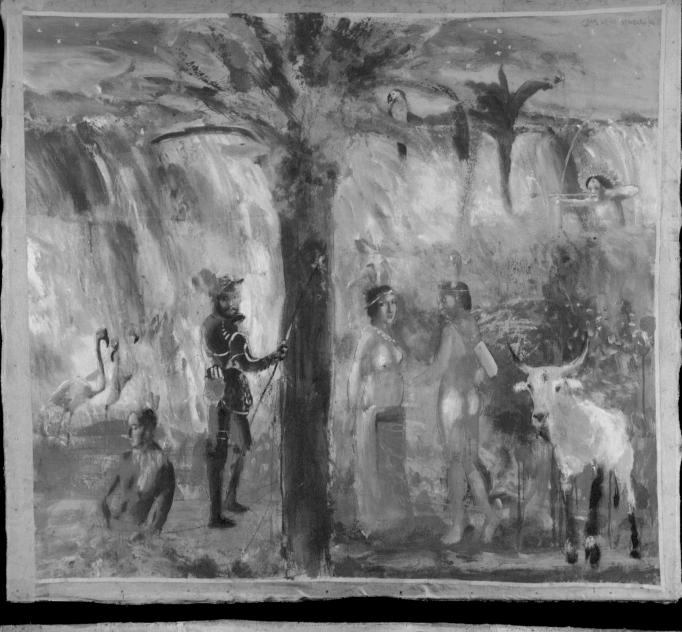
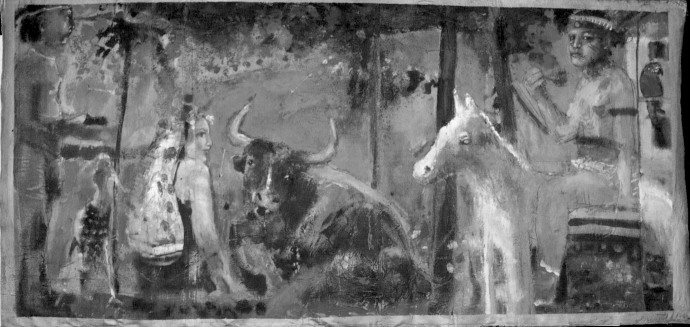

The classical explanation of the origins of 'Europe' linked the notions of history, myth and sexuality into a complex allegory. In D'Arienzo's painting the power relations of the original are inverted. The transgressive lustful figure of the disguised Zeus, the bull, is still the central focus of the allegory. Here, however, he becomes not just the godly antagonist but the Spanish presence. D'Arienzo's bull seems more tragic than aggressive, his America a temptress not a victim. The scene evokes the spirit of the bullfight (a sport imported with enthusiasm by the Spaniards to their colonies) rather than that of an abduction and rape. The bull appears confused and wounded, dying a victim of its own obsession.

If the languages of allegory have formed an important part of the dialogue between the 'old world' and the 'new', they have also served to highlight the culturally specific meanings of the power relations within the traditions of metaphor. In a time of changing valuations of identity, both sexual and ethnic, the shifting focus of these contemporary Latin American artists represents a complex and sensitive response to a world of change and uncertainty.

NOTES

1 For an exploration of the issues raised by the quincentenial, see: 'The Wake of Utopia', *Third Text*, issue 21, Winter 1992-93.

2 The beginnings of this debate are recounted by Jean Charlot in *The Mexican Mural Renaissance, 1920-1925* Yale, 1962. For a more complex perspective on the internal arguments of the Mexican movement see: *Art and Revolution*, the collected writings of David A Siqueiros, Lawrence & Wishart, 1975.

3 See Chapter 4 ,'The Sons of La Malinche' in Octavio Paz, *The Labyrinth of Solitude*, translated by Lysander Kemp, Penguin, 1985.

4 See Chapter 5, 'Body and Soul: Women and Post Revolutionary Messianism' in Jean Franco, *Plotting Women: Gender and Representation in Mexico*, Verso, 1989.

5 I discussed this aspect of Kahlo's work in greater detail in 'Her Dress Hangs Here: De-frocking the Kahlo Cult', *Oxford Art Journal*, vol 14 no 1, 1991.

6 The best way to gain an insight into Rivera's methods and aesthetic arguments is through his own writings. A selected list of his articles is included in the catalogue to the exhibition *Diego Rivera: A Retrospective*, Detroit Institute of Arts, 1986.

7 This argument is made very clear by Valerie Fraser in 'Surrealising the Baroque: Mexico's Spanish Heritage and the Work of Alberto Gironella', *Oxford Art Journal*, vol 14, no 1, 1991.

8 I would like to thank Elizabetta Andreoli for allowing me to see her interesting account of Gironella in the unpublished dissertation *Cultural Anthropophagy in the work of Aimé Césaire and Alberto Gironella*, University College, London, 1993.

9 This theme is discussed further by Valerie Fraser in her article 'A Greener Modernism', see this issue, pp52-61.

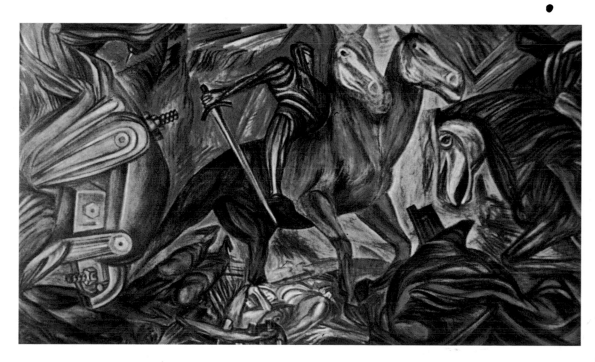

OPPOSITE, FROM ABOVE: Miguel D'Arienzo, The Conquest, *1992, Private Collection; Miguel D'Arienzo*, The Rape of America, *1993, Durini Gallery, London; ABOVE: Chamuco and La Llorona; LEFT: José Clemente Orozco*, La Conquista, *1938-39, Guadalajara, Jalisco, Hospicio Cabañas.*

METAPHOR: THE ENERGY FOR BEGINNING

NIKOS PAPASTERGIADIS

Diego Reboredo Ferrari is a young artist. He was born in Argentina and has lived in Barcelona and London. My interest in writing this essay is governed neither by the mastery of his practice nor by the exceptionality of his journey. This essay is not a comment on achievements, interventions and arrival. It is about the dynamism of beginnings. The colour blue for both of us, and in different ways, signifies both home and horizon. The blue used in Renaissance paintings as background, to heighten the outline of a subject, is taken by Diego Reboredo Ferrari and transposed onto the surface of his installations. The background steps forward, carrying within it the suggested androgyny of the Renaissance subject, whilst also beckoning the sublime. Meditations on beginnings are less involved with the identification of an original location than they are an engagement with the practice of mediation and assemblage. To find the beginning is as much an invention as it is an excavation. In this sense discovery is not a return journey, but the forward search of an initiation point. The power of discovery is thus found in the confirmation of knowing how to go on. Beginnings are sources of energy.

The despatching of starting points and the cross-dressing of impasses is a predicament that is shared by many other artists from Latin America. Where to commence and to what end? Home and exile have many forms. Juan Davila left Santiago and moved to Melbourne. Shifting from one periphery to another, perhaps this dislocation sharpened his attention to the loss of language and history, a loss which a nationalist iconography would rather gloss. Davila's reply to the exilic condition of isolation and fragmentation is found in his transvesting of itinerancy. Eugenio Dittborn has made mailing his art from Chile to elsewhere, as both the conceptual grid for its construction, and as a message that gives resonance to the positions of distance and proximity implicit in the act of sending and receiving. It was not just the physicality of restraint and freedom that compels the questioning of borders. Which language and what skin will reveal presence? A still from a video shows Tunga holding a model brain in his palm. With the pressure of Gabriel Orozco's fingers on a ball of brick clay followed by a clean release, a heart is revealed. The open palm is the gesture

of offerings. Both Tunga's *The Silver Nerve*, 1986, and Gabriel Orozco's *My Hand is the Memory of Space*, 1991, are bafflingly simple. Yet the resonance that is activated through the twin axioms of absence and presence slightly jolts the fragile walls of our self-understanding. How will history speak and geography map this continent? *Mestizaje*: the metaphor for the 'hysterical' syncretism at every level of being. There is no straight continuum which coordinates origins and destinies.

The difficulty of starting points is to be found in the contradictions between production and validation. It is in the gap between the dynamism of living cultures and the static terms of institutions which either cover the vastness of other civilisations with flimsy cliches or turn their backs on the enigmas of new formations. The paradoxes of location and orientation, which were delicately poised by Guy Brett in the exhibition 'Transcontinental', 1990, have alerted us to a peculiar figuration of surplus and lack in the resourcing and referencing of Latin American cultural identities.[1]

To consider the complex patterns of influence and projection I would like to interweave the stories that Diego Reboredo Ferrari recounted to me. The story concerned with growing up in the Argentine pampas is as significant to self-understanding as are the stories that outline his response to the work of other artists. The central concern of Ferrari's work has been an examination of the position of the spectator. The alienation and/or integration of the spectator has been posed in relation to particular responses to light and space.

Diego Reboredo Ferrari's fascination with the qualities of the horizon is clearly linked to childhood experiences in the pampas. The horizon, or what Waltercio Caldas called 'the line that's nowhere',[2] presents us with the instance in which it is possible to both visualise and contemplate the border between absence and presence. This possibility is particularly heightened by two features: a road and the sunset. As a child Ferrari would stare down the straight roads leading into the pampas as if he were looking into the barrel of infinity. Similarly, when the sun seemed to dissolve into the flatness of the pampas and the day merged into night, the expansiveness of earth and sky found

Diego Reboredo Ferrari, Time and Space, *1989*

new proportions at the cusp of mutual penetration. The solitariness, not solitude, of a figure framed within the immensity of elements, presented to Ferrari's attention the experience of the relationship between background and foreground and the oscillation between near and far. The ambivalent sensation of open and closed, light and dark, are the constant axioms in Ferrari's installations.

There are three figures – Michelangelo, Saenredam and Durham – which can be proposed as markers in Ferrari's practice. Each figure serves as a station through which he passes, enhancing the beginnings and clarifying the multiple crossroads of a modern myth. With each arrival, the examination of one question becomes all the more restless: how does the work of art communicate the potentialities of competing realities?

To recount this journey let us commence with Michelangelo and the story of the eye. This is a familiar starting point. We all know that Michelangelo was commissioned to paint the story of creation, and what we admire today more than the technical virtuosity is the incorporation of meanings and values which were previously excluded from the genre of painting. This was a titanic struggle between individual will and institutional dogma, which centred on the determination of the 'diameter' of interpretation. Michelangelo challenged the code which excluded the possibility of ambivalence. 'Look into the way he painted the eyes of the prophet Jeremiah', declares Ferrari, 'How could we overlook that the benign gaze may also hold evil?' Folkloric wisdom does not deny the existence of such contradictions. Protection from the evil eye is not a defence from the external enemy. It is rather, an acknowledgement that the look of admiration can also carry the harm of envy. Embracing such contradictions and displaying ambivalence is the deepest threat to an institution founded on dogma. Within the enclosed world of dogma there is no space for the underdetermined or polyvalent signs. Michelangelo's refusal to comply with the rules of codification and the portrayal of ambivalence in the structure of vision and interpretation presents Ferrari with a number of salient starting points for investigation.

The concern with the ambivalence of vision was developed in the installations, *Reflection*, 1991, and *The Split Personality of Light*, 1993. Both installations construct a scenario in which the spectator's perception of the space is time bound. The images are substantially affected by the passage of light and the position of the spectator. The interaction between light and position is intensified by the 'competition' between internal (artificial light) and external (sunlight). In the case of *Reflections*, this 'competi-

tion' affects the perception of the central image of the eyes of Jeremiah, whereas in *The Split Personality of Light*, it affects the projection of the spectator's shadow from the internal wall to the dark exterior. In the latter work this play with exteriority opens up the philosophical dimensions of transmission and absorption as well as exposing the subject to being cast into the psychological abyss of non-reflection.

Apart from the thematic continuities between these two installations there is also a significant development. The ambivalence of vision and the opposition between objectivity and subjectivity are balanced in different ways in the two installations. In *Reflections*, the two eyes are also surfaces on, and through which, light is most delicately or forcefully filtered. This staging of the source is also cast with specific values. One eye narrows and turns inwards: it withholds or banishes communication. The other eye looks outwards with an inviting gesture towards possible dialogue. The axis is divided and the spectator is forced to negotiate this uncertain gaze. Jean Fisher astutely observed that an echo of this dual message is established by positioning three discs which seemingly float over fluorescent lights outside the room:

The ambivalent surface of the solar film as both penetrable and reflective, and the light halo around the discs at night each moment functioning as an immaterial interval between states. This interval or border is a limit that cannot be said to be either inside or outside, but an indeterminable and vacillating interface between two different spatial dimensions or fields. As such, it may be said to function as a metaphor of the artist's self as the 'gap' which separates and conjoins two geographical spaces.[3]

This gap is posed more radically in *The Split Personality of Light*, where the projection of artificial light passes through a small hole from the back wall that divided the kitchen and the living room. Upon entering the dematerialised living room, the spectator has taken a position within the frame. The absence or presence of a shadow onto the facing window is determined purely by the rotations of sun. The reflection of the spectator's self-image is thus bordered by the horizon formed between two sources of light: external sunlight and internal projected artificial light. Within this installation the splitting of forms is also a convergence, the site of ambivalence and the ambivalence of sight is further locked together.

From the rebel, whose struggle is to expand the terms of referencing, to the reactionary, whose compulsion revolves around establishing a strict equivalence between signification and meaning, Ferrari turns to consider the figure

Diego Reboredo Ferrari, Reflection, *1991: OPPOSITE, FROM ABOVE: Working drawing showing the electric cable running from the interior to the exterior, and the three discs which appear to float over fluorescent lights; Interior view shows the source at which the electric charge creates the reflection from the interior to the exterior; Street level view showing the light halos around the discs at night; ABOVE: Detail*

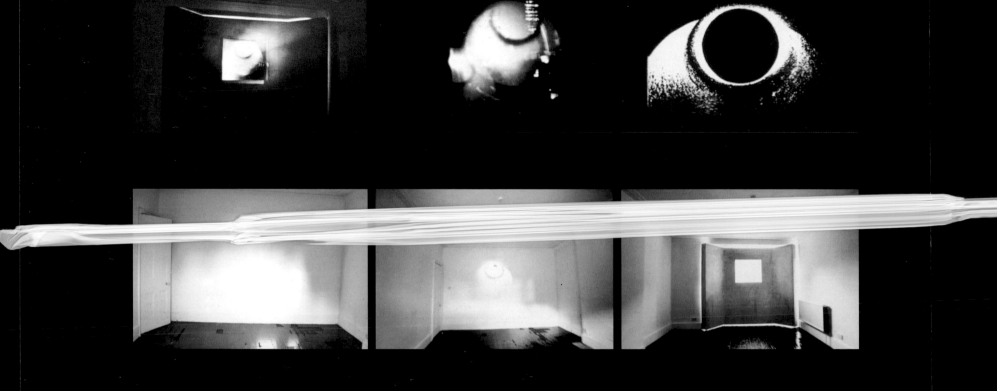

Diego Reboredo Ferrari, The Split Personality of Light, 1993: ABOVE, L to R: Working plan showing the fluidity of light between artificial (projector) and natural (sun) light; General descriptive plan illustrating sunlight and space of room with the kitchen on the righthand side and the living room on the left; Working plan with the spectator positioned in the middle of the living room, indicating the space of the two rooms; CENTRE, L to R: The light source positioned upon the kitchen cupboard, penetrating its luminosity into the living room; Detail, 1pm, showing the light creating and casting the shadow of the spectator in the living room; Floating wall, 1pm, the image of the spectator is here projected upon the window in the floating wall which consists of double glass with solar film; Floating wall, 5.30-6.30pm; The projected image is captured on the surface of the window, the reflection of the opposite wall is projected outside, interacting with the public space. Thus, private is made public; Graphic image of the split personality of light; BELOW, L to R: The left (1pm) and central (2pm) images show artificial light projected through the kitchen, travelling through the living room and then reflected back through natural light; 2pm, floating wall with natural light travelling through the window and the gaps in the wall

of Pieter Saenredam. The painting *De Groote Kerk, Haarlem*, by Pieter Saenredam, was for Ferrari an example of the contradiction in the construction of an idealised field of vision within the terms of the Renaissance. This painting also provoked a proposal for a collaboration with artist/critic/architect Mark Pimlott. For both Pimlott and Ferrari, it is the presence of a dark spot within an almost transparent interior that produces a disturbing tension. The linear gaze into this expansive interior is arrested and then absorbed within the dark painting that is positioned inside Saenredam's painting. Their proposal suggests that the presence of the dark painting hung on the white columns within this painting contradicts the principles of optical certainty:

> The painting within the painting denotes representation, it is flag, token and icon, it is temporal, historical and commemorative, it is *momento mori* and subjective, it is obscure, it is subject. Its conventions and knowledges conflict with those of the depicted interior, which present themselves as rational, ahistorical, illuminated and objective. The internalised discontinuity of the painting calls attention to its status as representation, as exposed and troubled artifice. It shatters its own initial claim to a vision of objectivity, by opening up its own ambiguity, its place between knowledges, between object and subject. The rational is thus revealed as representation, the representation as presence. The painting as subject (as an inversion of optical confirmation) interrupts the agreement between viewer as subject and painting as object. An empathy is demanded, as boundaries of otherness collapse.

Ferrari's concern with the interaction between the position of the spectator and the embodiment of the vision finds a tantalising twist in this project. By identifying the tension between the different levels of image, and the contrary uses of light, he directs attention to the repositioning of the spectator, away from a fixed exterior vantage point, to an exilic shuttling between the inside and the outside of the frame. The perspective is decentred and the hierarchy of interpretation destabilised. The Enlightenment's promise of integrating the scopic drives of vision and knowledge appears to negate itself within its own framework. It is in this project that the multidimensional conception of exile becomes apparent in Ferrari's work. Exile is perceived not just as an experience of physical displacement but is also linked to the semantic raptures in representation. Exile is inserted as a conceptual process that heightens the metaphorical mode of carrying difference into critical thinking. It alerts attention not only to the difference between things but also to the connectivity of the space between them. Space is no longer seen as a neutral stage, but an active field constituted by dynamic forces. Situating the body of the spectator in this field undoes the Renaissance's certitudes that grant the unity and clarity of insight, as they abstract and neutralise the concept of space. This exilic perspective is seen as counter to the vision proposed by the Enlightenment. However, this is not to be confused with an embrace of boundless relativism and disunity. The exilic perspective is the product and the process of shuttling from one position to another; if it appears loose and open-ended, this is not because it is unstructured but because it is structured without a centre.

If we imagine the struggle for interpretation in Michelangelo, in terms of a contestation over the range of possible meanings, an opening of valves that expand on the flow of interpretation, admitting new levels of heterodoxy, then, despite Saenredam's intended code, the presence of the black painting within *De Groote Kerk, Haarlem*, represents the impossibility of the return to orthodoxy. The constriction of the potentiality of meaning is prevented from arriving at a singular point of intersection. Dogma demands an absolute and predetermined fit between the sign and its interpretation. The power of this absolute fit colludes with the promises that truths and errors are always fixed. Reassuring as it may be, the security of this symmetry rests on denials and exclusions. The relationship between an image and the eternal can only be stable if the metaphoric mode of interpretation is confined to a codification of symbols. The multiple connectiveness in the tissues of thought are striated and hardened into linear veins which singularise the suggestion of a glance into the tyranny of the stare. The position of the spectator and the politics of representation have been brought to the surface of many debates within the transnational art world. Some of the best informed critics and most celebrated artists have not succeeded in creating critically-engaged perspective and interpretation. Gayatri Spivak (an Indian cultural critic working in New York) and Alfredo Jaar (a Chilean artist also based in New York) in *One or Two Things I Know About Them*, 1991, set out to represent the intimate realities of the Bangladeshi community in East London. The division of labour between the theorist/critic and photographer/artist did not find a tone that affirmed the identity of their subjects. The disjunction between the text and the image aroused protest from the very girls who had been photographed. The collaboration backfired, exposing that the pedagogy of the investigative camera and the dialectics of the gaze are easily turned against

each other. The truth of the glance is hard earned.

The meeting of eyes can be the precursor of communication, the invitation for exchange, the first breath of dialogue; it can be as full as the horizons of silence that surround speech. I am reminded of Pantelis Voulgaris' film *Stone Years, 1985,* which depicts the horror of repression and persecution most powerfully in moments when emotion is necessarily withheld. There is a haunting scene where two condemned lovers face each other across the bridge of the ship that was carrying them to exile, and for fear of further retribution they dare not even weep. Any expression of recognition could only intensify their suffering and endanger clandestine networks. The space between them stings with denial. The lovers were bonded by history, both personal and social, past and future oriented. Entwined like this they need not speak of their love. Their solidarity required no testimony. Understanding the lexicon of eyes implies profound intimacy. In other situations the understatement is part of the violence of silence as it rebounds between the mirrors of misrecognition.

When we look into distant eyes, what do we discover about ourselves and about the other? There is a tendency which recurs throughout the history of Western art which seeks a transcendence from the limits of the self via an incorporation of the other. The aim usually involves the combination of two perspectives in the construction of a new single image. This romantic escape rarely produces the intended result. The utilisation of other subjects and codes also requires a questioning of the methods of interpretation and the definition of perspective. The colonial hierarchy of vision and interpretation was ironically the structure which secured the strategy of the appropriation of the other for the benefit of the self. Latin America was being reinscribed by the terms of Europe. The dilemma that is born from the dissatisfaction with one code of representation, is only compounded as the desire to reach a synthesis which promises a universal reach floundering on the rocks of repetition. The inevitable return to the dominant code. There is no break, at best an extension through incorporation. There is just the oscillation within the binarism of romantic idealisation of the other and the acknowledgement of the other as the same. To confront other traditions as if they were static and timeless, is to see the artifact and lose sight of the methods for working through. The complexity of working with another way of seeing is blocked by the blindness to the inflections of power in culture.

We seem to have passed through the Trinity of rebellion, reaction and appropriation without a sense of resolution. Perhaps the fourth stage will be the place where a reconciliation of opposites can be found? Yet the moment the name Jimmie Durham is announced as a present-future source I smile, prepared for further complexity. The insight of Durham follows directly from the blindness of appropriation. Durham's work consistently follows two trajectories: an attack of the exploitative thematic of non-reciprocity, and a mockery of the codes of misrecognition. The starting point within Durham's work that is offered to Ferrari, is the perception of absences within the dominant language and barriers between competing codes. This knowledge induces a melancholy, a tragic awareness of the inevitability of alienation, yet the irony of this sadness is heightened as Durham plays it out, for instance through the desirous eyes of two lovers, Malinche and Cortez. What bonding could entwine these strangers? I wonder of those exchanges before she learnt to speak his language. What dreams were held in the cusp of Malinche's desire as he became the bridge between two worlds? She presaged the destruction of her culture as she translated his desires. The conqueror remained in his language. The asymmetry and the vilification of her body has spawned its own complex, but we end with her name not as a symbol of betrayal but as metaphor for ambivalence.

Commenting on Jimmie Durham's installation *Ama, 1992,* Jean Fisher observed the etymological dissonance within the title. In Spanish it is the imperative 'love me!', but in Cherokee it means 'salt' or 'water', serving as a metaphor for the asymmetry of gift exchange that defines colonial relation. Durham's re-offering of vessels begs the question, what is Malinche? Jean Fisher answers back:

> One might think at first that, by 'collaborating' with the invaders in the destruction of her culture, she is no more than a contemptible symbol of the submission and 'Feminisation' of the Americas to European machismo. And yet was she not already a gift a form of currency circulating within the symbolic system of intercultural exchange amongst the Mesoamericans? Again as lover and interpreter to Cortez, Malinche's body becomes the site of a linguistic transcription across which coloniser and colonised trace out the contradictions of their relations. For Durham, she is 'water'; bearing an almost infinite capacity of absorption, she will eventually dissolve salt – that crystalline form which, in any case, contains its aqueous other. Her reality is, then, as it always was: resilient, and ionisable on contact with salt, whereupon it transforms into a power unrealised, undreamt.[4]

The dialogue between these two artists/writers is most resonant for Ferrari. Who is the interpreter? What worlds are being exchanged/

translated in these acts? The status of the writer is not held up as subordinate to the artist. The two forms oscillate in a state of unstable equilibrium. Both Durham and Fisher move across these boundaries. They both take the responsibility of representation, and in that gesture there is also a sacrifice. First World and Third World, such polarities and the nomenclatures which sustain Eurocentric hierarchies are repeatedly transgressed. The plurality of the Americas yields a surplus that does not conform to the history of the self as either primitive or exotic. In a text called *Here at the Centre of the World* Durham asserts:

> Until tomorrow, the culture and the cultural history of what is incorrectly called 'Latin America' is nothing more or less than a backwater of European culture.[5]

These propositions and gestures which call the West to take account of itself in the terms it projected to the other, do not offer any resolute conclusions, they are all intimations for new beginnings. The melancholic beckoning of each practice outlined in this essay emanates from the desire to hold contrary worlds in one language. Given Ferrari's predicament, such an impossible gravity is not only alluring but also axiomatic in the itinerary of his own practice. The starting point of his work includes the bittersweet consciousness of partial translations, the gap between absence and presence in every

exchange. It is the ambivalence within language, vision and interpretation which is his field. The forms of the aesthetic utterances in Ferrari's practice is not motivated by an act of either integration or alienation but an investigation of the space that activates the gap between them. It was the philosopher/sociologist Georg Simmel, while meditating on the transformations of space – the bridge as unification and the door as separation – who articulated these metaphorical dynamics that dominate everyday life:

> Because the human being is the connecting creature who must always separate and cannot connect without separating . . . that is, why we must first conceive intellectually of the merely indifferent existence of two river banks as something separated, in order to connect them by means of a bride. And the human being is likewise the bordering creature who has no border. The enclosure of his or her domestic being by the door means, to be sure, that they have separated out a piece from the uninterrupted unity of natural being. But just as the formless limitation takes on a shape, its limitedness finds its significance and dignity only in that which the mobility of the door illustrates: in the possibility at any moment of stepping out of this limitation into freedom.[6]

NOTES

1 Guy Brett, *Transcontinental: Nine Latin American Artists*, Verso, London, in association with Ikon Gallery, Birmingham and Cornerhouse, Manchester, 1990.

2 *Ibid*, p71.

3 Jean Fisher, *Border Patrols: Art Criticism and the Margins of Art*, Guadalajara, 1992.

4 Jean Fisher, 'The Savage Gift: Jimmie Durham's Ama', *Third Text*, No 21, Winter 1992-93, p25.

5 Jimmie Durham, 'Here at the Centre of the World', *Third Text*, No 5, Winter 1988, p22.

6 Georg Simmel, 'Bridge and Door', *Theory, Culture and Society*, Vol II, No I, February 1994, p10.

Diego Reboredo Ferrari, The Split Personality of Light, *1993: Detail of the spectator silhouetted against the artificial light projected from the kitchen*

SAULO MORENO

AN INTERVIEW WITH CHLOË SAYER

Saulo Moreno is a distinguished Mexican crafts-man who works predominantly with wire and paper. Born in Mexico City during the early 1930s, he has developed his own unique style over four decades. Moreno's work has been included in several international exhibitions including 'El Día de los Muertos: The Life of the Dead in Mexican Folk Art' at the Fort Worth Art Museum and London's Serpentine Gallery. It has been seen most recently in the exhibition 'The Skeleton at the Feast: The Day of the Dead in Mexico' at London's Museum of Mankind. In 1993, the Mexican Government and Visiting Arts paid for Moreno to visit the Museum of Mankind as artist in residence.

Chloë Sayer: *Mexico is a land remarkably rich in arts and crafts. Why do you think this is?*
Saulo Moreno: It is difficult to say. Perhaps because Mexico has so many indigenous cultures. Even today more than 50 Indian languages are still in use. My grandmother spoke not just Spanish but also Náhuatl.[1] Each Indian culture has its own customs, religious needs, ways of dressing to suit the local climate, and so on. In mountain areas, where there are few roads, villages are very isolated and artisans need to travel long distances if they are to sell their goods. Here, on the central plateau, we have inherited many things from the Aztec, or Mexica. They were great sculptors. Wonderful stone carvings were found even recently when the metro was built. It might seem simplistic to say that we are descended from a race of artisans, but I think that we feel a need to express ourselves. I know that I do.

– The term 'artesanía' is usually applied in Mexico to handicrafts, or works of popular art. What term would you like to see used?
We're on tricky ground here. Educated people, 'intellectuals', look on *artesanía* as second rate. In the past, Mexican craft shops often used to advertise their wares in English by calling them 'Mexican curios' or 'Mexican curious'. I'm glad to see that those signs have mostly disappeared. I've talked about this with other artisans, and the term that I prefer is '*artes del pueblo*' (arts of the people). Because 'high' art is exhibited in galleries, people approach it with awe, even when it's hollow and pretentious. I think that more respect should be given to the 'arts of the people' of whatever country. Of course artisans in Japan already get recognition. When I was invited to take part in a festival in Japan I worked next to a kite-maker who was deemed a 'national monument'. This is perhaps extreme. But I think that artisans in Mexico deserve more recognition than they get.

– Such work has traditionally been seen as the anonymous output of nameless creators. Now, however, increasing numbers of popular artists are signing their work. Are attitudes changing in Mexico?
Yes. This change is necessary and logical. Questions of modesty apart, I don't see why an artisan who creates his or her work with effort and love should be overlooked. It is unjust and absurd. Of course it gives you pleasure to see your work exhibited and to know that it is yours. But the experience is even more pleasurable when the public is allowed to know your name. Then you are doubly rewarded! I'm not saying that artisans should think themselves more important than they are – that would be going to the other extreme. But there is enormous satisfaction in recognition, in seeing your work credited to you in a book, for example. That is the most lasting payment of all. After all, your work may be destroyed. But if two or three copies of that book survive somewhere in the world, then someone, some day, may turn the pages and say: 'Just look at this! It was made by so-and-so'. Some people still seem unable to understand this, but the time for anonymity has passed. Artisans are not stone-age cave-dwellers painting bisons or gazelles on the walls of caverns. If makers want to sign their work, they should do so. We need to rid ourselves of the idea that true *artesanía* should be anonymous and its creators nameless.

– How did you first come into contact with Mexican popular art?
As a child, I lived with my grandmother and she sold vegetables in a vast, covered market in Mexico City. I spent my earliest days in a crate on the ground by her stall, surrounded by the smells of fruit, parsley and coriander. I watched people pass, and listened to the general hubbub and the cries of traders. Now, when I see a

market, I feel at home because it's where I grew up. When I could walk, I would look at all the handmade toys: tin cars, wooden carts, spinning tops, yo-yos, marbles. I especially admired the puppets that hung in clusters – devils and skeletons that moved, some with springs and some where you pulled a thread. Each Christmas there were colourful and fantastically-shaped *piñatas*,[2] painted pottery figures for nativity scenes, and mounds of Spanish moss on sale in the street. Towards the end of October there were flowers, candles and sugar skulls for the Day of the Dead.[3] The market was my first school, my first academy, and it gave me my introduction to popular art.

– Were there no artisans in your family?
My mother worked as a cook. My father drove a taxi. Although both came from Puebla – a state rich in handicrafts – none of my relatives were artisans. Ideally, the love of popular art should be absorbed at birth, like breast milk. In the homes of the Linares or Soteno families,[4] children learn their craft while playing with paper and paste, or with clay. My own children amuse themselves with my skeleton figures; when they slosh my paints all over the house, I turn a blind eye. But things were different for me: I first learnt to use my eyes in the market where I spent my formative years.

– You say your mother worked as a cook. Did you see interesting things in the different houses where she worked?
I wasn't allowed to visit her often. She lived in, and some of her employers discouraged visits. When I arrived, I would go straight to the kitchen or her bedroom, so I never had a chance to look around. I was always afraid that I would be accused of snooping. Anyway, these were middle-class homes with luxurious furnishings and no popular art. The Mexican middle-classes like to have knick-knacks imported from the USA, from Europe or from China. They really have no affection for Mexican *artesanía*.

– Tell me about your school years.
I attended primary school in the Colonia Roma where we lived, but I hated it. Other children all had parents who brought or fetched them, and they used to tease me because I apparently had none. My father lived somewhere else with another woman, and my mother couldn't leave her job. I was always getting into fights. During my first year I was expelled ten times and my grandmother had to leave her stall and plead for me at the school. My escape was the cinema. I played hookey endlessly: for 20 centavos I could watch three films. What did school matter when I was seeing Buck Rogers, invasions from

Mars, or Basil Rathbone as Sherlock Holmes? I never missed Chaplin or Laurel and Hardy – their presence is still with me today. This was the culture that I gave myself. I gained my visual training from films and also from magazines. A weekly supplement, published in sepia tones by the newspaper *Novedades*, carried news and photographs of Europe: it showed the civil war in Spain and Hitler's army. I was fascinated by planes, tanks and ships. They were terrible, but they were also beautiful. Then there were marvellous art and fashion magazines from the wealthy houses where my mother worked. Her employers would glance through them and throw them out. They also threw away books if they were torn or damaged. My mother rescued these from the rubbish and gave them to me. That's how I was able to read Rudyard Kipling. I was living in the heart of Mexico City, but I had images in my mind of jungles, wild animals and tropical foliage.

– What happened later?
When I was old enough to leave school, I spent several months on the road with no money, sleeping rough and living from hand to mouth. I must have been about 14 years old. This, too, was an education of sorts – a very good one in fact, although some boys never survived it. Back in Mexico City, I went to live with my father, who had barely noticed me for 15 years. Now he decided I was old enough to be of use to him. In addition to his taxi, he owned a small general shop in the Colonia Narvarte, where he set me to work. More interestingly, he also bought a carpentry shop, complete with tools. In those days young people did as they were told, so it never occurred to me to argue when he put me in there as a sort of spy. My task was to keep an eye on things, to make sure the carpenters didn't do work on the side. You can imagine how they felt about me, a gormless boy of 15 or 16! In the event, I left the carpenters to their own devices. I learned a lot about woodwork and I also learned to mind my own business.

– Why did you decide to study art?
Everything I've described led me to realise that the visual arts were what interested me. For two years I was a night pupil with the ENAP, or Escuela Nacional de Artes Plásticas, at the Academia de San Carlos. These were evening classes for the workers. When you are 15 or 16, you want to set the world on fire. I longed to see new things, and expected to acquire the skills of Cézanne, Gauguin and Velázquez in a single week! I can still remember the life class with dried flowers in a vase or clay fruits in a bowl. Imagine us on our first day: 15 boys eagerly facing the table, with our pencils and paper. The

Large Skull made for the Museum of Mankind, London, while Saulo Moreno was in residence in 1993

28

teacher commanded us to draw what we saw and left the room. On his return he made a few comments and told us to start again. It was like this for the first week. It was like this for the first month, then the second, third, fourth and fifth. By this time we were becoming angry: 'We could be doing this at home!' 'Why can't we have a model?' 'Yes, let's ask the teacher for a model!' 'You ask him.' 'No, you ask him!' In the end someone put it to him: 'Sir, we want a nude model'. 'Well you can't have one. The school won't pay for you to have a model until your second year.' 'But Sir!' 'The answer is no. Back to your fruits.' Time passed, and our indignation grew. We agreed to pay the costs ourselves, and invited the school's beautiful French model to come to our classes. When we told the teacher, he said he would seek the director's permission. We became increasingly excited: 'No more fruits! No more flowers! We're going to draw the French nude model!' To cut this story short, the school gave us an elderly model with grey hair, and our teacher told us to like it or lump it . . . Of course we had other classes too. I studied painting, sculpture and advertising and lettering, which came in handy after San Carlos.

– In what way?
I decided to leave my father, to strike out on my own. I saw a job for a professional sign-painter. I duly presented myself to the boss, a very capable, speedy sort of man: 'See that truck over there? I want you to paint these words, using this style of lettering.' Two hours later he found me with a sheet of paper, a compass and a set square. 'What the hell's going on here?' 'I'm working out the lettering.' 'Are you crazy? Call yourself a professional sign-writer! You're not even fit to be a trainee!' With that, he grabbed the brush and the paint-pot, and the lettering appeared as if by magic. I wanted the earth to swallow me up! But I did stay on as his apprentice before going elsewhere. For several years I travelled the country painting signs for companies like Eveready and Pepsi Cola, then political slogans for the PRI.[5] I was single, relatively well paid, and the work was easy because I could trace the outlines. But I usually had to paint on white walls and the glare of the sunlight began to hurt my eyes. That's when I settled back in Mexico City. At twenty-something I became a craftsman because I wanted to make things with my own hands, in my own space, using my own materials and my own ideas. I wanted to distance myself from what I had learnt, but nevertheless make use of it.

– Did you ever want to be a professional painter?
Of course I did, but I knew that I would never

make much headway. There are lots of artists, lots of singers, lots of musicians. But you have to find your own unique voice, and I didn't think that I would discover mine as a painter. So I settled on another form of self-expression, and everything that I had experienced, all that 'baggage', served me well.

– Tell me about your early years as a craftsman?
Those were difficult times. You could say, in truth, that I subsidised my own efforts. I had a friend who was a woodcarver, and he offered me space in his workshop. I would spend part of the day there, and the rest of the day sign-painting to stay alive. Small shops in Mexico City often have metal blinds at the front, and I would get commissions from shop-owners to paint these with pictures and the shop's name. My earliest craft pieces were assembled from bits of wood, wire and paint. Even then I made skeletons. I would spend money on the materials, and put in perhaps two days work. Then I would take my piece round the craft shops. Sometimes the owners would laugh. 'What in heaven's name is this thing?' 'It's a skeleton ' 'How much do you want for it?' 'Give me 30 pesos.' 'You've got to be joking. There are many better artisans than you. I'll give you 20 at the most.' And, well, 20 pesos in my hand were better than none. But they probably didn't even cover the cost of the materials. That's why I say that I subsidised my early training as an artisan.

– You started out using wire and wood, then moved on to wire and paper. Why were you drawn to these materials?
Once again, the answer lies in my childhood. I lived with my grandmother, my uncle and a cousin, in a block of rented flats. We shared a flat with one or two other families. In those days, back in the 30s and 40s, there were no cheap plastic toys, so I used to make my own. I remember hoarding the metal caps off soda bottles. By adding them to a shoe box, for example, I could make a wheeled truck. Most children have this sort of manual dexterity. I would hoard old light-bulb sockets and bits of wire, and beg the carpenters in the local wood shop to give me their off-cuts. My grandmother used to tease me by calling me a mouse, because I kept these treasures hidden under my bed. Often I played with my cousin and with the other children on the block. We had seasonal games: when there were peaches, we would paint the stones and hold tournaments. But I also played on my own. With my bits and pieces I would build castles and bridges on a narrow strip of earth where dogs peed and drunks passed, and imagine myself in Rudyard Kipling's India. One amazing day a woman, who

had an apartment in our block, called me upstairs. Her son had grown up and moved away to the USA, so she gave me his old toys. I became the owner of a tiny puppet theatre. The puppets had pottery heads and hands, and costumes of cloth. For months I played with nothing else. Now, looking back on my life, I realise how important these experiences were.

– Can you explain why so much of your work deals with death?

I can't say why I love skeletons so much. I told you how, as a child, I used to gaze at toy skeletons in the local market. This may have something to do with my obsession. Or perhaps it's wholly a question of aesthetics. Of course death has been magnificently portrayed by artists in France, Germany, Japan and China – all over the world, in fact. One only has to think of Dürer. But in these works death is usually present because the theme demands it, or because it provides an interesting anatomical study. In Mexico, however, we focus on death itself: we never tire of representing death, whether in paintings, engravings, wood, metal, sugar or clay. The physical fact of death is terrible: to lose someone you love is one of the most painful things in life. We are all going to die and I, too, fear death. But someone – a poet, I think – has said that Mexicans do not hide from death, rather they joke and play with death.[6] In my case, I'm not playing with her, I'm sharing my daily life with her. I show her doing a thousand things. To a small degree I'm making her mine, before she takes me forever. It's a way of preparing yourself psychologically for the final step, of telling yourself that things will not be totally tragic – although, inevitably, they will. I once made a skull that was shown on a poster, and the accompanying words ran: 'Laugh and play with death – it's better to have her playing than busy'. That's very true: God save us from death when she sets to work! Then she is altogether terrible.

– 'La muerte' (death) in the Spanish language is a feminine noun. Do you perceive her as a woman?

Life and death are the eternal duality. Of course death is female. Although God is usually thought of as male, she is also a woman. She gives life and she takes it. We are born of woman and we return to Mother Earth. While working at the Museum of Mankind in London, I made a giant skull with many skeletons. The bodies of those who die decompose, feed the earth and are reborn. We are all part of this cycle of death and regeneration.

– You also portray the devil in your work.

I show angels too. Angels are sometimes de-

scribed as androgynous, but the devil is male. In Britain you make fun of these things. In Mexico, where we are perhaps more innocent, we still believe in the supernatural. People ask why I make so many devils. In Mexico we have a saying: 'Behind God stands the devil'. The devil is evil, but there is evil in everything. Good and evil run parallel – there is no light without darkness. The devil and the angel go together, as do death and the devil. There is also the aesthetic question: like death, the devil is a very visual subject. Although I never make fun of the devil, I try not to represent him in a frightening way.

– You often speak of José Guadalupe Posada.[7] Has he been an important influence?

I have always looked upon Posada as my mentor. I admire and love him, but admiring someone doesn't mean that you're free to copy their work. We should draw on our own inner resources. Too many artisans recycle the ideas of others. Together with Coatlicue and Coyolxauhqui,[8] Posada's *catrina* remains one of Mexico's most important and enduring visual symbols. The painter Diego Rivera made use of her in one of his murals, and he is not alone: countless artists and artisans have 'borrowed' her. People in the modern world lift imagery from here, there and everywhere – we are the product of innumerable generations, and originality isn't easy. But I've never copied Posada's *catrina* or his skeletons. I've been inspired by the idea of them, yet I try to have my own vision of the world.

– Which other artists have impressed you?

Gauguin has always meant a lot to me. I identify very much with his work and I love his sense of colour. I respect Toulouse Lautrec for his use of line and Rembrandt for his use of light. We must not forget Dürer, Goya, Turner, Daumier . . . But for me, most important of all, is Frida Kahlo. The intimacy of her work never fails to astound and move me profoundly. As for Diego Rivera, he is sometimes described as an illustrator, and I tend to agree. He was an illustrator of Mexican history and a portrait painter of rich women. Orozco, I admire greatly. Also Leopoldo Méndez, the Mexican engraver who founded the *Taller de Gráfica Popular*. But first and foremost I must name Frida Kahlo and Gauguin.

– Tell me about your own paintings.

I suppose one would have to call them 'naive' – the work of a 'Sunday painter'. My themes are rather metaphysical and dreams play an important part. I did go to art classes, it's true, but I'm largely self-taught and my drawing skills are poor. My closest affinity is with painting, so I paint when I can, in my spare time. But I've always been short of money – if I've had any, I've

spent it! To paint, you need time and total concentration. By now I've lost the contacts that I had with the Mexican art world. Besides, if a gallery did agree to take my work, they could only pay me once it had been sold. So I have devoted myself instead to popular art and to my skeletons. They never leave me. Perhaps, when all's said and done, I was born to be a *calaquero* (skeleton-maker).

– Do you feel that you have achieved a unique style as a craftsman?
I like to think that what I'm doing is very different, and that my technique is wholly my own. I've sometimes been told that my work is like that of an Italian sculptor – I don't recall the name but I only want to be Saulo Moreno. This has been my aim and there are moments when I think I've succeeded. Of course there exists a parallel between my figures and the 'Judas' figures that are traditionally burnt at Easter.[9] The late Pedro Linares, whose work I greatly admire, was a part of that tradition. He started out with Judas figures, and went on to develop his *alebrijes,* or fantastical creatures. I also make fantastical creatures, but mine are nothing like those of don Pedro and his son Felipe – theirs are very beautiful and exquisitely finished. Probably mine aren't as good.

– Has your style or your method of working evolved over the years?
Of late I've been casting and soldering metal for some of my pieces. To make my moulds, I use dentists' plaster. Sometimes, if I'm shown a photograph of my early work, I realise that my style has changed and that there's been a development in my technique. But my themes and my inspiration remain essentially the same.

– How does the public react to your work?
People in the USA are sometimes disconcerted by the presence of death. I was exhibiting my work there not so long ago and a small girl dragged her mother to my table where I had some skeletons riding a bicycle. The little girl didn't want to leave this piece, but the mother's face wore an expression of disgust that I found offensive. When she asked to buy the bicycle without the skeletons, I refused. Afterwards I felt bad because I had denied the little girl her treat. Sometimes people want to buy my pieces before they are finished: they like the wire armature, without the paper and the paint. 'You may prefer it that way', I tell them, 'but I am the maker and I don't.' Generally I won't sell work that I consider unfinished. One man – an architect – was particularly stubborn. I had been invited to work in a museum in Mexico City. I was making a cockerel and this man stopped to

admire it. 'What elegance of form! What use of line!'', he exclaimed extravagantly, asking me to quote him a price. 'It's not ready', I told him, 'you are looking at the wire armature. When it's finished, it will resemble those figures over there.' 'But you're crazy!', he told me. 'The wire outline is sculpture. Those other figures, with the paper and the paint, are just craft. Why be a craftsman when you could be a sculptor?' I thanked him for his advice and explained, as politely as I could, that I was happy to remain a craftsman. He became angry, and stormed off. Apart from these few incidents, however, I enjoy hearing the public's reactions. I like it when children and ordinary people ask questions and watch me work.

– Where is your work sold and who buys it?
It has sometimes been sold by government-run craft centres, such as FONART and the Museo de Artes e Indústrias Populares in Mexico City, but now I mostly deal with two or three specialist shops. I feel certain that around 98 per cent of what I make is taken out of Mexico, and I imagine the same is true for many of my fellow artisans. I hope my work gets shown in public places, but most of all I like to think it ends up with individuals who enjoy and appreciate it.

– What sort of status does the artisan have in Mexico?
Now you're making me laugh! Most Mexicans don't appreciate the *artesanía* of our country. You will see them strut and put on airs if a foreigner mentions our arts and crafts – then they're proud as can be: 'Oh yes! Here in Mexico we have beautiful things made by our wonderful artisans, bla bla bla'. But when they're at home, they don't say: 'Let's buy this pottery vase, these hand-blown glasses, or that carved wooden table from Michoacán'. Sometimes, if I'm exhibiting, a Mexican may say to me: 'What a splendid skeleton'. 'Would you buy it and have it in your home?' I ask. 'Me? Why would I want it? There's nowhere I could put it. Anyway, my kids would break it. It makes more sense for me to buy them something in plastic.' I don't get offended or hurt, because these remarks are the artisan's daily bread in Mexico. It's the same story at an official level. When there's a festival or fair, the organisers rush about like headless chickens: 'Let's invite so-and-so. Let's ask Saulo . . . ' But as soon as the fair's over . . . forget it! You'll be consigned to oblivion once again.

– To what extent do market forces shape your work?
To be honest, I started making birds and animals out of economic necessity. I'd be happy to stay with skulls and skeletons, but my clients

occasionally ask for something more! You can't imagine how many people collect birds and animals. So I specialise in cockerels, horses, bulls and other creatures that lend themselves to a particularly visual treatment. Clients also put the breaks on you in other ways. I would love to spend weeks making large, intricate pieces like the one commissioned by the Museum of Mankind. But shop-owners would be horrified – with some justification. 'How in heaven's name do you expect me to sell *this*?' they'd say. 'It might sit on the shelf for a year or more. It's too large and too expensive. Bring me small, saleable items.' Then there's the problem of transportation. For the last 11 years I've lived three hours away from the capital, in a small town called Tlalpujahua in the state of Michoacán. To deliver my work I take the bus, and large items have to go in the hold where they could easily get damaged. So I restrict myself to sizes that I can hand-carry and that shops can sell. As you see, it's a balancing act: I need to sell my work while remaining true to myself. Shop-owners want artisans to be like bakers, able to turn out bread-rolls and cheap buns to order. But creativity is never that easy!

– How do you and other artisans establish your prices?
If an artisan sells work to a shop for 100 pesos, the shop won't let it go for less than 200. That's understandable – the owners have to make a profit, and cover outgoings such as electricity and rent. If a piece is large or heavy, and the purchaser foreign, packing and freight costs could quadruple the shop's price. As artisans, we take all this into account. If I want my work to be affordable, I can't spend too long on any one piece. As we say in Mexico: 'Beware of putting too much cream on your taco'. I work at home most days from 9am to 3pm. That's flat out – without stopping as office workers do, for coffees and chats – and I count this as a day. To decide the price of a piece, I consider the days worked and the cost of materials. Usually, I forget to include my bus fare or some other expense! Of course I'm not always paid what I ask, but you get the idea: I calculate my prices as any workman might. This seems to me the only honourable course. If popular art is to remain 'popular', it has to be affordable. I realise that painters and sculptors think differently. As an artisan I want the public to like what I do, whereas artists should feel free to do as they like. Successful artists can charge thousands of dollars for something that took them just hours. I remember a friend who was a painter. He would say: 'I'm not working to please other people. I paint the way I want to. If people feel like buying my pictures, well and good. If they don't, what the hell! I'm not here to pander to the rich'. That,

basically, is the difference between the artist and the artisan. I want my work to give pleasure while, of course, enjoying what I do. The trick is to adapt to demand, without slavishly following orders. I don't want to be an artist but I don't want to be a manual worker either! Clients sometimes ask me to copy someone else's work, which I definitely won't do. And sometimes clients ask me to reproduce my own work. I'll refuse, because I'm not a robot. I hate the idea of copying – even my own images.

– Do you know any artisans who have become rich from their work?
Very few. If artisans make money, it's usually because they have 'industrialised' their methods of production. I know of some rich potters with lots of employees: they turn out virtually identical plates and candlesticks by the thousand, but they are no longer true craftsmen relying on their own hands. Authentic popular art is the work of an individual creator. Popular artists may get help from family members – my first wife used to help me paint my pieces. But the end result is always the vision of one person, which means that the output will always be small. Even in my heyday, when I was younger and full of energy, I never made a lot of money.

– Have you sought to pass on your skills?
I've spent three years, on and off, teaching my craft. Ideally crafts should be absorbed in the cradle, but they can be learnt in later life. Everything began at a symposium for craftworkers. I was close on 50, with no children as yet, and becoming increasingly aware of my mortality. I spoke about the deaths of major artisans who had gone to the grave with the secrets of their calling and I was later invited to consider teaching. I gave classes to two groups of youngsters, in the state of Mexico and then in Michoacán where I settled. Of course, manual dexterity alone is not enough, and I had some clashes with the bureaucrats who were funding my courses. They thought that good artisans could be 'made' in a matter of months. Despite these problems, however, two of my ex-pupils now earn their livings as craftsmen.

– The years 1970-75 were the sexenio *(six-year term of office) of President Luis Echeverría. Was this, as is sometimes said, a 'golden age' for craftworkers and how do official attitudes compare today?*
It's certainly true that a lot of government money was spent under Echeverría on the promotion of popular art. Those were good times for me and for many artisans. We were given a high profile and encouraged to work. I was awarded a lucrative prize and offered many things that I didn't accept. But we must not forget that the

high-spending of that period led Mexico into crippling debt. Echeverría thought our oil wealth would last: his government threw money in all directions, and craftworkers benefited from this largesse. Now we live in very different times. The government of Carlos Salinas de Gortari is committed to industrialisation on a massive scale. But politicians shouldn't overlook the importance of popular art. They spend large sums promoting tourism, yet seem to forget that Mexico's arts and crafts also generate a lot of revenue. Myself, I'm not political. Politicians come and go. I do what I do for Mexico, because only Mexico endures.

– Will craftworkers be affected by Mexico's new free trade agreement with the USA and Canada?
The ones who are most likely to suffer are the producers of functional goods. For centuries they have been meeting people's needs. Now Mexico is increasingly flooded by cheap imports: plastics and synthetic fabrics are supplanting earthenware pots and hand-woven clothing. Mexican craftworkers can't compete with the industrial might of the USA or Japan. But artisans who make non-functional items, as I do, have less to fear. Perhaps our work will even find a wider audience abroad.

– Looking back on your life, after nearly 40 years as an artisan, do you feel satisfied?
No creative person is ever satisfied. I am still learning. I am still seeking to improve my work. With each piece, I think that something is missing, that something is wrong. In the end it is the public who will judge one's work. It is the public who has the final say. Life has not always been easy: at times I've felt like giving up. When my first wife died some years ago, I barely had the heart to carry on. I thought about becoming a scrap-metal dealer, and perhaps painting pictures on the side. But destiny had other plans. Today I still live from hand to mouth, just as when I started out. Occasionally I even paint shop-signs! But now, with my second wife, I have three small children to support. I would like a one-man exhibition of my work – but where it's all gone, who can say? I own not one single piece. Of course the same is true for most artisans. Driven by economic necessity, we sell everything we make and leave little for our children to remember us by.

NOTES

1 The Náhuatl language was spoken by the Mexica (Aztec). Today it is spoken with minor variations by the Nahua. Although Spanish is the official language of Mexico, 56 indigenous languages remain in use. For information on Mexico's indigenous peoples, see *Handbook of Middle American Indians*, 7-8, Ethnology (1-2), University of Texas Press, Austin, 1969 .

2 The *piñata is* a clay jar filled with fruit and sweets. Covered with *papier mâché* and brightly coloured tissue paper, it is broken during *fiesta*. Ships, stars, flowers and animals are traditional decorative forms.

3 The Mexican Festival of the Dead is celebrated on 1 and 2 November (All Saints Day and All Souls Day). It is widely believed that the dead have divine permission to visit the living on earth. They are welcomed with flowers, candles, incense and offerings of food. For more information see *The Day of the Dead in Mexico* by Elizabeth Carmichael and Chloë Sayer, British Museum Press and University of Texas Press, London and Austin, 1991. Also *The Day of the Dead*, edited by Chloë Sayer, Redstone Press, London, 1990.

4 Members of the Linares family, who live in Mexico City, are famous for their work in *papier mâché*. The late Pedro Linares made seasonal items for different festivals. Using traditional production methods, he went on to make skulls and skeletons, inspired by the engravings of José Guadalupe Posada, and brightly painted, imaginary creatures that he called *alebrijes*. Today his sons and grandsons continue with this work. Members of the Soteno family live in Metepec in the state of Mexico. They specialise in making pottery candelabra. Known as 'trees of life', these portray the Garden of Eden and other Biblical/historical themes.

5 The PRI (Institutional Revolutionary Party) has been in power since 1929. Originally called the PNR (National Revolutionary Party), it was re-named in 1946.

6 The Mexican attitude to death has been most famously described by Octavio Paz in *El Laberinto de la Soledad (The Labyrinth of Solitude): Life and Thought in Mexico*, Penguin Press, Harmondsworth, 1967. Saulo Moreno is referring here to the following lines: 'The word death is not pronounced in New York, in Paris, in London, because it burns the lips. The Mexican, in contrast, is familiar with death, jokes about it, caresses it, sleeps with it, celebrates it; it is one of his favourite toys and his most steadfast love'.

7 Little is known about the life of José Guadalupe Posada (1852-1913). Using skulls and skeletons, this gifted engraver exposed the transitory nature of earthly pursuits and ridiculed leading figures of the Porfirian era. His most famous engraving – *la calavera catrina* – shows a fashionable lady in the guise of a skeleton. See *José Guadalupe Posada: Messenger of Mortality*, Redstone Press, London, 1989.

8 Coatlicue, the earth goddess, was an important deity within the empire of the Mexica. She was portrayed in sculpture with a necklace of hands and hearts. According to myth, Coatlicue was the mother of Coyolxauhqui whose dismembered body was represented in stone in the ceremonial precinct of the Mexica capital.

9 'Judases' are grotesque, often gigantic figures inspired originally by Judas Iscariot. Brightly painted *papier mâché* covers a cane armature. Decked out with fireworks, they are exploded after dusk on the Saturday of Glory (Easter Saturday).

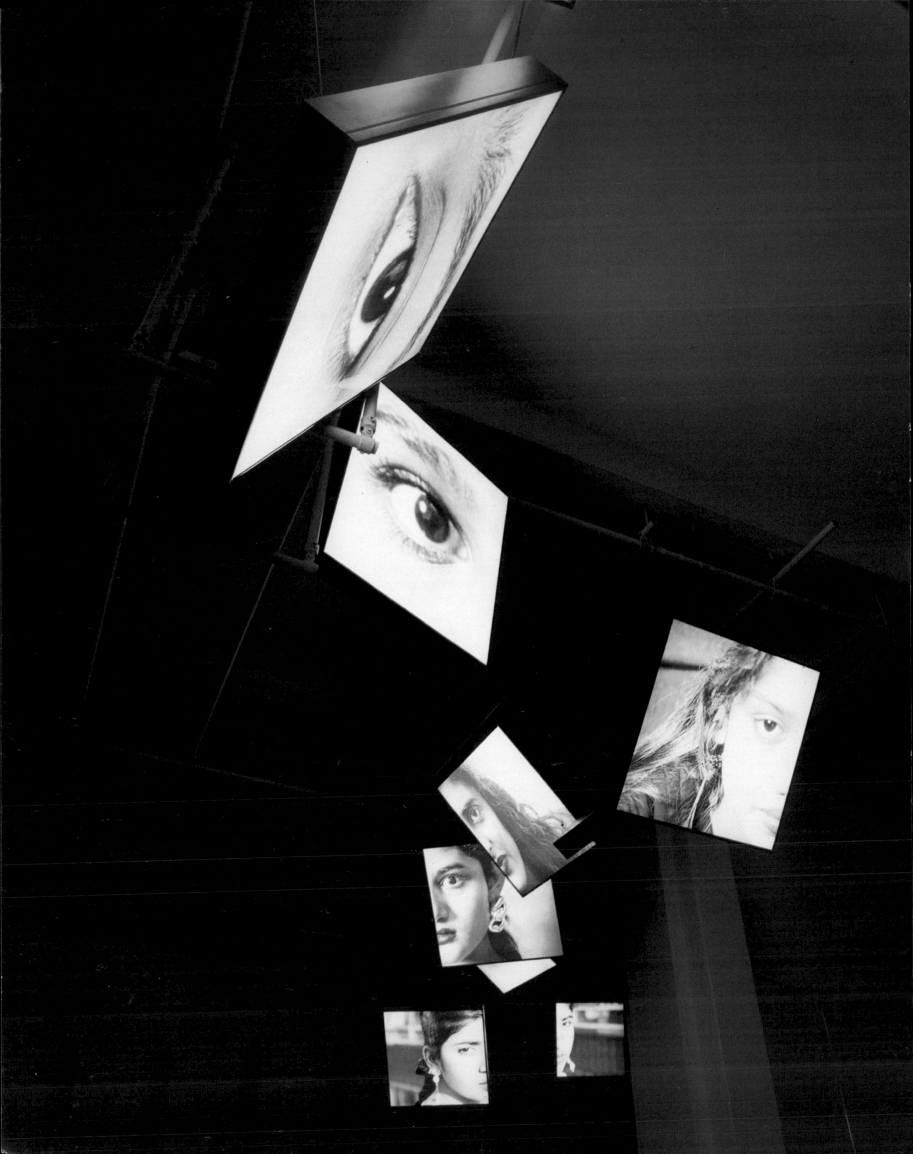

MAKING VISIBLE: DIFFERENCE AND REPRESENTATION IN THE WORK OF ALFREDO JAAR

JON BIRD

Part I

Writing about Montaigne's essay 'Of Cannibals', Michel de Certeau suggests that at the heart of the text is the question of 'the place of the other'. This quest is characterised by a double movement of the space of the other within the text, and of the place of the text within culture: 'Montaigne's essay functions both as an *Index Locurum* (a redistribution of cultural space) and as the affirmation of a place (a locus of utterance)'.[1] 'Of Cannibals' follows the tripartite narrative structure of travel accounts where the discovery of the strange, of difference – the other – is temporarily and spatially framed by the outward journey and the return, or homecoming. Each stage represents a movement away from the conventions of the home culture, breaking with the classificatory systems that assign positionality and hierarchy (self/other, civilised/barbaric, etc), so that the traveller has to venture beyond the boundaries of the known to encounter the 'savage body'. Only through this encounter, framed by two histories (departure and return) can the traveller 'speak in the name of the other and command belief'.[2] It is, then, through the return that the 'savage body' re-enters culture, carried by the experiential and material evidence of the traveller's narrative disrupting and consequently rearranging the discursive field.

If one of the most persistent tropes of recent cultural theory is the metaphor of mapping, then this partly derives from our repetitive concern with issues of boundaries and borders as the interstitial spaces where signification initiates new meanings and possibilities. At the border identities are confirmed or resisted, recognised or denied, abandoned or reclaimed; journeys begin or end in the movement across an imaginary line demarcating the spaces of familiarity from 'elsewhere' as the border functions as a place-metaphor of crossing. The disciplines traditionally mapping the terrains of cultural difference – anthropology and ethnography – have increasingly come to focus upon travel as the key concept for understanding relations of exchange and negotiation that define culture as process rather than stasis.

At times it seems that a cartographic imaginary frames the Post-Modern world, tracing the contours and boundaries of subjectivity and community as they interact and define a sense of place and position. Travel constantly recurs as the central metaphor in narratives of identity, particularly those identities forged by migration and mixed histories and languages. Diasporic identities and nomadic experience are the options, glamorised in some accounts as the schizophrenic subject, mourned in others as homelessness, dispossessions, the loss of collective memory. Travel is either a luxury or a necessity, escape or exile, a departure that implies a return, or a one-way ticket: discovering 'roots', or uprooting. In this process some identities are hard to avoid. When travel is an expression of privilege and choice – a journey in search of difference – a tourist identity accompanies us as we constitute others as the exotic object of our gaze, confirming and reproducing the relations of observer and observed. We seek the difference that confirms our sameness, a process that does not necessarily involve traversing great distances but repeats itself across the kaleidoscopic territories of urban culture. Thus, in a recent essay titled 'Travelling Cultures', James Clifford asks how 'national, ethnic, community "insides" and "outsides" are maintained, policed, subverted, crossed, by distinct historical subjects for their own ends, with different degrees of power and freedom?'[3]

Amongst a number of 'post-colonial' artists, Alfredo Jaar's practice represents a form of Post-Modern ethnography in its conceptualisations and procedures. Location, boundary, identity, displacement, movement, community – the dimensions of fieldwork characterise his installations, while the unequal patterns of exchange that define intercultural encounters, the histories of colonialism and the political economy of globalisation and the patterns of migration and diaspora that are fundamentally reconfiguring our world, provide the context for his deconstructive documentations and installations.

The troubled history of Western modernism's culture contact with peripheral cultures has been thoroughly documented: colonising representations that inscribe the 'savage body'/ 'primitive other' as exotic, romantic, transgressive, desired, feared, natural, archaic . . . a metonymic chain signifying a history of appropriation. This is now no longer a matter of rewriting a simple domination-dependency relation. Critical Post-Modernism fragments theo-

Two or Three Things I Imagine About Them, 1992, Whitechapel Art Gallery, collaboration with Gayatri Chakravorty Spivak

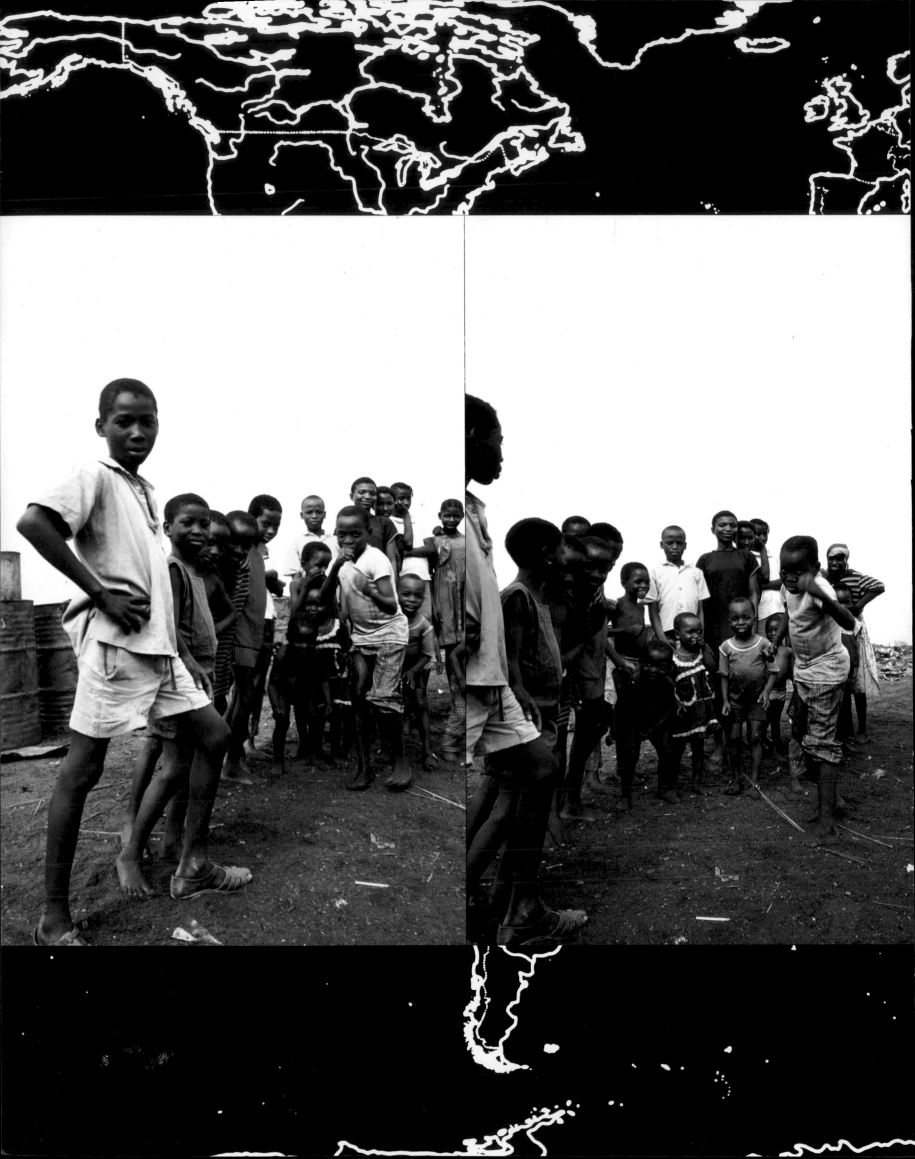

ries of totality and the fixed polarity of centre/ periphery, suggesting something more heterogenious in the interweaving of marginality and centrality. The global circuits of informational flow cut across established categories of national and cultural identities and boundaries, and the metropolitan eclecticism of contemporary street culture from London to Lagos attests to an emergent postcolonial consciousness.[4] Over the past decade, particularly in the field of visual arts and international exhibitions, we have seen the development of 'hybrid' forms of cultural exchange, global/local crossovers from tourist or airport art and souvenirs to the staging of world exhibitions, ('Magiciens de la Terre', Paris 1989), or concepts of cultural pluralism as curatorial policy (the 1993 Whitney Biennial, New York).[5]

Alfredo Jaar was included in 'Magiciens' with the work *La Geographie ca sert d'abord a faire la guerre*; later developed into a large scale installation *Geography=War*.[6] In both these works Jaar's ordering motif was the map which is central to many of his projects, the *Peter's Projection*. Since the mid-16th century, the dominant two-dimensional transcription of the three-dimensional world has been Gerdardus Mercator's *Projection Map*, a colonial world view that had little to do with geographical accuracy and everything to do with imperial expansion and market domination in the first phase of global capital and empire building. Privileging Europe – both through its centrality and enlarged scale – the 'Third World' is spatially relegated and marginalised. The *Peter's Map*, first published in 1974, represents the areas of the world according to relative size, inverting the scale and revealing the Southern hemisphere to be twice the size of the Northern.[7] In this corrected representation, South America is double the size of Europe, which is decentred and relocated in the northernmost corner. *Geography=War* combines maps, charts, photographs, mirrors and text to document the West's dumping of toxic waste on sites in West Africa, in this case at the port of Koko on the Benin River on the coast of Southern Nigeria. Jaar uses architectural components to create diverse spatial experiences for the viewer, metaphorically re-enacting the journey from the economic centre to the exploited periphery.[8] *Geography=War* culminated in a shadowy compressed space: the viewer initially encountered the photographic image of young people scavenging amongst the toxic barrels and waste – the shit of the West – then interrupted by a greatly enlarged cut-out figure of a young man, defiantly occupying the space between viewer and image, foregrounding the relations between 'self' and 'other': the experience of 'contemplating ourselves contemplating other peo-

ple contemplating us'.[9]

In another work from 1990, *The Body is a Map*, Jaar displays nine photographs in a cellular, grid-like arrangement. Eight close-ups surround a central image of the back of a man's upper torso, detailing the lines and fissures of his neck browned by the sun and marked with the signs of manual labour. This work is analogous to a micropolitics of the body, of the struggle for visibility and identity in the marginal spaces of global power, of the body described by Foucault as 'the inscribed surface of events . . . the locus of a disassociated self and mass in perpetual disintegration . . . a body invested by history and history ravaging the body'.[10]

Part II
The body as a site of particular histories or narratives of oppression, survival and resistance, caught in the web of geopolitical economies and individual and communal struggles for existence and recognition, has been the subject of Jaar's work since the early 1980s. Invited to exhibit at the Whitechapel Art Gallery in 1992, Jaar combined recent works on enforced migration and colonial power with his largest installation to date, occupying the entire ground floor space: *Two or Three Things I Imagine About Them*. For this Jaar collaborated with Gayatri Chakravorty Spivak[11] to produce a site-specific work narrating the social relations of a community – Bangladeshi women living, studying and working in East London – through the textural interrogation of Spivak's discourse in English and Bengali, focusing upon an issue of cultural representation: 'How to make the street visible?'

The street is where we negotiate the complexities of cultural difference made deceptively familiar through the repetitive encounters of daily life, at one moment we are made to feel our singularity, at another to sense our otherness fragmenting in the fleeting connections of community and dependency expressed in a glance or gesture bridging a gap, dissolving a boundary, initiating a dialogue. Of course, this does not happen everywhere in the city, but generally only in those localities where culture, histories and traditions mingle and rituals and symbols are interwoven throughout the social and material fabric of the environment: the public and private spheres where frontiers become thresholds for movement and exchange. Whitechapel has long been such a locality with a history that has reflected and resisted the patterns of colonialism and the political and economic geography of global capital. Most of the forms of oppression have been registered here, as have the emancipatory struggles which are a crucial constituent of the collective memory of the community, against racist abuse and attacks in particular. The rag trade continues to dominate

EKÒ IJÍNLÈ NÍPA AYÉ JĘ EKO TO WULO PATAKI JULO FUN OGUN JIJA

LA GÉOGRAPHIE ÇA SERT, D'ABORD, A FAIRE LA GUERRE

OPPOSITE AND ABOVE: La Geographie ca sert d'abord a faire la guerre, *'Magiciens de la Terre', Paris, 1989; BELOW:* The Body is a Map, *1990*

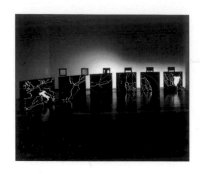

as a focus for production and consumption for the Bangladeshi community, with many women employed in the easily exploitable and unprotected practice of homeworking. This is not merely an unstable economy dependent upon local conditions and relations of production. The imperial trade markets of the East India Company initially placed the Docks and East London at the centre of the East-West traffic in labour and commodities. Now, however, the growth of the garment industry in Bangladesh and the development of computer-integrated systems of automation, together constitute a major threat to the Bangladeshi's contribution to the global textile industry. This move in the international division of labour reached as high a level of unemployment in Dhaka as it did in Tower Hamlets.[12]

Two or Three Things I Imagine About Them conducted the viewer on a journey across the space of the gallery, modified by partitions and obstacles; the time of history; three generations of Bangladeshis represented by a video projection of Spivak; images of young men and women suspended in light boxes from the ceiling, and a looped film of skipping schoolgirls projected onto the end wall of the gallery. Spoken and written texts accompanied, interrupted and framed the objects and images: Spivak's discourse, the racist comments of a sweatshop manager,[13] initially overlaying the images in the light boxes but subsequently removed; neon lighting in the reversed form of two sentences from the video read 'correctly' in their mirrored reflections; a tape with the voices of Jaar, local residents and a gallery interpreter speaking English and Bengali, issuing from loudspeakers situated on the floor at the rear of the gallery, along with an explanatory wall text.[14]

Two or Three Things . . . was constructed around a series of confrontations between viewer and work, the most dramatic occurring just inside the entrance to the gallery where three 12-foot screens on a diagonal axis to the internal space obstructed the movement into the installation. A central vertical wall on which Spivak's image was projected was flanked by two cantilevered mirrored walls, the left wall impending towards the viewer and reflecting the floor, the right leaning back and reflecting the ceiling. Beneath the central screen a 12 foot shallow black metal tray, filled with water, reflected and corrected the inverted image on the screen. Immediately, then, the viewer encountered a disorientating spatial and architectural field that signified issues of positionality and the fragmented body. By emphasising eye-level and point of view, Jaar's installation encouraged the viewer to reflect upon looking as a socially and historically constructed process. His reflective surfaces of water and mirrors

allow the 'other to consistently escape our gaze – as we move they move, we track the trace of their presence, off-centre, out of sight, then, abruptly visible. As we are caught in the same reflection, images of self and other briefly merge, disembodied projections of a reality that always exceeds the frame of reference: and what is it to make the visible, visible? How do we make the street visible?' (Spivak).

In most of Jaar's installations the subjects are anonymous. Marked with the signs of racial and cultural difference the faces and bodies act as 'types', their very specificity – a lined face, sweat on a body under duress, an expression of distrust, apprehension or anger – typify histories of exploitation and resistance. There is consequently a delicate balance between catharsis and critical knowledge.[15] Jaar's work formally disrupts the conventions of documentary photography and any claims to a privileged relation to the real, insisting instead upon meaning (social, cultural, psychoanalytic, etc) as a production of the processes of signification. *Two or Three Things . . .* attempted to 'make the street visible' through heterogenious and fragmented images and sounds of locality and community which represented identities as constructed intertextually across the channels and networks of everyday life. However, other issues were also at stake. Museums and galleries, particularly those existing within the networks of international (post)modernism, uneasily negotiate between the dominant culture and the local context. Given the history of the Whitechapel and its original remit to respond to the interests and concerns of local inhabitants, the construction of a public space which can enable the production and circulation of oppositional imagery has been both a commitment and a contradiction, an institutionalised area for critical interaction. Jaar's work, and especially this site-specific installation, raises the possibility of the aesthetic dimension contributing to change across the terrain of the social formation.[16]

First, of course, there is a boundary to be crossed – from the street into the gallery. The foyer marks a difference, a mediation between the messy disorder of 'out there' and the composed geometry of approved culture. It is not always easy to make the transition, not easy for art's 'others'. How do they enter – as tourists or travellers, at home, at ease, or out of place? Jaar has a special interest in who crosses or patrols the border between the official and unofficial cartographies of power. He reminds us that maps (actual and metaphorical) are frequently fashioned according to the deceits of history, hidden agendas that veil the landscapes of domination and exploitation; the traces of these social and geopolitical configurations are imprinted directly upon our bodies.

Geography=War, *1990*

This is complex work coming out of a history of critical representation of the visual, of Conceptualism and site-specific art practices, and Jaar's own background in architecture and film. It is far from transparent; in fact, transparency (of meaning, truth, representation) is consistently exposed as another illusion. Jaar's recurrent structural devices of the wall, the mirror and the water, help us to read his installations against the grain of certainty and authority – the official discourse of the nation state, the global media, the dominant institutions. Hidden histories and oppressed lives are invited into his narratives, the street seeps into the museum, voices and faces transform the spaces of official culture into the habitus of subaltern cultures: something is being called into question, a space or order transformed into a site for resistance.

Part III

Jaar's installation derived its title from a Godard film of the mid-1960s *Deux ou trois choses que je sais d'elle*, the substitution of 'imagine' for 'know' and 'them' for 'her' was intended to push to the fore the tension within representations of cultural difference. This film marked the moment when Godard finally broke from the conventions of narrative cinema. The protagonist, Juliette, is both positioned and misrecognised by Godard's own voice-over description. Based upon a newspaper story of housewives on Parisian estates turning to prostitution to enable them to purchase consumer durables, Juliette's identity is filtered through the advertising images that surround her while her daily life is dominated by the technology of reconstruction. As massive earthmovers and bulldozers redefine the urban environment, the images on advertising hoardings articulate desire towards a utopian future of unrestrained consumption. Shifting camera angles constantly disrupt the viewer's expectations and block identification, making the relation between the image and desire central to the film. Godard made explicit both the viewer's investment in looking, and of the reciprocal relation between subject and object, self and other. The advertising image replaces reciprocity with possession – the subject becomes the consumer, the world the product.

Perhaps now it is evident why Jaar selected this particular film as a reference point for his installation. Godard's critical framing of libidinally invested images, the imaginary plenitude offered by advertising, questions the narcissistic gaze which refuses to recognise the place of the other. *Two or Three Things I Imagine About Them* combined architectural structures, reflective surfaces, various viewpoints, contradictory perspective and uneven sound to disturb the viewing subject, interrupt and deflect the gaze,

question what is real and what is imagined. Who looks and who is observed, the coordinates of subject/object relations, became explicit through a series of critical engagements which stressed heterogeneity and fluidity rather than unity and stability. The 'I' in the title of Godard's film was his own voice on sound track, but instead of the authoritative narrative or classic documentary where text anchors image, the dislocation between the spoken and the seen introduced an aberration into the field of knowledge. Similarly, Jaar and Spivak's 'I' fragments in the off-centred reflections and confrontations that deny unity and recode the relations of self/other as a process of encounter and discovery. Three times Spivak asked 'How do we make the street visible?' and the timber of the voice expressed something of the anger and refusal of misrepresentation – of all the complex cross-hatchings that constitute a community and a locality historically and how that complexity continues to elude the good intentions of the enquiring eye – anthropological, sociological, aesthetic, patriarchal, Eurocentric. As her discourse slipped between English and Bengali, a different subject was empowered by the text, both 'we' and 'they' made to experience our otherness but differently – in the same way as the social field fails to recognise equality amongst differences, it is no longer an even division.

To some extent the space of the gallery (particularly the international modernist art gallery) masquerades as a transparent space, a container for display, least effective when most intrusive. This apparent neutrality reinforces a certain kind of knowledge and visibility – disembodied and detached, these spaces are infused with masculine subjectivity. Jaar's architectural modifications introduce issues of social space and social meaning into the gallery. We feel the pressure and the threat of material structures upon our bodies, directing our movement, redefining the institution or collapsing through the tensions that the political poses for the aesthetic: how to make the image 'speak'.

The photographs that Jaar uses are selected after an extended period of research and documentation. Illuminated in the light boxes, they possess the surface qualities of publicity images – high definition, close-up or detail, large scale, but he employs a double decentering to disturb the viewer's gaze within the frame of the image and the architectural frame. These faces are not where the viewer expects them to be, they are radically out of place, challenging the place of the other. Another phrase from Spivak's discourse contextualised this relation of subject to object, the admonition to 'learn to see differently'. In the middle section there were also two phrases from the video, reversed in white and green neon on opposite walls and made legible

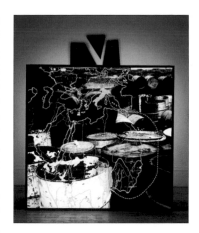

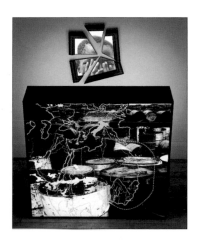

Geography=War, *1990; OVERLEAF:* Bonjour Sécurité, *1993, CFA Miami, Florida*

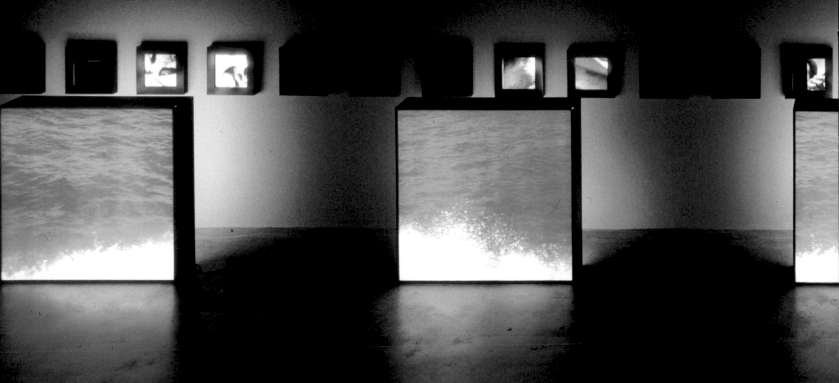

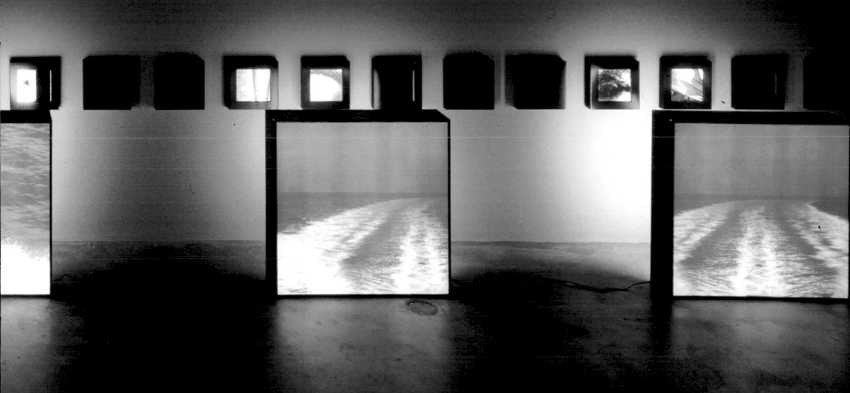

in their mirror reflections: 'What is it to make a street visible?' and 'What is it to make the visible visible?' Without unduly privileging these questions, they could be said to function metonymically, initiating associative chains that bound the various elements like the warp and weft of a piece of cloth. Metaphor and metonymy describe the fundamental relations of language, metaphor expresses analogous relations; metonymy, sequential relations.[17] Visual images are generally understood in terms of metaphor, but Jaar's work and this installation in particular emphasised metonymy, just as the texts acted as 'relays' rather than 'anchors' for the images. Fugitive and elusive, meaning had to be tracked across the stages of the work. 'What is it to make the visible visible?' articulated a doubt, an anxiety about the possibility of representation, a disjunction where the forces of historical memory and present reality traced the uncertain boundaries of identity. The mirrors opened up a fictional space, a space of questions subverting any claim to a sovereign perspective.

There were two more sections to *Two or Three Things . . .* the scattered speakers, only a few of which were wired for sound, and the looped film of the skipping children moving in and out of frame. In both these sections the representational field was again fragmented and the place and mode of enunciation called into the ques-

tion. The voices echoed Spivak's discourse, in their combination of languages (English and Bengali), but there was nothing authoritative in these conversations. Interpretation and understanding were again the product of positionality, a space within a discursive field where meaning was contextualised rather than given. The fiction of ethnographic representability was exposed in the muted speakers and broken exchanges between the participants. In straining to locate the source of expression and the nature of the message we abandon the pretence of a vantage point outside the realities of cultural difference.

In an interview with Brian Wallis in *Art in America*,[18] James Clifford suggested that in order to convey the full social meaning of cultural objects, 'one would have to find a way to enact in the display a sharp discrepancy between the universal art story and the more local stories. How to present the power of the "story" as an ongoing site of cultural identity'. Jaar's installations and documentations highlight the complex relations between different stories and stories of difference, of the plurality of cultures, forcing us thereby to acknowledge, as Paul Ricoeur wrote in 1962, 'The end of a sort of cultural monopoly . . . Suddenly it becomes possible that there are just others, that we ourselves are an "other" amongst others'.

NOTES

1 Michel de Certeau, *Heterologies: Discourse on the Other* (trans Brian Massumi), Manchester University Press (Theory and History of Literature, Vol 17), 1986, p68.

2 *Ibid* p69.

3 James Clifford, 'Travelling Cultures', *Cultural Studies*, ed Lawrence Grossberg, Cary Nelson and Paula Treichner, Routledge, 1992, p108.

4 For a critical view of these shifts see Arif Dirlik, 'The Postcolonial Aura: Third World Criticism in the Age of Global Capitalism', *Critical Inquiry 20* (Winter 1994) and Aigaz Ahmad's meticulous unpicking of Fredric Jameson's account of Third World Literature: 'Jameson's Rhetoric of Otherness and the National Allegory', *Social Text*, Fall 1987.

5 'Hybridity' as a concept and practice is now a key component of postcolonial dicourse; see Peter Wollen 'Tourism, Language and Art', *New Formations*, no12, Winter 1990; Annie E Coombes 'Inventing the "Postcolonial": Hybridity and Constitueny in Contemporary Curating', *New Formations*, no18, Winter 1992; Homi Bhabha, Beyond the Pale: Art in the Age of Multicultural Translation': catalogue essay for the 1993 Biennial Exhibition, Whitney Museum of American Art in association with Henry N Abrams Inc, New York.

6 Exhibited at the Diane Brown Gallery, New York, April-May 1990; Virginia Museum of Fine Arts and Anderson Gallery, Virginia Commonwealth University, Sept-Oct 1991; Museum of Contemporary Art, Chicago, May-Aug 1992. See catalogue Alfredo Jaar: *Geography=War*, Virginia Museum of Fine Arts and Anderson Gallery,

Virginia Commonwealth University, 1991.

7 Designed by the German historian Arno Peters, this map shows countries in proportion to their relative sizes. The map is based upon a decimal grid which divides the surface of the earth into 100 longitudinal fields of equal height. It treats the rectangles around the equator as squares and builds the other rectangles onto these in proportion to the areas they represent. The Zero Meridian in this system is combined with a proposed new International Date Line.

8 For a full description of this work see Catalogue Alfredo Jaar, *op cit*.

9 The 'other' is a term now employed so extensively as to have lost its earlier, more specific meanings – either as signifying everything culturally 'different' from the dominant Western (white, male) perspective or, psychoanalytically, as the founding of the subject through absence, the entry into language as the move from the imaginary into the symbolic. For an introduction to the other as cultural difference see Tzvetan Todorov, *The Conquest of America*, Harper and Row, New York, 1984, and in relation to psychoanalytic theory by Homi Bhabha, 'The Other Question', *Screen*, Nov/Dec 1983.

10 Michel Foucault 'Nietzsche, Genealogy, History', *Language, Counter-Memory Practice: Selected Essays and Interviews*, Ithaca, Cornell University, 1977, p148.

11 Spivak had seen Jaar's work in Paris at the exhibition *Magiciens de la Terre* in 1989. Jaar met and discussed the Whitechapel project at length with her, and he has

Two or Three Things I Imagine About Them, Whitechapel Art Gallery, 1992, collaboration with Gayatri Chakravorty Spivak

always emphasised that *Two or Three Things I Imagine About Them* was a properly collaborative project. In the post-exhibition debates, the issue of authorship and responsibility led to a polarised and accusatory confrontation. See Spivak's letter to *The Guardian*, 'Invisibility of the Sweatshop Worker', 29/2/92.

12 For a detailed account of the role of gender in the international division of labour see Swasti Mitter, *Common Fate, Common Bond: Women in the Global Economy*, Pluto, 1989.

13 This read: 'They are all illiterate and have no skills. Their £20 a week will help towards the family income. We are like a big family here'. On the first day that the exhibition opened to the public, the young Bangladeshis pictured in the light boxes objected to this text printed over their faces. After a meeting with Jaar, the latter agreed to remove the offending images, reprinting them without the text. The text was retained but moved to the large screen at the entrance on which Spivak's face was projected, addressing the viewer.

14 Spivak's text ran as follows: 'How to make the street visible? How to learn to see differently? To learn to see differently is to see with the back. To learn to see differently is to see well in front. Learn to see differently. You are innocent, they are not. They are innocent, you are not. Seeing differently – is it to make the street visble? What is it to see? What, then, is it to make visible? Who are they? Who makes visible? Who sees? How do we make the street visible? . . . (a section in Bengali) . . . There is no ground to stand on. Who sees? Who is seen? To see from the back of your head. To see in front. The short haul of many indiviudal excellencies. The long haul of an in-

volved history and an involved future. To see wide. To see all around. And then what is it to see? And what is it to make the visible, visible? How do we make the street visible?'

15 This exhibition became the focus for the critical debate, particularly over the right to self-representation. See David Widgery, 'Journey of a Good Man Fallen', *The Guardian*, 17/2/92; Sue Hubbard 'Third World First-hand', *New Statesman*, 28/2/92; Lynn MacRitchie, 'When Politics and Art don't Mix', *Financial Times*, 29/2/92; Eddie Chambers, 'Alfredo Jaar', *Art Monthly*, April 1992.

16 Summarising Jaar's project in her catalogue essay for his exhibition at the La Jolla Museum of Contemporary Art, California, 1990, Madeleine Grynsztejn wrote: 'Jaar's installations actively call upon independent critical awareness: such a summons becomes itself an act of social and cultural intervention, for it encourages the attitudes of vigilance and reform rather than of complacence and denial. Inherent in Jaar's installations, physically and thematically, is a critique which aims to provoke and reorganise the viewer's consciousness on a multitude of planes simultaneously – politically, geographically, psychoanalytically, ethically, aesthetically'.

17 The distinction between metaphor and metonymy derives from the work of Roman Jakobson. See *The Fundamentals of Language*, The Hague, 1956. The emphasis upon metonymy rather than metaphor for visual signification has been usefully expounded by Fred Orton, see 'Present, The Scene Of . . . Selves, The Occasion Of . . . Ruses', *Block* 13, Winter 1987/88.

18 'The Global Issue: A Symposium', *Art in America*, July 1989.

ABOVE: Two or Three Things I Imagine About Them, *Whitechapel Art Gallery, 1992, collaboration with Gayatri Chakravorty Spivak; LEFT:* Blow-Up, *1993, Museum of Modern Art, New York*

UPPER SPIRITS

ACTIVE SPIRITS

PASSIVE SPIRITS

Mise-en-Abîme, 1993 A.Duclos

LOWER SPIRITS

SEARCHING SOUTH: TWO SOUTH AMERICAN ARTISTS

Mario Flecha

ARTURO DUCLOS

In Santiago de Chile, between the years 1977 and 1982, two groups of experimental artists offering resistance to the status quo emerged. These two groups formed the origins of a new generation of Chilean artist for whom new forms of expression (photography, video, installation etc), dominated artistic activity. One group, known as 'Escena de Avanzada' included such artists as Juan Davila, Eugenio Dittborn, Carlos Altamirano and Carlos Lepe, while the other group, CADA, was started by Lotty Rosenfeld, Raul Zunipa, Diamela Eltit and Juan Castillo. Arturo Duclos, born in 1959, is one of these. The socio-political context of Chile and the discourse of the critical conceptual artists left very little space for painting at this time. Due to their more traditional nature, paintings can be interpreted as a reactionary form of art, subjected to the oppressive political situation. Duclos chooses to ignore the artificial limits put upon the activity of a painter, developing his own personal language in a continuation of the discourse initiated by the artists in the 'Escena de Avanzada'.

Duclos' work is autobiographical and his paintings, a catharsis. A common internal thread exists in his paintings which unites his work and enables him to continue his discourse beyond the limits of any one painting into the next.

Je ne regrette rien, 1989, is painted on a curtain 2x1.5 metres. Along each side, two bones link small corner stars. In the centre, a dog bites a hand. A crown is painted in the top left-hand corner and balancing this diagonally, there is a sketch of three hanged ducks.

He repeats this structure in other paintings as a way of establishing a common communication channel between him and the viewer. This is illustrated in another painting of the same period called *Mr Gorbachov*, oil paint on a sleeping bag, 1989. There is a black square in the centre, under which is written the words 'Mr Gorbachov'. The columns at either side stand on a painting of a closed rectangle covered with bones and are connected at the top by an arch of golden leaves which is interrupted in the centre by a circle surrounding a pyramid and one open eye. The painting works as a fragmented association of ideas: each element can be read separately or as a whole.

The paintings of Arturo Duclos are like the mandalas painted on cloth by the Tibetan monks in the XI and XII centuries. Jane Casey Singer comments, 'In its most common form, the mandala appears as a series of concentric circles. Its deities are housed in a square structure with four elaborate gates', and like them, Duclos' paintings are a representation of the cosmos, a fusion of myth and reality. He uses painting with the obsession of an alchemist, reaching the viewer through accumulation and repetition.

Born into the Christian, Manichean tradition of good and bad, educated at a Jewish school and having lived through one of the most ferocious dictatorships Chile has suffered, Duclos' paintings reflect a tradition in South American thinking: a duality of regionalism and internationalism in evidence amongst the intellectual classes, such as the poet Pablo Neruda, writer Jorge Luis Borges and artists Matta and Lucio Fontana.

Duclos studied printmaking at the Catholic University of Santiago, under Eduardo Vilches, who taught him the craft he needed to express himself. With a group of university friends who were similarly frustrated by the limited education they were receiving, Duclos opted to study under Eugenio Dittborn. It was here that Duclos discovered the work of Roland Barthes which was to influence his work so greatly.

In the catalogue for his exhibition, 'Biothanatos', art critic and writer Claudia Donoso explains, 'when a child, Arturo Duclos lived in Cerro Alegre de Valparaiso. It was Frei's time and he heard rumours arising from the conversations of his parents: the communists would take over the country, they would eat little children and proletarian gangs would ransack the homes of respectable people'. This left a profound mark on the psyche and work of Duclos.

An installation realised in 1983 and exhibited two years later at the Enrico Bucci Gallery, Santiago, Chile, was made of human bones from the morgue. These he painted with oils and placed on a towel on the floor. Three skulls surrounded by other bones are painted with child-like drawings in primary colours. Anthropological references apart, death is playfully displayed while keeping the real content of an adverse political climate hidden. Duclos' installations are powerful reminders of that dark period of Chilean history.

In 1990 he painted a series of beautiful small

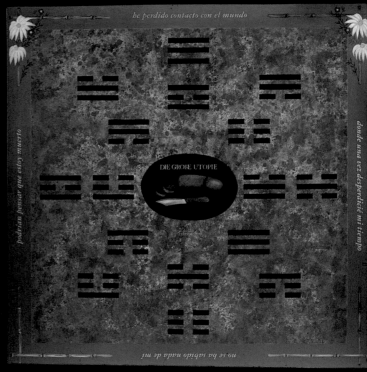

works on paper while continuing his discourse in the large format. By 1992 he represented Chile in the Biennale of Sydney and in the Expo Sevilla, 1992. That same year he painted *Osculum Infame*, the most esoteric painting he has made, full of the rites of a masonic lodge. In the centre, a small wooden chair is on fire. The flames leaping from it are each inscribed with the words: knowledge, piety, justice, beauty and eternity. On each side a vertical rectangle contains a snake surrounded by crossbones. The one on the right moves upwards and is titled, 'Active intellect', whilst the one on the left moves downwards with the inscription 'Passive

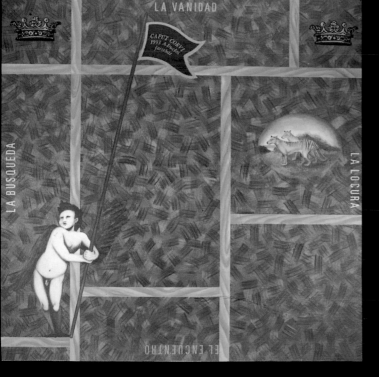

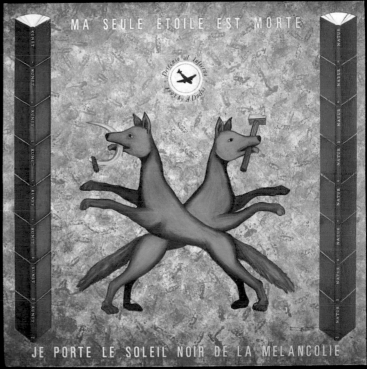

intellect'. There is a painted border of vine leaves at the top and bottom of the canvas. Singer explains, 'The mandala is brought to life by rites. Visualisation, the inward mental construction of a mandala, plays a role in esoteric Buddhism'.

Duclos' paintings are visual stories: iconographical, saturated with text, religious and political symbols, they reveal and conceal to the same degree – they are seductive. He gives us clues but does not dictate what we should think. The validity of Arturo Duclos resides in the way he tells his individual history and transmutes it into a collective one.

L to R: Caput Corvi, *1993, acrylic, oil and enamel on canvas, 150x150cm, Tomas Andreu Gallery;* Soleil Noir, *1993, acrylic, oil and enamel on canvas, 1.5x1.5m, Tomas Andreu Gallery*

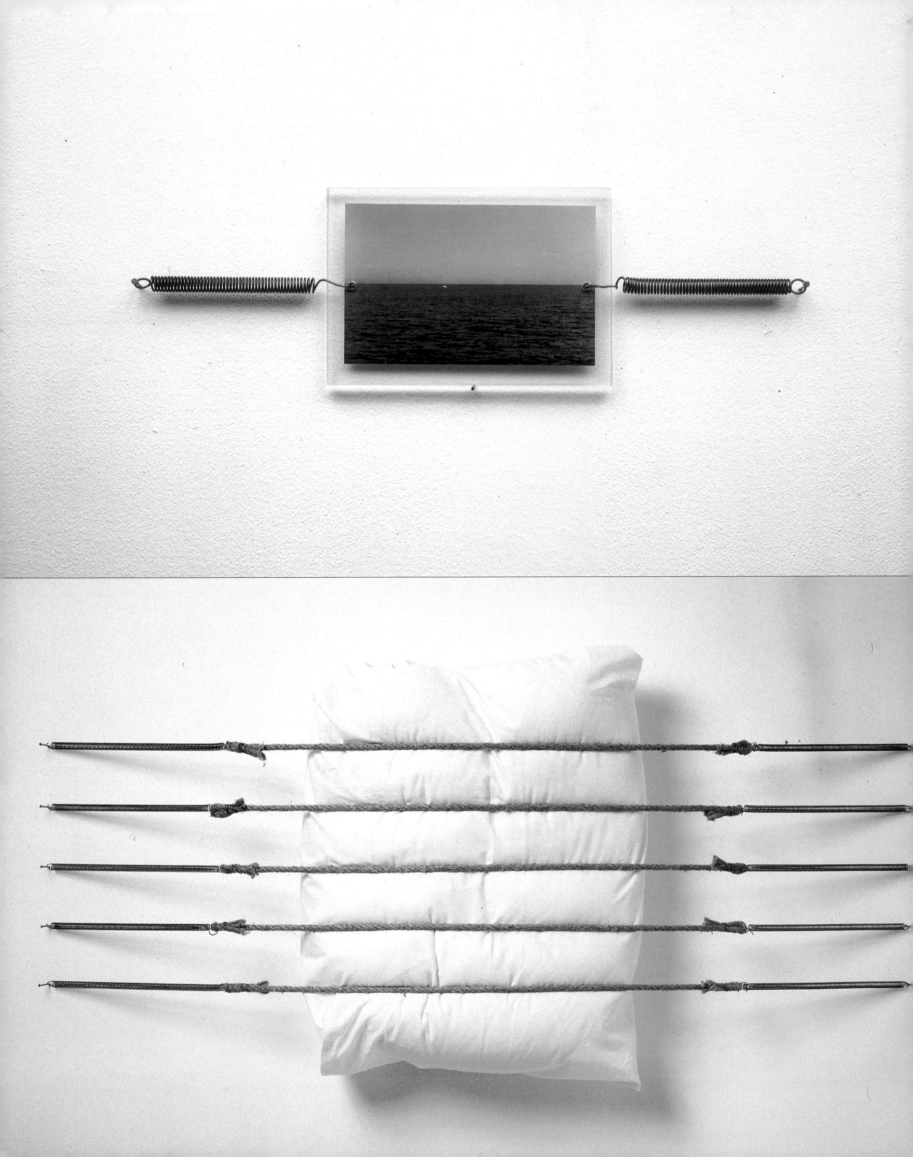

JORGE MACCHI

Jorge Macchi was born in 1963 and studied at the Escuela Nacional de Bellas Artes Prilidiano Pueyrredon, reinforcing his studies at the studio of Miguel Angel Vidal, Elsa Soinbelman and Marino Santa Maria. His first solo exhibition at Jorge Elia's Gallery had the extraordinary title of 'La Pintura y Retablos de fines del siglo XX' (The Painting and Altarpieces of the End of the XX Century). This title is similar in style to the letters sent by the Spanish conquerors to their queen, telling of their experiences and tribulations in South America – an idea that could have been awkward for an exhibition of contemporary art in the cosmopolitan Buenos Aires of 1987.

Macchi returns to the colonial origins as a starting point, as Helena Olivera states, 'Signs of the collective memory with religious connotation are used by Jorge Macchi to develop a personal vision of the contemporary world'.

A decade of generals, during which the prediction of Leopoldo Marechal (in his novel *Adan Buenos Aires*) that the country was ripe for a civil war became reality, and internal confrontation between the army and guerrilla groups resulted in the disappearance of thousands of people. The horror and degradation of the conflict, as well as losing an external war, are tragedies that have awoken some artists of the new generation from the dream that Buenos Aires is closer to Europe than to Lima or Santiago de Chile. Macchi realises that there is only one way in which it is possible to gain an identity and that is to begin accepting the common background with other South American countries.

Macchi looks around for clues. While most of his contemporaries are thinking in international terms, imitating the Italian transavant-garde and the German neo-expressionism, he organises an exhibition unrelated to the immediate environment and totally eccentric to the international scene. He uses waste materials, assembling them in a primitive manner. Rough pieces of wood set as a triptych provide support for nails, glass, asphalt and are sometimes combined with figurative painting, deliberately using poor craftsmanship. Some of the works presented are folded and closed, making it necessary to touch them in order to open them and look inside. This participation of the viewer from a contemplative to a more active role

reminds us of the traveller preparing for prayer in same remote place in this vast continent.

Macchi continues his aesthetic investigation using paints on traditional canvas. He starts painting large-scale monochrome interiors of church or palace vaults, small unidentifiable strokes appear, interfering with the central image, making it difficult to define these fragmented houses of power despite their mysterious simplicity. Do they represent the disintegration of society and nostalgia for better times? Argentina before the generals or a simple return to childhood?

In *Untitled*, 1992, Macchi continues the idea of a culture in decay and uses rags as the support for his paintings. These are normally square, grey and thick in texture. He attaches nine of them to a canvas and draws another of his vault interiors over them in black ink. The top right-hand corner of each square is peeled off, interfering with the image. This is unsettling as he is keeping his intentions hidden. The continuous reading between the lines is part of anyone who has lived under a brutal regime – you learn how to say one thing and mean another.

Macchi's ambition escapes the confines of the canvas and starts working with the space. His first installation work was shown at the Fundación Banco Patricios in the only space not yet refurbished. The floor of cement was uneven, the iron column deprived of any ornamentation, a dismantled ceiling the space chosen by him to create a mystical experience in a very unmystical city.

Armed with his skill as a painter, craftsman and sculptor, he transformed the room into a temple. In the centre, suspended over the floor, a circle of candles blazed. Above hung an open umbrella, a persistent image echoing the painted domes. Assembled on the floor, a hexagon represented the Tao's union of *yin* and *yang*. The walls were subdivided by painting black, white and brick red over them. Different objects were hung, such as ropes, small photographs of a cathedral and a huge canvas in the shape of a star stretched by springs at each point. Edward Shaw, reporting on the installation in the *Buenos Aires Herald* said, 'It will be hard for anyone to duplicate the spiritual electricity that Macchi generates. While each of his

OPPOSITE, FROM ABOVE:
Untitled, *1992, photograph, springs and nails, 12x40x2cm; Pentagrame, 1992, cushion, rope and springs; ABOVE:* Untitled (tool), *1992, wood, iron and photograph, 12x15cm*

49

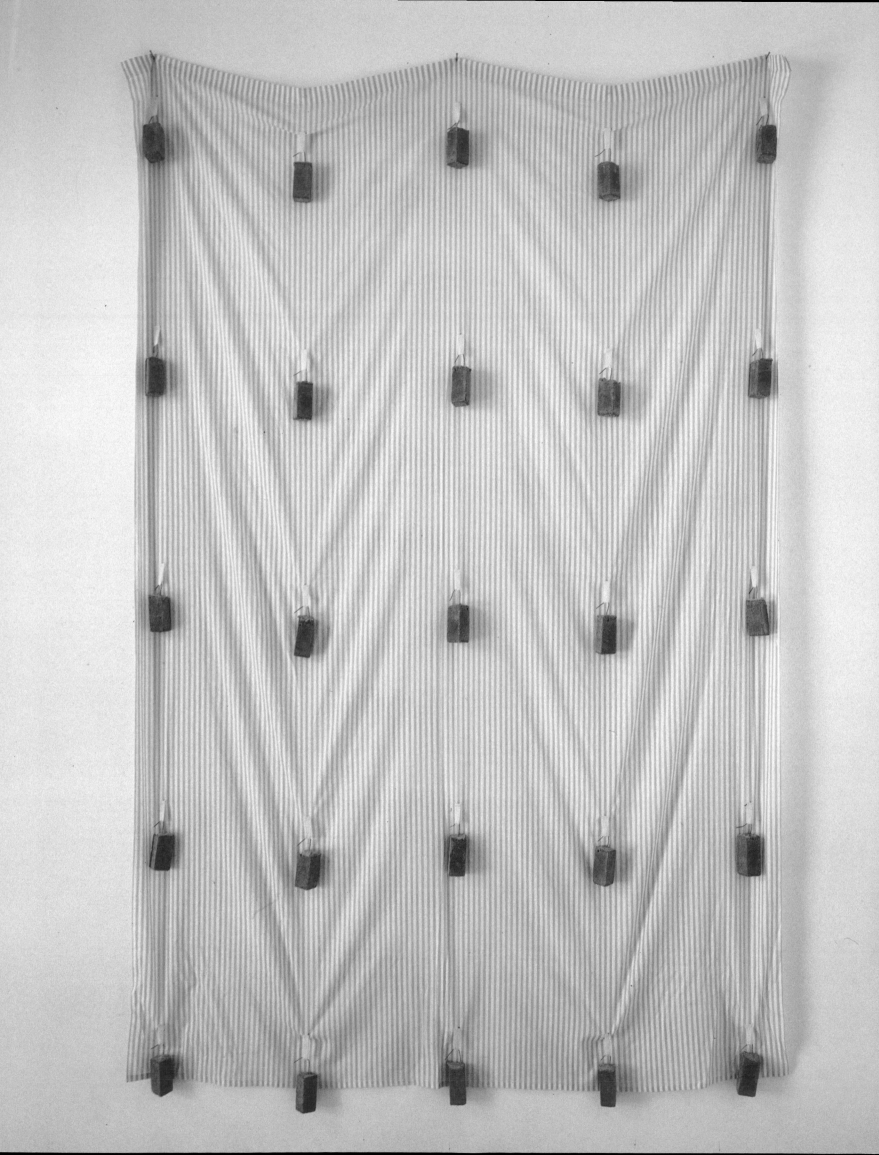

pieces is minimal in its content, sketchy in execution, each atom combines to produce an essential entirety that envelops the observer'.

But why do religious rituals get in Macchi's way? Is it a reaction to a cultural and political climate which pushes him to the unfashionable realms of religion? Or a form of developing and confirming his individuality in a world where fiction and reality are separated by a narrow gap? It is a question without an answer because Macchi continues his search, apparently finding a channel of communication only to abandon it and begin all over again.

In an exhibition at the Casal of Catalunia in Buenos Aires, he departs from his past towards a new and uncertain future. The work becomes more conceptual and the execution more professional. He still uses domestic and ready-made objects, as in a magnificent piece called *Pentagram*, where a cushion is pressed against the wall by rope and springs. Images are created by painting or changing the nature of an object.

His last exhibition in Buenos Aires was a group show in a disused basement called 'Ole como va' with Eduardo Gazzotti, Claudia Fontes and Dean Whatmuff. Macchi teamed up with David Oubina and used a video form for 'The

Crime of the Super 8', a short story of how films on Super 8 died. This consisted in a three minute scream. The poorly-lit space was ideal for the overall effect of the installation in which each artist presented one work. Claudia Fontes hung a ghost-like skin of a cow projecting a distorted shadow on the damp floor. Walking into the darkness we were confronted with a column that Dean Whatmuff had covered with the lyrics of pop music, and hidden in a small room with the television screen and the constant shout: the lack of vision adding to the confusion of the viewer. Getting out of the room we found ourselves looking at Eduardo Gazzott's piece – a chair attached by the legs to the ceiling with a very intense light on the seat. The sense of drama by then was very moving and uncomfortable. The installation worked as a theatrical piece with each artist sending different and contradictory messages to the viewer. Perhaps 'The Crime of the Super 8' was prophetic.

In his last two exhibitions Macchi has abandoned his investigation of the past and his search for identity through spiritual means. He has accepted the common past and is now free to concern himself with the present

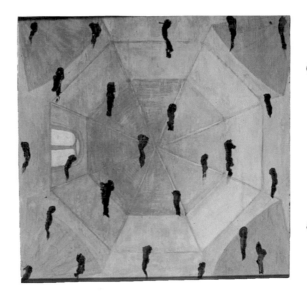

OPPOSITE: Peso, *1992, cement and sheet, private collection;* *ABOVE:* Untitled (tool), *1992, wood, iron and photograph, 12x25x8cm; BELOW, L to R:* Untitled, *1994, mixed media on canvas, collection of Sophie Schneiker;* Untitled, *1993, glass, acrylic and wood*

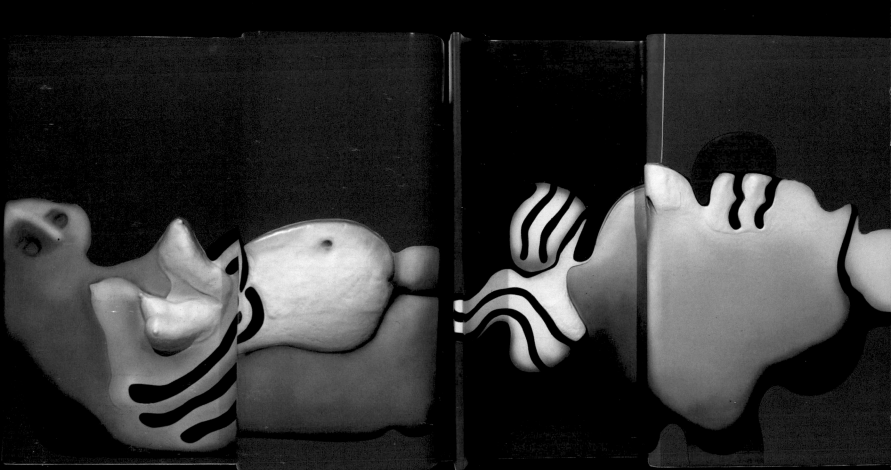

A GREENER MODERNISM: THE AMAZONIAN PAINTINGS OF MARIA THEREZA NEGREIROS[1]

VALERIE FRASER

The tropical rainforest is among the most powerful images of Latin America, for visual as well as ideological reasons. The fascination which it has exerted over foreigners can be traced back to the writings of explorers and conquerors in the 16th and 17th centuries, and in the 18th century, traveller-scientists like Humboldt, who helped to disseminate a vision of tropical America full of massive trees and strange and luscious undergrowth, overflowing with scientific and economic promise.[2] It was this sort of imagery which in turn inspired Le Douanier Rousseau's exotic scenes of imaginary encounters in an environment where Nature always has the upper hand, paintings which have been exceptionally influential on 20th-century Latin American art, both for their naive form and their jungle content. In recent years another dimension has been added to this image of the tropical rainforest: that of its role in the preservation of our world as an inhabitable environment.

In 1990 a work by the artist Maria Thereza Negreiros was chosen as the emblem of the International Treaty for Amazonian Cooperation, a treaty which laid out certain basic guidelines for the preservation of the Amazonian region, and which was signed by all the countries which incorporate areas of rainforest within their boundaries: Brazil, Bolivia, Peru, Ecuador, Colombia, Venezuela, Suriname and Guyana. The artist was well-chosen. Negreiros' recent work is centrally concerned with the Amazonian rainforest and with its destruction; she also thinks of herself as an Amazonian, as a Brazilian born and brought up in the state of Amazonia, but now living and working in Colombia. Her work, which raises both ecological and art historical issues, deserves better recognition in Europe.[3]

Negreiros was born in 1930 in Maués, a small town on a tributary of the Amazon about 150 miles from Manaus.[4] At 15 she went to Rio de Janeiro to complete her secondary education, and stayed on to study art at the Escola de Belas Artes. In 1954 she married a Colombian architect and they settled in Cali in Colombia where she has remained virtually ever since. Her work over the last 35 years has been wide-ranging in style, subject matter, material and technique, suggesting restlessness and searching in the face of innumerable artistic possibilities.

When Negreiros first began to paint full-time in the early 1960s she worked in oil on canvas, producing series that were essentially abstract but with titles derived from the natural world such as *Butterfly Wings*, and *Magic in the Mountains*. In 1961 she won first prize in Cali's first art festival with the title work of the *Butterfly Wings* series, a painting full of depth and strange shadows, the idea of butterfly wings perhaps suggested in the soft handling of the edges of the different blocks of colour. In 1963, after a return visit to the Amazon, she (as she herself puts it) 'sacrificed colour for material'. Deeply influenced by an exhibition of Spanish informalists which she saw in Bogota, and by the work of Tapiès in particular, Negreiros produced an extensive series entitled *Genesis* which incorporate sand, stones and mineral earths, and often seem suggestive of primordial geological strata, of fossils and prehistoric bones.

In 1964 she became interested in other aspects of Latin American culture – in popular and colonial art. She traces the origins of her *Angels* series to the colonial art of Quito in Ecuador, and to the little rag dolls made by the peoples of the region spanning the border between Colombia and Ecuador. Some of the 'angels' are foetal in form, others have smooth, brittle surfaces like eggshells, suggesting an evolutionary progression from the *Genesis* series of paintings. *Angel's Head* (1966), has some of the qualities of the shiny polychrome sculpture of colonial Quito, where the translucent pink bottoms of curly-haired cherubs glow against the darkness of the church interiors. The bold colours and shapes of *Angel in Striped Pyjamas* (1966), on the other hand, suggest a more popular source.

Negreiros' work during the late 60s and early 70s represents the furthest point from her painterly origins. She moved away from wall-mounted art to three-dimensional objects, from oil on canvas to photography. In a linked pair of glass fibre reliefs entitled *Woman on the Moving Staircase* (1968), it is as if the angels have grown up and matured: fully released from the two-dimensional setting, the body undulates provocatively across areas of flat, clear colour. Different again is the *Great Series of Eyes*, enlarged photographs of single eyes mounted in perspex boxes, or as in the example illus-

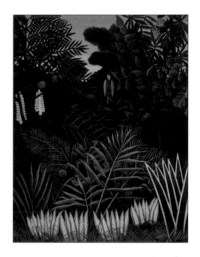

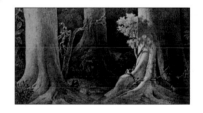

OPPOSITE: *Maria Thereza Negreiros*, Woman on the Moving Staircase, *Nos 1 & 2, 1968, glass fibre relief, each section 176x176cm; FROM ABOVE: Henri Rousseau*, Exotic Landscape, *1908; CFP von Martius*, Spix and Martius in the Amazonian Forest, *from* Flora Brasiliersis, *1840-46*

trated here, as if trapped in the lens of a telescope.

In 1974 she returned to her home in Amazonia. Her father died the following year, but she stayed on until 1979, sorting out the family affairs, as well as herself. This was self-confessedly a time of much soul-searching. She suffered a crisis of confidence about the pointlessness, the impotence of being an artist when faced with the social and ecological problems she encountered in the Amazon region: she felt what was needed were practical skills such as engineering which, of course, she could not offer.[5] But in the end, this return to her geographical roots resulted in a return to artistic roots as well. Her artistic explorations came full circle, and she returned to where she had begun, with that most traditional of techniques – oil on canvas, and to a subject matter rooted, like her early paintings, in the natural world. This time she chose to paint her native Amazonian landscape, its beauty, its fragility, and most importantly, its destruction. What she *could* do as a painter, she realised, was to 'bear witness' to what was happening to the rainforest – and the religious tenor of the language is surely not accidental here.[6]

These are large canvases, up to two metres square, and at first sight it is possible to read many of them as abstract colour field paintings – large, swirling areas of colour, softly suffused at the edges. They could be classified alongside the work of the Abstract Expressionists – Motherwell, perhaps, or Barnett Newman or Mark Rothko. But the titles alert us to the fact that these are also urgently representational works – many of them belong to a great ongoing series simply entitled *Amazonian Fire* – and with this guide we can recognise the burning trees, the heat and the fumes. Sometimes the forest is simply suggested by a green area in the lower register of the canvas, a green mass that is being sucked up into the heat and smoke above, as in *The Burnings* of 1983. Sometimes the subject is much more evident, with the trees apparently writhing, almost screaming in agony, as in *Offering No 9* (1992) from the *Amazonian Fire* series. Others again show not the death but the life of the region: mossy vegetation, swampy riverbanks, slimey green water. *Great Current* is a series of large paintings conceived of as modules which can be organised at will to create a vivid, livid green Amazonian environment. But there is a tension about these works too. They can be read as suggestive of the powerful forces of nature – luxuriant growth, sweeping rivers, wind, rain and steaming jungle heat – but there is also a sense of destructive powers at work, of unnatural winds, or of the way in which the heat from a forest fire creates fierce draughts and currents ahead of the fire itself.

These are not pictures of a landscape at peace, and in a room surrounded by modules from the *Great Current* the spectator would be in danger of being overwhelmed either by the jungle itself or, perhaps, by the winds of change sweeping through the trees.

These paintings of the Amazonian rainforest represent the resolution of Negreiros' many explorations into different materials, techniques and modes of expression during the previous 30 or so years. In her earlier work we can already identify a recurrent concern with a sense of place, with the land, landscape and culture of Latin America. The eventual choice of Amazonia as her central theme is rooted in her own personal history, but contemporary ecological debates and the historical exploitation of the Amazonian region by Europeans for economic gain (and for visual imagery) inevitably impart a political charge to her work; all the more as she herself is an Amazonian. These paintings raise a range of issues about the nature of Latin American art, about its evolution during this century, and about its relationship to the art of Europe and the US.

The iconography of the tropical forests has been so powerfully utilised over the centuries by European artists that its recuperation by Latin Americans has not been easy. Like Negreiros, the Uruguayan José Gamarra first worked in a style similar to that of the Spanish Informalists, but since settling in Paris he has deftly turned the popular image of South America as nothing but wild forest, to his own ends. His is indeed a mythical jungle, with strong echoes of Rousseau, but these historiated woodlands include all manner of improbable conjunctions across time and space, and alert us to our own contradictory attitudes to Latin America and to rainforests.[7] The Nicaraguan Armando Morales, who is also based in Europe, paints cross-sections of forests, as if a giant bulldozer has swept through, revealing the naked trunks of the crowded trees. But these trees are undamaged by such exposure: their tall, grey, anthropomorphic forms regroup and link their leafy arms against the intruding gaze.

The reclamation of this type of imagery by Latin American artists is not a recent phenomenon, but can be dated back to the early years of this century. Indeed it is the locus of some of the most interesting confrontations between Latin American artists and European Modernism. The Brazilian Tarsila do Amaral spent some years training in Paris with, among others, Léger, and returned to Brazil in 1923 equipped with a visual vocabulary dominated by the machines of modern industrialised Europe. But to paint a world dominated by machines in Brazil in the 1920s would be to paint dreams and phantasms, so what to do? She and other

members of the avant-garde 'anthropophagist' movement in Brazil proposed to tackle the problem of their relationship with European culture by inverting the early colonial image of Brazil as a land populated by cannibals.[8] They embraced the role of cultural cannibals as a positive strength: they could take whatever they chose from Europe, stew it with Brazilian spices, chew it over, swallow and digest it, or spit it out. In the process the imports would become fully naturalised. Tarsila applied aspects of the formal language she had learnt in Paris to Brazilian subject matter, and particularly to the landscape, vegetation and popular culture of Brazil.

In her paintings of the later 1920s she avoids the mysterious exoticism of Rousseau, although she is certainly influenced by him, and succeeds in suggesting that her plant life is powerful and full of import. Her painting *Anthropophagy*, 1929, of two figures, one with a single gigantic breast, is a thoroughly 'anthropophagist' way of reappropriating the strength of the classical myth of wild women, the Amazons, who cut off one breast in order to be able to use a bow and arrow unhindered. Europeans had first applied the term to the region in the 16th century, in response to supposed sightings of the Amazonian women as described by Pliny and Plutarch, and Tarsila accepts the full implications of the idea, naturalises it, and, by implication, refuses Europe further access to it.

The Cuban artist Wifredo Lam is another interesting example of the imaginative importation of Modernism to Latin America. He came to Europe in 1923 and, like Negreiros, experimented with several different styles – a sort of socialist realism while he was in Barcelona during the Spanish Civil War, for example, and, most famously, with Cubism while he was working in Paris in the circle of Picasso.[9] His return to Havana in 1941 marked the development of a confident personal style which is thoroughly permeated with the imagery of tropical vegetation. He abandons the predominantly indoor, cotidian imagery of European Cubism – the café tables, wine bottles, glasses and guitars – and transforms his canvases into dense thickets of bamboo, populated with watchful Afro-Caribbean spirits. As for Tarsila with Léger's Futurism, Lam found that Cubism's roots were too urban for it to be transported wholesale to Cuba. The oppressive vegetation in Lam's paintings stands for all those elements of 'otherness' which he recognised and reassessed on his return from Europe. The jungle is the perfect metaphor for all the many aspects of Cuban society, religion and culture that are so far removed from the views of Modernism as propounded in the cafés of Paris and Barcelona. It is a metaphor for the colonial process, for the way in which that which has been apparently conquered and subjugated, continues to reveal other facets, other faces, more sinister and unknowable than ever.

It is interesting that for all four of these artists, travel has played an important part in their artistic development. Gamarra and Morales make use of the iconography of the tropical forest from the perspective of Latin Americans within Europe; for Tarsila and Lam it was the return to their roots after a period of absence, of distance, which was the catalyst, stimulating new forms and new subjects. For Maria Thereza Negreiros, too, it was her return to her home in the Amazon after years living in the highlands of Colombia which marked the turning point, both personally and artistically. What distinguishes her experience is that, for her, the Amazonian rainforest is reality as well as metaphor. For the other artists the experience of travel in the tropical forest would be that of outsiders; for Negreiros it was to return home.

However, it is not just her subject matter which can be seen to fit into a broader genre of Latin American art; it is also the form. Negreiros' apparent abstractions resolve on closer attention into devastating representations. These two paths, abstraction and representation, which in Western art are so often seen to be utterly opposed, in recent Latin American art are often quite deliberately brought into conjunction. Again, a few examples will serve to illustrate this point. The Venezuelan Jacopo Borges uses the device to advantage in *Meeting with a Red Circle*, 1973; in fact, as if to stress the ambiguity, it is also called *Ring of Lunatics*. A piece of pure geometry – the red circle – dominates the lower two thirds of the canvas while in the upper register the flat surface gives way to an all-too credible three-dimensional room, where we see a Mafia-like ring of faceless military generals and other grandees, their corruption expressed in the figure of the flamboyantly naked woman who sits amongst them.[10] In a rather different way, the Ecuadorean Osvaldo Viteri constructs large collages using the same type of rag doll which influenced Negreiros' *Angels* series.[11] In *Eye of Light* (1987), he superimposes the simplest of geometrical shapes, the circle, within the square, on these extremely tangible, brilliantly-coloured, handmade, miniature figures. Avant-garde forms are juxtaposed with what may be seen to be a-temporal values of popular Andean art – the Western preoccupation with science and rationality, with the perhaps more human (or human-scale) philosophy of indigenous culture. In *Eye of Light*, life and light reside with the latter.

This type of creative tension between the different poles of 20th-century art is not new amongst Latin American artists. Joaquín Torres-García returned to his native Uruguay in 1934

Maria Thereza Negreiros, FROM ABOVE: Multitude, 1974, from the Large Series of Eyes, cylindrical sculpture, PVC, acrylic, lenses, photograph, steel, 25cm long, 16cm diameter; Angel in Striped Pyjamas, 1966, from the Angels series, mixed media, 150x130cm; OVERLEAF: Great Current, Modules 1 & 2, 1993, from the Amazónica series, oil on canvas, each 180x180cm

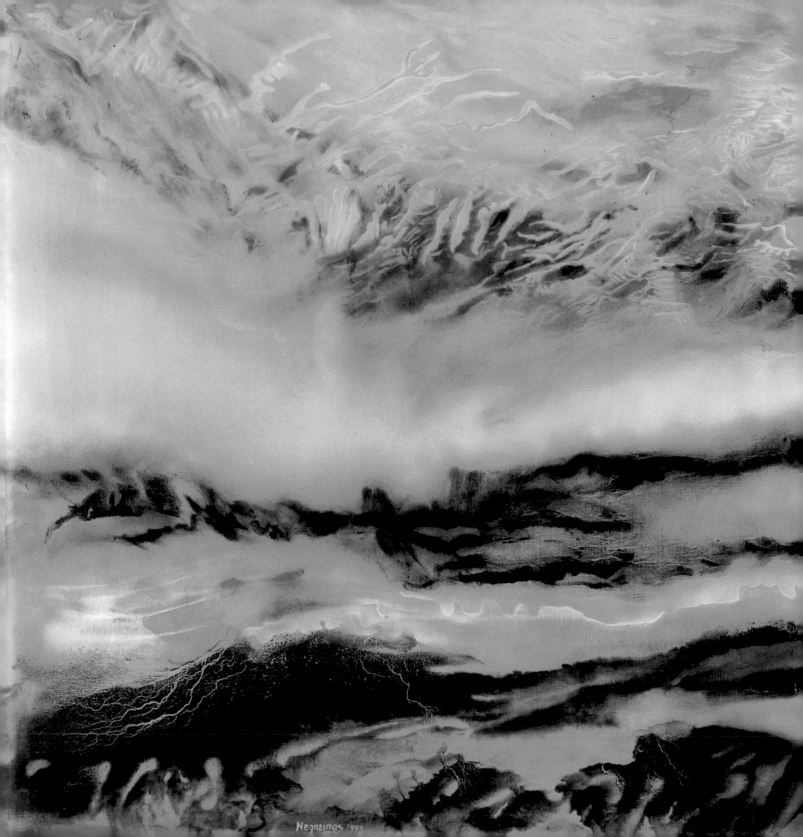

Negreiros 1993

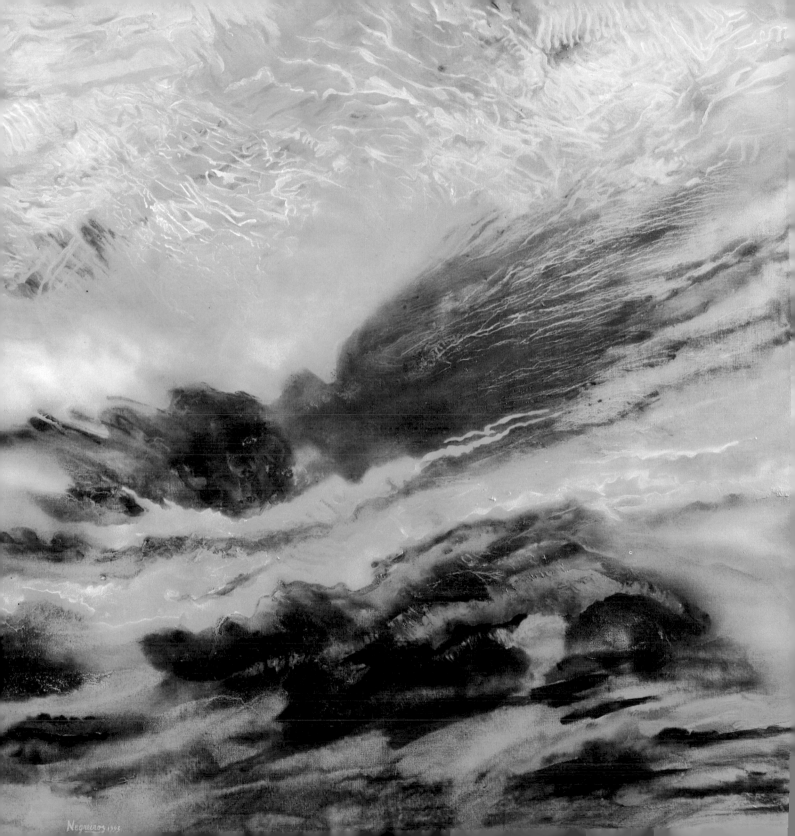

*Maria Thereza Negreiros, FROM
L to R:* Offering No 7, *from the*
Amazonian Fire *series, oil on
canvas, 130x150cm;* Amazonian
Fire, *1992, oil on canvas,
130x130cm;* Offering No 9, *1992,
from the* Amazonian Fire *series,
oil on canvas, 120x120cm;*
Amazonian Fire, *1992, oil on
canvas, 58x58cm*

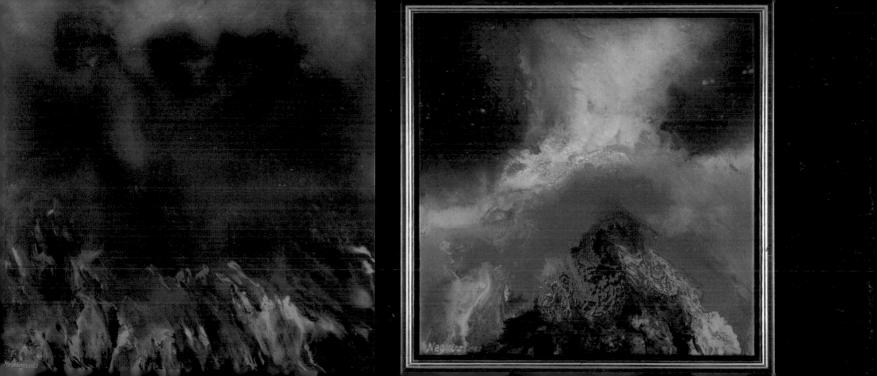

after a long residence in Europe and developed a way of including ideas and motifs from native American art into a modernist framework.[12] Sometimes, whether one reads his work as abstract or not, depends on the eye of the beholder. To some, his Construction in Black and White of 1938, for example, might seem uncontestably Constructivist, but place it along-side a little alabaster chaqra from Peru, a ritual object associated with the fertility of the flocks and the safety of the farmstead, and it becomes clear that Torres García intended his composi-tion to be read both as ritual object and as abstract pattern. These various examples are not in any tidy sense easy reconciliations of the concerns of very different cultures; on the contrary, much of the interest lies in the tensions between such diverse visual languages.[13]

Maria Thereza Negreiros' paintings of the burning Amazonian rainforest create similar tensions. Having experimented with acrylics, mixed media, fibre-glass and photography, Negreiros has returned to oil on canvas, the medium in which she was schooled during her thorough and traditional training at the Escola de Belas Artes in Rio. She is, of course, not alone in the 1970s in having tried, as it were, the bad new things and returned to the good old things. She takes that very traditional European genre, landscape, transforms it from a spacious horizontal view to a more nearly square or even slightly vertical canvas, and represents a par-ticular, and to many, peculiarly American form of landscape in a state of turmoil and destruc-tion. And she does so in a language closely akin to that of Abstract Expressionism.

It is worth considering this juxtaposition of landscape genre with an Abstract Expressionist language in a broader context. As is now well documented,[14] Abstract Expressionism was ex-ported from the US to Latin America in the 1950s precisely because of its apparently apolitical character. Abstract Expressionism was not, of course, 'a monolithic expression of Cold War ideology'.[15] It is important to recognise that the aims and intentions of the government agencies involved may not represent those of the artists themselves. Nevertheless, Abstract Expression-ism is commonly perceived, especially perhaps in Latin America, as an artistic language which was developed in New York during the cold war, in a context utterly different from those in which Latin American artists found themselves then, or find themselves today. The validity of such a language within Latin America must be at least questioned. As we have seen, a number of Latin American artists have explored the possibilities of combining abstraction with other very differ-ent visual languages. In the case of Negreiros' work, I think we cannot help but see the references to a style which propagandists ac-

claimed as the art of the 'free world', a style that could transcend the politics of figuration (and in Latin America this has traditionally tended to imply social or socialist realism), a style that addressed the spiritual rather than the material concerns of the world. On the other hand, her subject matter places her work firmly within the Western tradition of landscape painting, a tradi-tion which has also sometimes been portrayed as above ideology but which, if you scratch the surface, tends to reveal itself – from the moment when it first emerged as an independent genre in Holland in the 17th century – as highly politicised. Of course, in relation to the tropical landscape of Latin America, history has deter-mined that a political undercurrent is inescap-able. With a visual tradition that evolved in Europe as an adjunct of colonialism, and estab-lished the tropical rainforest as the stereotypical image of South America – a tradition which has now been successfully reclaimed and trans-formed by recent generations of Latin American artists – the case could not be otherwise.

What gives Negreiros' work its particular power is that it combines so many of these different art historical strands. At one level she can take her place in the pantheon of artists who have acclaimed the abundance, the strange power and vitality of Nature as manifested in the Amazonian rainforest. Her dramatic green can-vases can be seen as an evocation of reality, and also as a metaphor for the richness and fertility of Latin America and Latin American art. Furthermore, as we have seen in relation to the work of other artists, the image of the jungle can also be understood as a metaphor for the otherness of Latin America, so very different a world from that of Europe and North America. At another level she takes up the challenge of Abstract Expressionism, exploring the juxtapo-sition of colour and texture, suggesting an intense personal involvement with the canvas surface. But in the context of her burning Amazon pieces there is a bitter new irony to the idea of 'abstraction': she is in fact representing the transformation of the forests into heat, smoke and gases, the transformation of tangi-ble reality into something much more abstract. The impact is heightened by the forms the fires take, which can be read at both a microcosmic and a macrocosmic level, suggesting either particles seen through a microscope, or at the other extreme, an atomic explosion, the fires of hell. We are aware that what is at issue is the very substance of life.

Negreiros confronts the problem of Modern-ism in Latin America and produces pictures whose power derives from the contradictions they embody. She uses a style popularly thought of as above or beyond politics to say something profoundly political. Her works are both modern

and traditional. They are unquestionably Latin American, and at the same time of supremely universal import. In front of such visions, debates about the relative merits of figuration and abstraction appear insignificant. The one is being transformed into the other. In this case, it is a one-way process, and the result, however beautiful, could too easily be final and absolute.

NOTES

1 This essay (March 1994) is a reworking of a paper first given at the Annual Conference of the College of Art Association in Washington in 1991.

2 See Dawn Ades, *Art in Latin America*, London 1989, pp41-99

3 Her work was exhibited in Britain for the first time at the Durini Gallery, London, in July 1994, in a show entitled 'Latin American Women Artists'.

4 Biographical details are derived from personal communication with the artist, from the catalogue of an exhibition of her work: 'Retrospectiva, 1961-1981', Cámara de Comercio, Cali, 1982, and from *Negreiros*, Publicaciones Muro, Cali, 1993.

5 'My true encounter with my culture was when I came back to my people . . . I discovered I could have been much more useful as an engineer or an agricultural engineer in the jungle, not as a painter', interview with Maritza Uribe de Urdinola, 'Retrospectiva, 1961-1981', Cámara de Comercio, Cali, 1982.

6 It is to be found again in a series of works entitled 'Offerings', two of which are illustrated in these pages.

7 I discuss Gamarra's work in greater detail in O Baddeley & V Fraser, *Drawing the Line: Art and Cultural Identity in Contemporary Latin America*, London, 1989, pp24-30.

8 Dawn Ades, *op cit*, pp132-134, and pp310-313, where the manifestos are reprinted; Aracy Amaral, *Tarsila: Sua obra e seu tempo*, São Paulo, 1986.

9 'Wifredo Lam', catalogue of an exhibition at the Fundació Joan Miró, Barcelona, 1993, includes examples of his earlier work.

10 See Baddeley & Fraser, *op cit*, pp96-98.

11 See Ades, *op cit*, pp 298-299.

12 'Torres-García: Grid-Pattern-Sign', catalogue of an exhibition at the Hayward Gallery, London, 1985.

13 David Craven, arguing for an interpretation of Abstract Expressionism as more than simply an expression of the ideology of the ruling class in the US, uses a formulation of Mikhail Bakhtin whereby 'an artwork is not a unified whole, but rather an open-ended site of contestation wherein various cultural practices from different classes and ethnic groups are temporarily combined. Any visual language in the arts is thus understood as a locus for competing cultural traditions along with conflicting ideological values . . . Artwork such as that by the Abstract Expressionists should be approached as an uneasy synthesis – more or less stable but *not* conclusively resolved – of hegemonic values with subordinate ideological tendencies, out of which broader signification is constructed.' David Craven, 'Abstract Expressionism and Third World art: a post-colonial approach to "American" art', *Oxford Art Journal*, 14, No 1, p45.

14 'Expressionism, Weapon of the Cold War', *Artforum*, XII, no 10, June 1974, pp39-41. More recently, Serge Guilbaut, *How New York Stole the Idea of Modern Art*, Chicago 1983.

15 David Craven, *op cit*, p44.

Maria Thereza Negreiros, The Burnings, *1983, from the* Amazónica *series, oil on canvas, 90x80cm*

ART FROM ARGENTINA

DAVID ELLIOTT

The Museum of Modern Art, Oxford, presents an exhibition (2 October-31 December 1994) which traces the development of art in Argentina from the 1920s until the present. It does not attempt to present a complete survey but concentrates on art which has a specifically Argentine identity and which cannot be dismissed as a regional or provincial variant of European or North American art. It is the first exhibition of this kind to be presented in Europe.

Of all the cultures of Latin America, that of Argentina has been regarded as the most 'European', but its ostensible familiarity covers a disquieting strangeness. Here, as the work of Luis Benedit makes clear, the native Indian population did not survive colonisation and, unlike neighbouring Brazil, there was no substantial influx of African slaves. Originally a Spanish colony, Argentina was transformed at the end of the last century when Buenos Aires rivalled New York as a destination for European immigrants who, escaping poverty and persecution, wanted to start a new life. Strong cultural links with Italy, Spain and Great Britain have been maintained to the present.

These many and varied influences made Buenos Aires seem like a crucible – an unpredictable, even chaotic, source of energy. However, these same influences also led to a rootlessness, an insecurity and a sense of isolation. For the inhabitants of one of the American continent's southernmost capitals, bounded on one side by the ocean and on the other by the vast plains of the pampas, this isolation seemed to be a cruel trick of geography, but it was also psychological as so many had been forced to sever contacts with their mother countries and could not identify completely with either their past or their present.

Melancholy and the anxious need to build on the frail reality of each moment to create a sense of identity is a recurring motif in the work of Argentine artists. It appears also in the writings of Jorge Luis Borges and Manuel Puig and can be heard in the plangent strains of the Tango, the music of the Buenos Aires waterfront. To be an artist or writer in Argentina, experience and reality cannot be seen with an innocent eye, they have to be fixed and mediated by allusions, metaphors and symbols.

This exhibition shows artists whose work may be characterised by this sensibility. Xul Solar's earliest watercolours were made in Europe at the time of the First World War in the form of a brightly coloured calligraphy. Here he created a remembered and exotic Argentina – a synthetic land where ancient and arcane beliefs could be freely expressed. In the 1930s and 40s, he painted impenetrable labyrinths and ziggurats. A close associate of Borges, he also began to experiment with grafias: works constructed out of different visual languages which could be read as pictographs as well as being transposed into other art forms; for example, some of his paintings could be played on a special piano of his own design.

Racquel Forner was one of the leading women artists working in Latin America during the 1930s and 40s. Like the much better-known work of Frida Kahlo, her paintings, influenced by both Surrealism and Socialist Realism, explore her own body, role and identity.

Antonio Berni worked in Paris during the late 1920s and early 30s as a member of the Surrealist group. A number of his early Parisian paintings will be shown at the forthcoming MoMA exhibition in Oxford. Back in Argentina he worked on a monumental amalgamation of surrealism and socialist realism in paintings which showed, in a striking and disquieting way, the unemployment and social unrest he found there. By the late 1950s and early 1960s Berni's work had transformed yet again into a series of neo-pathetic narratives – vast, ironical painted collages, using sheet metal and detritus, chronicling the life and times of Juanito Laguna, a young slum dweller, as well as of Ramona, his prostitute girlfriend.

Not all early modernist art in Argentina was either fantastical or realist. From 1944, a young group of Constructivist artists began to work in Buenos Aires and were of great influence for the development of art in Latin America; their work has only recently been reassessed. A display of previously unseen structures from the mid and late 1940s by the Madi Group and related Arte Concreto Invencion group have been incorporated as a section in the exhibition, including the first works to be made using neon tubing.

The art of the 1960s focuses on the Neo-Figurationists – in particular on the work of Jorge de la Vega and Luis Felipe Noé. Both made

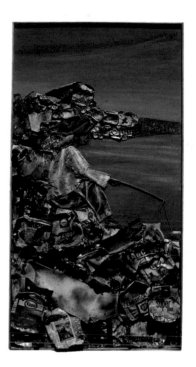

OPPOSITE: Lidy Prati, Concierto No 2-B, *1948, oil on hardboard, 60x60cm; ABOVE: Antonio Berni,* Juanito Sleeping, *1978, oil and collage on wood, 156x1,115cm*

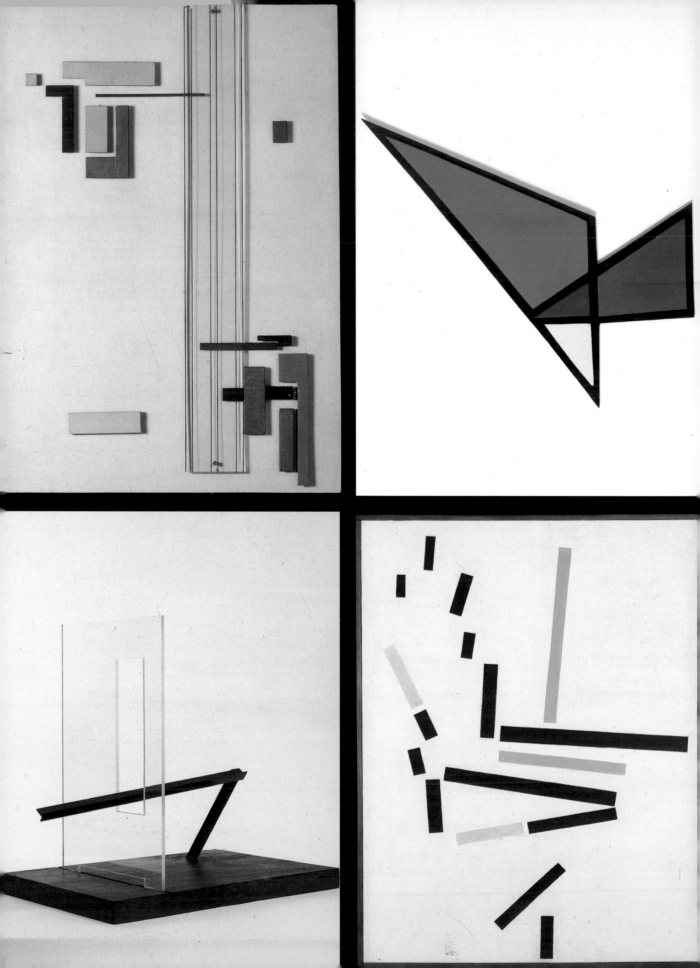

violent expressionistic paintings on a monumental scale which conflated social, personal and political events. Both collaged advertisements and other printed material into their work in what may be regarded as a specifically Argentine hybrid of Abstract Expressionism, Réalism Nouveau and Pop Art.

The contemporary section of the exhibition will include installations by Luis Benedit, Victor Grippo, Alberto Heredia and Pablo Suarez. Heredia makes violent expressionist sculptures which reflect the times he has lived through, but Benedit, Grippo and Suarez, all in their 50s, have a more conceptual approach not only towards art but towards the definition of reality. Benedit examines the 'scientific' myths upon which modern culture is based, particularly when related to a sense of Argentine identity

and history. Grippo, formerly a scientist, tries to distil poetic essence from the most elementary of materials; his boxes, which contain real objects and simulacra made of lead, provide a framework for a number of visual poems and puns about the nature of reality. Suarez, the most politically engaged during the 1970s and early 80s, shocks and disorients the viewer by presenting both artist and onlooker as accomplices in an absurd and grotesque parody of cultural narcissism.

The exhibition also includes the work of a younger generation of artists including Guillermo Kuitca who has already exhibited widely in Europe.

With its fully illustrated catalogue, it presents an alternative history of Modernism which is little known in Europe and the West.

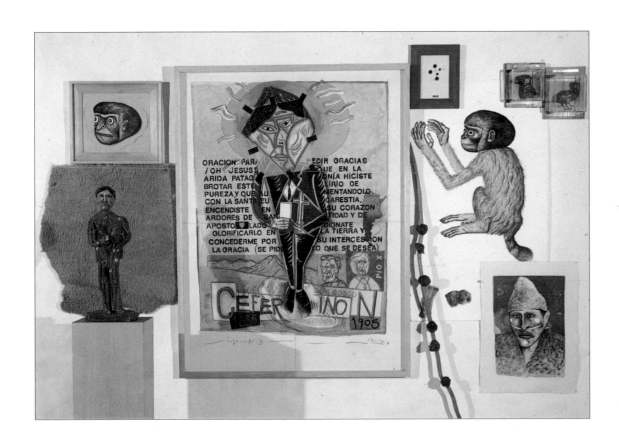

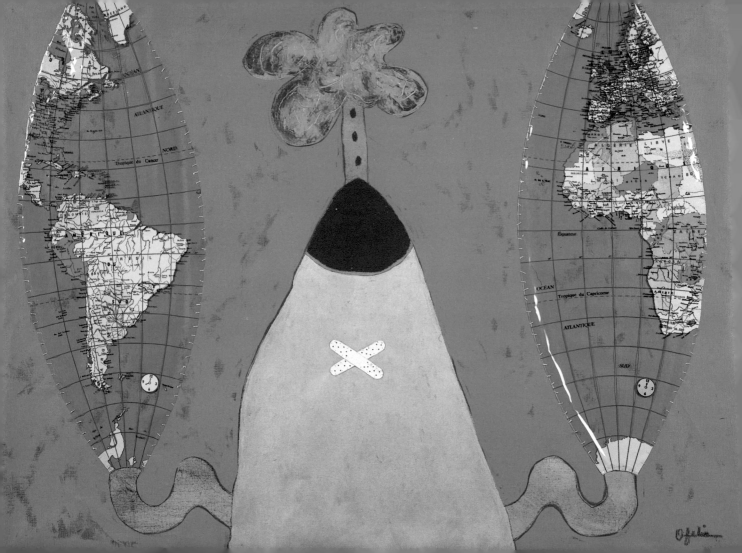

OFELIA RODRIGUEZ

AN INTERVIEW WITH JANE PAVITT

Ofelia Rodriguez grew up in the coastal town of Barranquilla, Colombia and trained in Fine Art at the University of the Andes in Bogota between 1964-69. Working in Colombia, she developed a personal language of organic abstraction, heavily influenced by her experience of her regional culture. She was taught in Bogota by Santiago Cárdenas who, despite working in a realist manner himself, nevertheless encouraged her to experiment with popular art forms and abstraction. She was subsequently awarded a scholarship by the Ford Foundation to study at Yale University (1970-72) where she was taught by, amongst others, Lester Johnson and Al Held. Her highly personal abstract language appealed to the dominant ethos of the fine art faculty at that time – which coincided with the final phases of Abstract Expressionism and the rise of Pop in North America. However, their readings of her work failed to recognise the potency of her connection to her native culture, and she had to struggle hard to maintain her distinctive identity, although she has said that her time away strengthened her links with the culture she grew up in.

After leaving Yale she returned to Bogota to teach and work. She continued to develop her use of collage – sewing, glueing and hanging objects to her large canvases. She uses large areas of pure colour in her painting, often in floating, biomorphic shapes (something which shows in her early abstract cellular compositions), which resemble dreamlike landscapes – mountains and huge expanses of sky. The floating forms or objects are attached by threads or hangers, anchored in some way but always suspended above ground level. This feeling of hanging or floating, she says, is a dreamlike state she associates with the experience of Colombia. These fantastical landscapes have a close relationship with the body – veins like rivers, as well as bleeding hearts and drips that form into lakes.

She has participated regularly in the annual Salons of National Artists in Colombia since she was a student in 1969, and is now represented by several galleries there. After leaving Colombia, she settled first in Paris where she worked for nearly eight years. Since the mid 1980s she has been based in London, where she has two studios. Her work in London, she says, benefits from the sense of separation she feels here, and the lack of distraction which English culture offers. She returns to Colombia annually, and exhibits in other South American countries. She has currently been invited to participate in the Havana Biennale.

Aside from her large, collaged canvases, she also creates 'magical boxes' – colourful and humorous constructions which contain totemic emblems and 'found' objects; toys, scraps of fabric, nails and bottlecaps. These collections are often erotic and violent – nature is 'red in tooth and claw' – bloodred fingernails, spikes that would puncture the skin, animal horns and tiny animals in cages. The animals are almost always exotic or fantastical; something, she says, which reflects both the image of Latin America and the occasional reality she remembers from her childhood.

Here she discusses her Colombian background, and her relationship to both Latin American culture and European fine art traditions. Her concept of her own 'Latin Americaness' and her interest in popular forms of art as well as literature – particularly the 'magical realism' of Gabriel Garcia Marquez – form an interesting context for her work. Often her work is read as a continuation of a tradition of Surrealism in Latin America this century, but Rodriguez's relationship to her Colombian region, and her use of its imagery and tradition demonstrate how closely her work ties in with popular traditions of fantasy and storytelling.

Jane Pavitt *Your work draws heavily on forms of popular culture from your region of Colombia. What attracts you most about the popular?*
Ofelia Rodriguez When I think of Colombia the first thing that comes to my mind is the physicality of it all; I guess I always think of it as a place, a setting for my ideas. The images of Carnival – masks and costumes – have haunted me since I was a child. Carnival is an incredible phenomenon for the reason that once a year all the different levels of culture in Colombia come together – although it's very regional, and it's different wherever you happen to come from. The region I come from is extremely sensual and direct and outward, but I was a little bit of a stranger in a way, as my mother was not from there and thought the north very barbarous and

Landscape with Two Hemispheres Floating, *1992, 129.5x97cm*

crude. There has always been friction between the two regions – the interior, especially Bogota, sees itself as the real Colombia, the authentic culture, more refined and tasteful and civilised. It's a very free, permissive culture on the Caribbean Coast. The language is very loose, and everybody uses rude words – the vocabulary is at times incredibly shocking – and although I lived this, I was constantly being reigned back by my mother.

– *How much did you participate in the Carnival as a child?*
Even within my family I have those regional differences I mentioned; my mother comes from the interior and my father from the coast. My mother found the culture of the coast rather alien, and my father was, I suppose, an intellectual; so we were not the type of family who took a great part in the Carnival. But still, it was part of the culture, like Halloween, so we participated at school. After Carnival the maid would be pregnant and my mother would be so upset. The whole atmosphere was so attractive and alluring, everybody would be so excited, and everything would revolve around the carnival. Much of the ritual comes from Spain originally, much like Brazil's came from Portugal, although Rio's carnival has become much more sophisticated. Ours is much more local. There is one dance called the 'Comparsa del Congo' which is a dance that has been done for 100 years or so, where the group dancers always inherit their places from relatives. The oldest of about 80 to the youngest child will all dance for days and will go from one end of the city to the other. Everyone, from the poorest to the richest, has their 'comparsa'.

– *Is it still so localised?*
What is interesting is that this Caribbean culture is spreading itself across Colombia and gaining acceptance in everyday life through music and literature, for example. I remember when Gabriel Garcia Marquez's first book came out (he is from the north as well), many found his language vulgar, so unlike traditional, classical literature. He used local stories and much of what he uses is part of a common, popular memory.

– *This popular memory, as I think you said to me before, is something that you've found to be at times unreal, or fantastical . . .*
There is that sense of unreality – elements from the popular imagination become accepted as truths. I think that is true of all South America. There is a feeling of being on the edge of the world, at its margin. For instance, there is a feeling of floating, of being suspended in mid air – a dreamlike state – which is inevitably reflected in my work.

– *You've said that the region you come from is very multi-racial, which must add to the richness of the popular culture you describe.*
I think it does. We have a lot of African blacks on the Caribbean Coast. The region was on the slave route and they were brought in to build the fortifications along the Colombian coastline, as it was one of the main exits for gold. As the original Indians were mostly killed during the Conquest in this area, many more were moved from the interior, and they died off as they had never been in a hot tropical climate, so the Spaniards brought in the black population. This has given our northern culture a different flavour, more similar to Brazil.

– *How does this contribute to the popular imagination?*
I always wondered if the 'comparsas' had any African roots – although I've never gone into all the symbolisms – but they wear very tall hats with flowers, sunglasses, paint their cheeks white and carry the smallest children. Women smoke tobacco and they dance for three days, some dressed as birds and crocodiles. Apparently, some of these comparsas date back to dances from the Basque region. I feel that Catholic, Spanish heritage very strongly as well. My mother is very Catholic. When she came to live at the coast she decided: 'my children will not be brought up this way!' So that was how it was – we were very foreign without being foreign.

– *What you've described is very much a living culture, connected to everyday behaviour at every level. So how do you relate to the history of your country?*
Only in a very remote way, as I feel that indigenous culture is very far away from me. Whenever I have a need to relate to Indian culture it's because it intrigues me. We live over their land, and I love my land, but yet still feel a distance from it. It's not really mine, I haven't really inherited the culture of my land, so that always leaves me in a strange situation.

– *Is the Indian presence very strong in society?*
There are very few Indian communities left in the region I come from and they live very separately from us, far away in the mountains, hardly part of modern society at all. And at the same time you go to Bogota where I studied most of my life, and there is much more of an Indian presence. The interior is where you feel that the Spaniards populated a region that was Indian. On the coast, it is not that easy to trace.

– *Do you feel any link to the ancient history of the land, to Pre-Colombian art, for instance?*
The only expression I see of that culture is the objects in the museums. I don't feel that they are

mine at all. The only thing I feel is that these are from this land, and this is my land as well. I think most people share this attitude. Maybe even the Indians themselves. Maybe we've just been segregated from our own reality. Some artists have been using Indian culture recently, such as exploiting the forms of pre-Colombian figures. What has made me shy away from that is my regional preoccupation – this for me is stronger, and everything else is secondary.

– *You've described it as a rather violent culture as well: both historically, and now, of course.*
I think this very violent character is inherent to the history of Colombia. Maybe it's the nature of Conquest – power was gained through a very brutal and bloody history. The nature of the colonisation was a violent one. Writers, for example, have talked about Mexico being born of a rape. And then there is the Catholic element, which visually sustains all this. The crucifixes in Colombia seem so violent and bloody. There is something gory about that religious culture that attracts me.

– *This element of violence is very strong in your work.*
Yes, I guess I want that element to come through.

– *How is it linked to your memory of your childhood?*
When I was a child it seemed that outside our house everything was very violent – I remember seeing men fighting with broken bottles in the street. I also remember being very scared by the Carnival. It was the letting out of all kinds of inhibitions, through all the folklore, the masks and the dances. You don't protect children during this time, you scare them in a way you wouldn't dream of doing here. I'll never forget a man with black oil all over himself, who looked like he had pushed a bone through his nose and was chasing the children on the street, driving them all to tears.

Your depiction of violence is more about violent nature, not deliberate cruelty, but that the world can be full of incidental, violent acts.
Society is violent and so is nature. There are often vultures circling the city, who will pick over dead animals in the street, hundreds of them tearing the carcass up, and the stench is terrible. The ocean is very dirty as well, and often dangerous. It can change quickly, its not like that postcard image of the Caribbean. When people go to the Tropics to find Paradise, I think: what a Paradise! How very deceiving these images are, because nature over there is always so threatening. I remember when I was six or seven, a shark had attacked and bitten off the leg of a fisherman. One day it was reported that

it had been caught, and the leg found inside. That night the whole town paraded down to the beach, everyone with candles; they had gone out to see it being brought in and were pounding on the shark, beating its carcass as an act of vengeance.

– *That's such a potent image, and of course you use images of animals, plastic toys and models, a great deal. They seem unreal somehow. They remind me of the fantastical creatures that were once said to have been found in newly 'discovered' lands . . .*
I'm fascinated by some live animals – iguanas, fighting bulls, sharks, snakes, crocodiles and manatees – they are so primeval and archaic and yet so much part of my everyday environment. The manatee, a sort of seacow, is surrounded by popular myths: it is said to lure fishermen with its women's breasts and other erotic qualities!

– *We've discussed already the recurrence of violent as well as sensual images in your work, about the physicality of it, and I wanted to ask about your use of the female body.*
That's because I'm a female . . .

– *But is that the only reason?*
I don't feel it in terms of my body, or indeed about violence against women in general. In the case of Frida Kahlo, for example, I think she exorcised the violence she had suffered, and felt this was probably the woman's position. I certainly don't think about it like that.

– *Have you ever asked yourself that question, whether the experiences you work with are to do with the 'singular' female experience?*
I have never thought of myself in terms of women's experience in general. On the contrary, I think that sometimes I make fun of all that, the 'suffering woman' for example. That's because it comes across in popular songs, for example, a sentimentalising of love and broken hearts. In those songs, it's also the men who are suffering! Cindy Sherman, for example, may feel that violence towards women, but I don't share that experience myself.

– *Whenever you've talked about your experience of childhood, and the memories you have, it's not often about the experience of things you have taken part in, but rather things that you observed.*
Exactly, I'm like a spectator in a way.

– *I have this image of you as a child, always peering out of a window at the world.*
Yes, that's probably true! I think it's about visual memories, rather than real experiences. I never

Travelling Magic Box with Suffering Woman, *1994, 13x22x44cm*

69

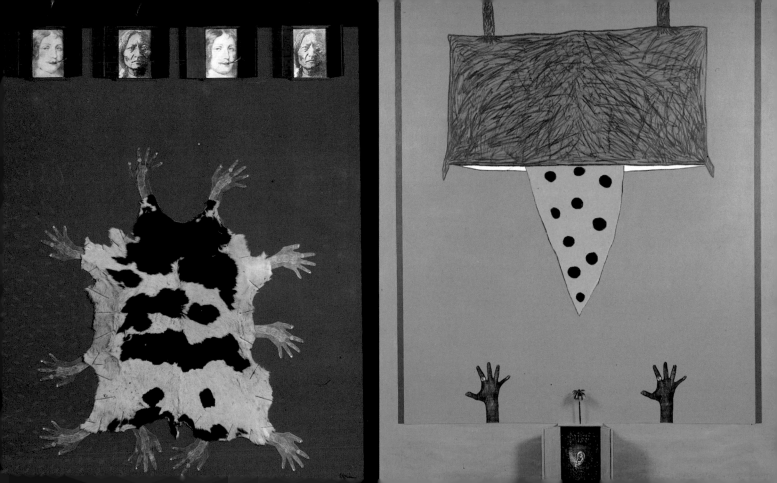

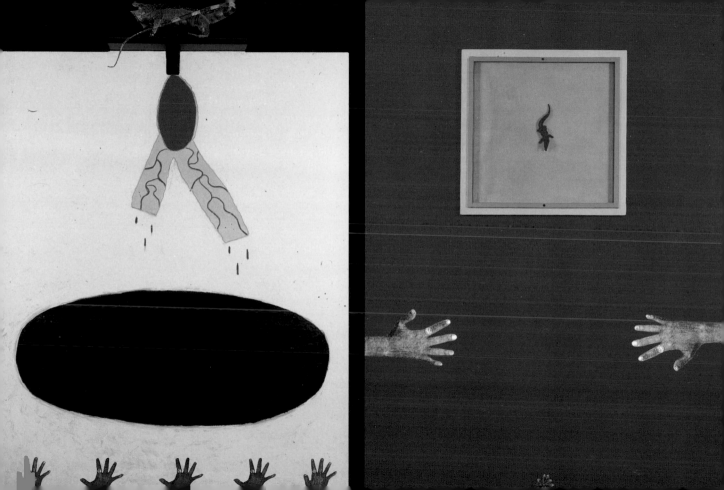

experienced that violence against myself.

– Does this account for your ability to make jokes about it?
Probably, although the experience of becoming a woman is such a physical and bloody affair.

– Although you constantly refer to the forms of popular culture in your work, there is this sense that you were in some way removed from that as a child.
I guess I'm near to it, but not that near. I do feel more like a spectator. The people who are creating it do so in an unselfconscious way; they don't analyse it, because it's their everyday world. I see it on two different levels, I'm observing it because I'm not actually producing it but on the other hand, when I'm there I cannot help feeling completely immersed in it.

– But, despite this distance, it is still the most 'authentic' culture to you?
In terms of artistic remembrances I tend to go to the popular. When I think of what is truly authentic, in terms of an artistic tradition in Colombia, it is hard for me to include Colonial or 19th-century 'Europeanised' art – or even the pre-Colombian museum pieces, for that matter. The popular traditions, however, represent in my eyes a truer form of culture. Their means of expression are often kitsch and banal and my using them, I suspect, embarrasses some Colombians who consider these things too crude and unsophisticated.

– The 'crudeness' or banality, as well as the sensuality of that culture you describe, seem to attract you very much.
In Colombia there is a strong tradition of sentimental, popular music, mostly ballads. They are very kitschy, there are often bleeding hearts in the lyrics, and some of these I use. In the window displays and on the street stalls there are always lots of plastic decorations – animals and flowers.

– There are also the vestiges of another culture, a consumer culture, like the Coca-Cola bottle tops you've used . . .
There is a such a strange relationship in Colombia between nature and technology. Change happens very quickly in Colombia – we have gone from mule transport to the supersonic age just in my father's lifetime. As is often the case in the developing world, primitive and consumer society live side by side and intermingle: TVs in shantytowns and the poor breakfasting on bread and Coca-Cola. Popular art is a direct reflection of that. For instance, bus drivers decorate their buses with hubcaps, plastic dolls and flashing lights and street shoe polish-

ers nail bottletops into designs on their boxes, so I've always wanted to find a use for them in my own work. Although once I'm working, the choice of objects is haphazard and they become just one more element of my general artistic vocabulary.

– How do you feel in relation to the European tradition of interest in primitive art – the appropriation of popular forms, and the classification of non-Western culture as more 'natural', more intuitive and supposedly less intellectual than Western culture?
How do I situate myself in that? I admire Picasso and one of the elements in art history that attracted me early on was the position of those many European artists who had decided to draw on the primitive. It reminded me of my attitude to my culture. It made me feel that I was not that wrong. In South America, we were being encouraged to look at patterns and traditions in art that were thought of as better than our own – but yet we had so much in our backyards. So I wanted to do something inspired directly by my region. Art schools in Colombia were very academic, and most of the artists tended towards realism. We were taught that nothing new could be done until we had learnt traditional ways of working, mainly through copying. I had one tutor who said artists must paint like Raphael before they could produce anything good of their own; I would die before achieving that! I wanted to do something Colombian that went against this tradition.

– But it's not just about looking for an alternative source of visual imagery, surely? It's also to do with finding a personal direction for your work.
Again, it's that notion about going back to basics. Picasso once talked about how, at the age of 18 he was painting like Raphael, but later he was trying to learn to paint as a child again. I believe very much in that. When I went to the States, I had already formulated the position that the validity of art lies more in the contact with the primitive in us – the most basic things of ourselves. Matisse was conscious of this as well. When I was much younger I used to paint portraits, and I was encouraged to do this by my family. But I always felt that there was more to art than that. I took the position that the right direction was the search for the primitive. Not, like Picasso, whose approach was to search within more primitive societies, but by going very deep into myself – to seek out, if you like, our most basic relationship to the world. Not that you can be a child all your life, because this attitude must be constantly revised, to make it much richer.

– So it's not about the return to an innocent state?

72

No, it's about rethinking your whole position along these lines. In this technological age, even artists, maybe, are being judged from a very rational perspective. There is a level of our intellectual life that was there – probably in a fresher state – when we were children. It was probably more intuitive, but just as intelligent. Artists, poets and writers can exploit this more. But in our lives we are only encouraged to take one of two routes, the rational or the intuitive. But the latter is just as intelligent, and even richer.

– It seems as if you think we should move away from an attitude that rationalises and classifies everything around us.
That part of our brain that likes to order and to categorise can take over, simply because it's so much easier. When you face yourself with difficulty, you can force that intuitive side out. Recently in Germany I was talking with some philosophers who were saying that in seeking to explore certain kinds of phenomena they were turning to art as a means of explaining.

– We talked a little about this earlier, when I asked you if you thought that a visual vocabulary could work where language – written or spoken – may prove inadequate in trying to encapsulate certain ideas.
I think so. For example, to talk about the Tropics can be misleading, because your concept of it is very different to my experience of it, and to the reality of it. Or Violence – as a word – can conjure up very different things for those who perhaps experience it in Colombia, compared to the way I may describe it in my work. As a word, it is inadequate.

– This reminds me about what you have said about memory – that it's not always about events that happen, but often about states of feeling . . .
Even abroad I can discover feelings that I had in Colombia. There are vestiges of Europe in Colombia, and in the culture there. I've found that there are cultural attitudes that I've connected with in Europe, and that alienate me from the States.

– You seem to have implied that the relationship between your work and your native Colombia has come about via contact with certain European attitudes or traditions. The structures that you work within – your attitudes to memory, to childhood for example, are at the same time highly personal and still informed by European ideas.
From a conceptual point of view, this is probably true. I had a need to do this, and that was reinforced by those European ideas. But only in the concept, not really in the execution. I took a number of philosophy courses at Yale and became very interested in the idea of exploring myself, and some of those fundamental questions about ourselves. In that sense, it was grounded in a European intellectual tradition.

But the execution of it had much more to do with the popular way of doing things in a very direct, intuitive, rough way. I liked Picasso's approach of finding within the primitive, a source of greater value in art, his idea of going back to basics. For instance he would say that when you have five brushes you should throw away three, and if you have ten colours, you should work with only three.

– At what stage do you think you had formulated this approach?
I tried consciously to go this way at Yale. I thought it would be a good discipline for me to erase what I had done before then and find new ways of working. I put much aside in the search for something more basic.

– How does this sort of discipline work?
Well, for instance, I knew that colour came easily to me, so I put that aside and decided not to use it for a while. Instead of drawing I started cutting the forms, using collage, all to force something out of the deepest within me. I started using raw canvas, and I also started sewing (which I always hated). I think the idea of sewing was also to do with developing a more intimate relationship with the painting, getting closer to it. There is also a link with pain, I think, as with my use of pins in some works.

– Why did you begin to use photographic images as well?
I like that sort of secondary image, and the way in which it fades. When I use cuttings from newspapers, I like that grainy quality. One of the first images that I used was of the thinker La Rochefoucauld, which I reproduced onto canvas from a news cutting and sewed it onto the painting.

– I was interested in how you made the selection of objects for a work when you began something, does it begin with the choice of object and build from there?
It's never really too conscious, and sometimes it happens in different ways. Sometimes I have to sit for a long time over it, but usually it could be an object that starts everything, or it could be an idea, or a form that I have in my mind.

– At what point do things start coming together for you? Do you think you formulate what will happen before you begin?
Well sometimes it's very direct and very logical.

Magic Box with Milking Cow,
1994, 22x32x41cm

For example, I've come to the point now when I think that I want a more intimate feeling within the canvas. I want the feeling that things are coming from deep within the canvas, instead of everything appearing as positive over negative, I want the negative to come from beneath. A line, for example, will come from the form. It's a less direct way of approaching the form.

– So the line is the last thing that comes?
Exactly, so you build into it more. That is what I'm doing right now. I tend to go through the process of liberating myself from patterns in approaching the canvas. It's easy to settle into formulaic ways of doing things, and I want to force myself away from that. So although I do start with images, I'm also very conscious of these other things.

– Did these things formulate over a number of months, or years . . .
I definitely decided to stay with images, with my memories, so the baggage of images that I carry around are selected from my life.

– That leads me to ask about the way that memory functions for you. It seems that it is not simply about a distant-remembered childhood, or significant events in your life, but a complex association of ideas with objects.
It is like a vocabulary, or tools that I try and work with – the plastic solution to a work of art. All these images, not only memory but objects that attract me now, are tools I put in front of me when I work.

– So you do replenish that vocabulary, you add to it all the time. Do you ever lose things from it?
I don't lose things, but I will put them aside and not use them. But they will still be there, in the background. All the things that I use – objects and images, forms, materials I like to work with – will all go into the same pot together. Sometimes I place an object on the canvas and paint or spray around it. I like the idea of things leaving their imprint.

– Like the memory of an object?
Yes, a memory, or trace, of what was there.

– Is that the same with your use of photographs? Because these are secondary images?
I think of them as the equivalent of objects. It's a way of keeping an image, holding on to it. I have boxes of images that I want to use eventually. As soon as I start using them, they become part of the family, if you like.

– Is there a distinction between images and objects that you use in a very knowing way, and those you use in a more intuitive way? There are some images where you seem to be be making a

conscious reference to the idea of quoting from another culture – the French philosopher image, for instance, which refers to an acknowledged intellectual tradition. But with some of the other objects you use – is this just as knowing or is it less self conscious?
I intermingle both. *Lending an Ear to the Past*, for example, contains an image that I appropriated from a child who I saw drawing in a café. He was trying to copy something from a natural history book. I thought it was an incredibly strong and beautiful image. I placed it on the canvas, very big, and after that I could decide which other elements I wanted. I had decided to try and integrate my boxes into the paintings, so I placed a box below. I was also trying to use my body a lot more, trying to be nearer to the painting in a more physical way – that's why my hands are in it. I wanted to make the contrast of two planes – one at a distance from me, and another, the photocopy, where the distance is not as big. So in one way some of the ideas I use are very conscious, but then the whole thing builds up around that.

– The hands are part of you wanting something more of yourself in your work.
At least, only with my extremities! It's a way of acknowledging a frontier.

– Putting your hands in a painting is a very different presence to, for example, the self-portrait, which is about looking inwards, rather than outwards.
Exactly, it's about reaching out to my past. Lending an ear, or reaching into my memory, my childhood. There is a sense of loneliness, and reaching out for something, which is very important to understanding my work.

– Is that loneliness to do with your self-imposed 'exile' away from Colombia, living abroad as you have for so many years?
Not entirely. I think it originally comes from something very deeply ingrained within me.

– You've said how you felt your work was misunderstood when you were at Yale . . .
My time at Yale was a very important point in my life, in defining myself and my work. I had quite a tough time and had to fight to prove I was going to survive. I was constantly thinking about Colombia, because I felt very alien and out of place. I had come there very fresh, trying to do my own thing, but came across a great deal of opposition.

– How much of an interest did you have in American contemporary practices when you first went there?
The funny thing was that the work I had done

before going to the States was very flat and abstract – which was why I was accepted at Yale. But I had developed it myself, and knew very little about what was going on in America at the time. In Colombia we don't really have museums, so we were not able to see the real work, only through books and magazines. In a way we were lagging behind, but it does make you very resourceful and inventive. I think I had arrived at the same point as the Americans, only they had done it much more by relating to Europe, whereas what I knew about that was only superficial.

– What was going on there when you arrived?
I got to the States just at the end of Abstract Expressionism. Oldenburg was very much discussed at the time, and I was very attracted to his work. He was working with raw canvas – it was a time when lots of people were – but I probably didn't do it for the same reasons as they did. I had, as I said, decided to make things difficult for myself. I think it was a reaction to what happened to me at the Art School. Suddenly I was being imposed upon, much more even than in Colombia, to develop a rational approach to my work. I had always tried to make sense of my work, but I'd never had to justify it in the very public way I had to at Yale. The teaching was very aggressive, you had to defend yourself. I even remember chairs being thrown when one tutor didn't like the work of another student.

– It must have been very hard for you to integrate yourself into that environment?
I had got there at a very difficult time. I found out that there had been some opposition to my being admitted – it was the time of quotas for black students, and some members of the faculty didn't think that South Americans could contribute anything valid to American art and therefore were usurping the place of a black student. It was only the tutors I had problems with, my fellow students were what made the experience worthwhile.

– What was the attitude to your interest in your Colombian roots at Yale? Did they see it as an appropriate 'authentic' source for you to draw upon?
The tutors at school didn't see it that way – well, only as a hindrance, not as a gift, as if I had to be brought into life and nurtured into this 'advanced' culture. I have now got to the stage where I think of these differences as a positive thing, because I can be in control of it. In the States I realised that I wanted to have something that was mine, that was Colombian. Yale made

me confront things, it gave me strength.

– So you found the attitude that you came from a 'natural' society, the antithesis of modern North American culture . . .
I came across the idea that I came from a 'natural' culture, a lost Paradise. The French especially seem to fantasise about the notion of a tropical paradise, imposing that view which is so wrong. It's not a paradise. It's dangerous and violent, and can be a very hard life.

– How do you think of yourself – as Colombian first, or as Latin American?
Now I think of it, even when I was in Colombia I felt very much part of the whole Latin American idea. I guess it has been reinforced within me since I've lived abroad. One does feel that sense of cultural contact with the rest of the Continent through the language, through newspapers and, of course, the literature. When you are far away, Colombia seems so small, and the whole continent seems much more in proportion to the rest of the world.

– From such a great distance, Latin America is often regarded as a coherent, single entity by the rest of the world – to think of South American art and culture, for instance, is usually to think of Mexico. How do you feel about this?
It doesn't really bother me. I think that when you live there, you are more aware of the regional and national differences. In reality the differences aren't that strong. Unlike Europe, we haven't lived through great wars between us. Being far away blurs the differences. The coastal region I come from, for example, is very close to the rest of the Spanish Caribbean, including Panama and Venezuela, perhaps closer than it is to the interior of Colombia, to Bogota. Some areas of Latin America may identify more with the culture of Bogota, such as Argentina or Chile. The regional feelings, those emotional ties that I talked about, can be recognised in other areas.

– And you've found this when you've travelled?
Once abroad, I started meeting many more people from other Latin countries, and this contact proved very moving. Paris, for instance, has traditionally opened its doors to the exiled intelligentsia from South America, so there is a very rich cross-cultural exchange there. I have kept in close touch with Colombia, through work and family and friends; though I can't help fearing that with time and distance, those links may lose their sharp focus, grow blunter and wash away. This is why I try to return there so often.

Magic Box with 3 Locked-up Beauties, *1994, 36cm circumference, 41cm in height*

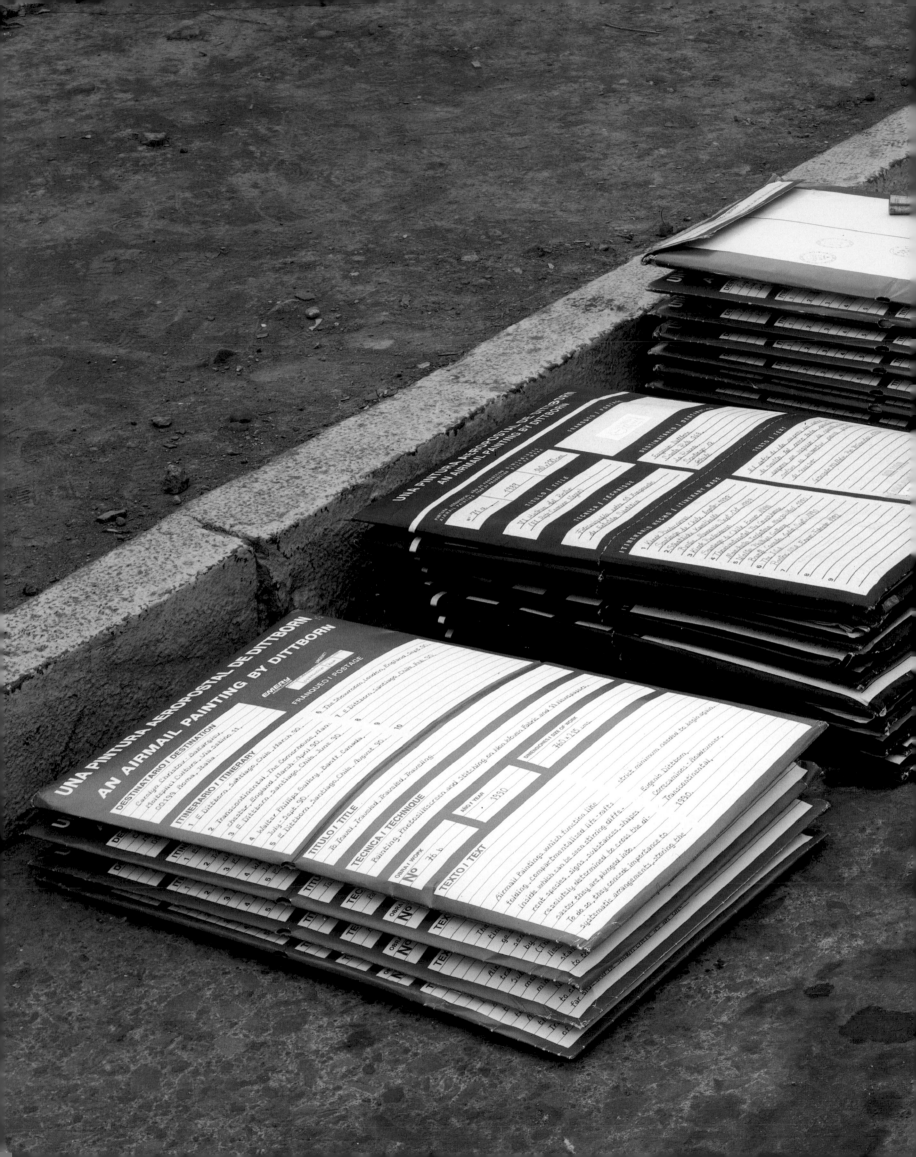

EUGENIO DITTBORN: TRAVELS ON THE PICTURE PLANE

SEAN CUBITT

Even now, after more than 20 years, the extremity of suffering in the days of the Junta is unmistakable. The wounded dove of Salvador Allende's crushed experiment in popular socialism is a symbol not only of national, but global tragedy. That extremity is not only one of depth but also of distance. The Western Left has long tried to gauge its local oppression by the measure of the distant sufferer; there was a way in which we gloried in the nakedness of the Junta, in its brutality. Each new report confirmed our diagnosis of the repressive power of transnational capitalism. There, we could say, one sees what they are capable of, what the world is like. We told you so. The terror in Chile gave us a perverse delight because it seemed to prove what we suspected all along. Their sufferings guaranteed our rightness.

Solidarity of the kind we could offer had everything to do with our own ignorance of what had occurred and why. Only the bare bones of history showed through the X-ray vision of geographical distance. All we could share was the fear, all we wished was to plunge ourselves deeper into the darkness of what the new empire could do in torture and despair. We looked to Chile to teach us suffering, but all unhappy families are unhappy after their own fashion. No two moments of pain are ever the same, or even commensurable. There is no yardstick to compare the moment of bereavement with a poke in the eye or the end of a love affair. Our profound and, I think, honest desire for solidarity failed because it would not recognise either the sheer difference that distance imparts to experience, nor the real proximity of the coup in Chile to the political and economic life of our own countries. If we are to take the notion of a global culture seriously, we must be ready to accept that all that unites us is the dark tide of exhaustion and extinction. Yet that is what divides us as well. There are no common judgements and no common measures, but there is still the necessity to communicate, since, in our lack of happiness, we cannot be content with our own company, reaching out, instead, to those others, close or far removed, with whom we are intertwined in a network of mutual dependency.

The premise of distance is a founding moment of Dittborn's work. This can be seen most

December 1992, 3 Airmail Paintings in envelopes in a street in Santiago, Chile, 3 months before leaving for the Institute of Contemporary Arts (ICA), London. Recently returned from journeys to Kassel, Boston and Rome, between May and November 1992. They comprise: Liquid Ashes, The 6th History of the Human Face *and* To Travel

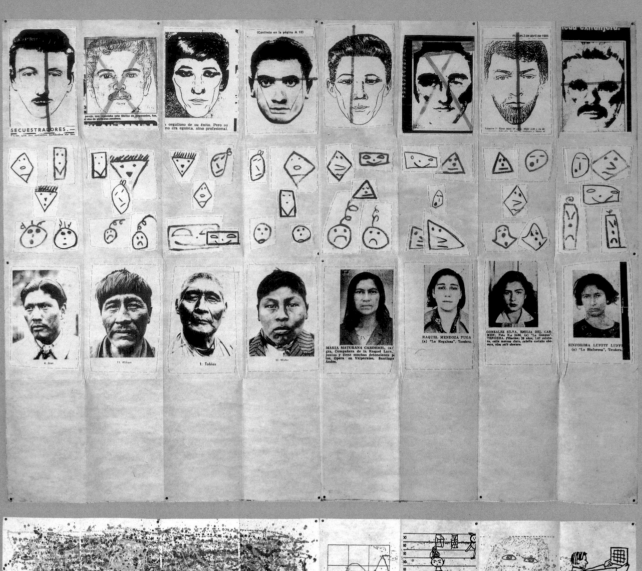

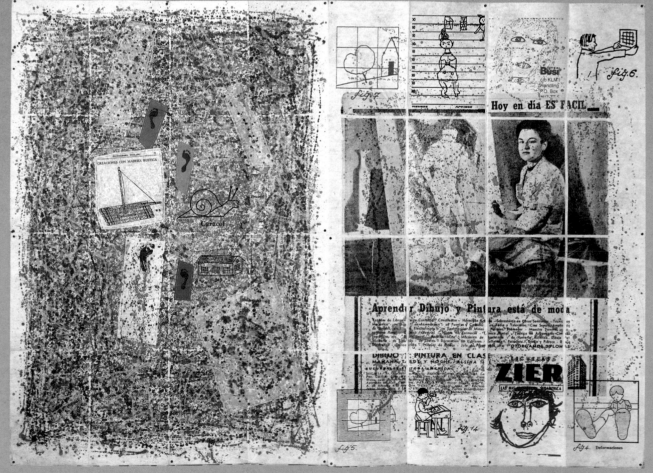

profoundly in the series, *Airmail Paintings* with which he has been concerned since 1984. Initiated as a way of maintaining contact with his friend and contemporary, the artist Juan Davila who had moved to Melbourne, Australia, the earliest *Airmail Paintings* compiled paint, silkscreens, found objects and stitching on a ground of ordinary brown wrapping paper. Folded and packed in envelopes, the paintings were mailed from Santiago, where Dittborn was born, lives and works. Two comments from a few years earlier illuminate Dittborn's use of silkscreen: 'I think the concept of serialisation is a fraud given the limited nature of publication here' (Luz Donoso), and 'Engraving has acquired the same category as painting: the structure of a single object' (Eduardo Vilches, both in *Cuatro Grabadores Chilenos*, Ediciones Cromo, 1977). As Nelly Richard observes (in her essential text on the Chilean *avanzada*, 'Margins and Institutions: Art in Chile Since 1973', *Art and Text*, no 21, Sydney, Australia, May-July 1986), the use of the serigraphic technique marks a departure from the expressive myths of paint-handling and the folklore of craft, but at the same time, each work, each recycling of an image, takes place in an unique setting, an uncommon combination with other imagery that cycles through the series. At every new surfacing, the 'same' image demands a new form of looking, the combination with others a renewed assault upon the homogeneity of vision.

If the Pinochet regime enforced with brutal certainty the positive conviction of its own supremacy, and announced as positive its ordering of social and cultural life for the *avanzada* (the group of avant-garde artists and writers including Richard, Davila and Dittborn), it was also the case that the opposition from the Left provided no more than a negation of that particular positive. From their perspective, local Marxists could refuse at every point the tyranny of the military, but they could not offer – and politically perhaps were debarred from offering – any way of comprehending and disputing the actuality of the life that had to be lived through those dark years. Dittborn's actions, videos, graphics and installations unearthed archeologies of oppression and evidence of impending dreams of better worlds. They enacted the seepage of bodily fluids in grand allegories in galleries and, in one famous instance, on the body of the landscape, when he poured hundreds of gallons of oil into the desert sands: a counter-ecological piece of land art that recognised the relationship between population and land, land and body, and the violence done to all three.

The allegorical figured powerfully in Chilean art of the *avanzada*, and not simply because of the necessary masking of revolt under the regime. It is one of the key characteristics of Modernism that it has redeployed allegory, a redeployment argued in detail by Walter Benjamin in pre-war Germany, covered over and denied in the canonical writings of Clement Greenberg in post-war New York, and claimed as entirely new by apologists of the Post-Modern. However, for Dittborn and his contemporaries, the allegorical mode offered ways of reclaiming the link between art and signification, art and meaning, art and its audience, that has so defined the modernist project in art. Their work used allegory as much as a method for avoiding sentiment as for coded communication and for the advancement of a distinct set of communicative protocols as for the making of statements. Their work, in short, dealt as primarily with the materiality of production as the work of Beuys, and as intensively with the conceptual armature of art practice as the sculptures of Sol LeWitt.

What Dittborn's allegory recognises and develops as a strategy is the simultaneity of the object itself, the work of which it is made, and the complexity and mutual contradictions of the many-layered responses that can be made of it. If the Baroque allegory was an attempt to anchor meaning in iconography, the modernist allegory is a way of setting it free. The High Modernism of Greenbergian aesthetics is not central to Modernism as a whole: it is a detour which ironically constructs a cul-de-sac for painting. In its cult of the signifier – of the bare materiality of the work, of its sheer presence in space – it attempts to foreclose the space of the viewer, offering only the instant and the perpetual present of the aesthetic moment. In its own way, it continues the Baroque attempt to subject signification to power, the power of authorship, of the code, or the work in itself. But Dittborn's work continues a different modernist trajectory, one which concentrates on ambiguity, multi-layered meanings, the polysemous productivity of the work of signification. Although Greenberg can be mistaken for a materialist, his essentialist notion of the medium, in abstracting the signifier from its history and hence from its audience, removes significance from the sphere of interpretation.

Dittborn's Modernism relies on the observation that making signs is only the beginning of a work's history: it continues to live through the many readings that its allegorical nature makes available to subsequent viewers. In this way, Dittborn's paintings exist in history, in time, and recognise as the condition for their existence as work, an audience, which is something far more than the still point of aesthetic consumption. His work is time-based because it speaks from a specific time and to many other specific times, just as it is geographically-based in speaking from one space to many other spaces. His work is spatio-temporal, a moving allegory of dis-

OPPOSITE, FROM ABOVE: The 7th History of the Human Face (The Scenery of the Sky), *Airmail Painting No 78, 1989, paint, charcoal, stitching and photosilkscreen on 2 sections of non-woven fabric, 215x280cm. Itinerary: 1990 Santiago (Chile), Birmingham (England); 1991 Buenos Aires (Argentina); 1992 Seville (Spain), Paris (France); 1993 Cologne (Germany); 1993 Rotterdam (Holland); The Gloom in the Valley, Airmail Painting No 74, 1989, paint, stitching and photosilkscreen on 2 sections of non-woven fabric. Itinerary: 1989 Santiago (Chile), Sydney (Australia); 1990, Melbourne (Australia), Canberra, (Australia), Adelaide (Australia); 1991, Buenos Aires (Argentina); 1993, London (England), Southampton (England), Rotterdam (Holland); FROM ABOVE:* The 6th History of the Human Face (Black & Red Camino), *Airmail Painting No 71, 1988, photosilkscreen on 10 sections of non-woven fabric, 210x1400cm. Itinerary: 1989 Santiago (Chile), Berlin (Germany); 1990 Manchester (England), Banff (Canada); 1992 Boston (USA); 1993 Southampton (England), Rotterdam (Holland); 1994 Wellington (New Zealand);* The 13th History of the Human Face (The Portals of H), *Airmail Painting No 95, 1991, paint stitching and photosilkscreen on 10 sections of non-woven fabric, 210x840cm. Itinerary: 1991 Santiago (Chile); 1992 Antwerp (Belgium); 1993 London (England), Southampton (England); 1993 Rotterdam (Holland); 1994 Wellington (New Zealand)*

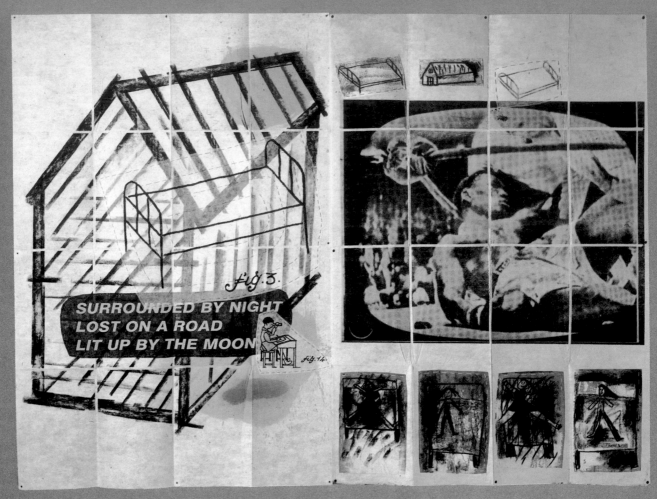

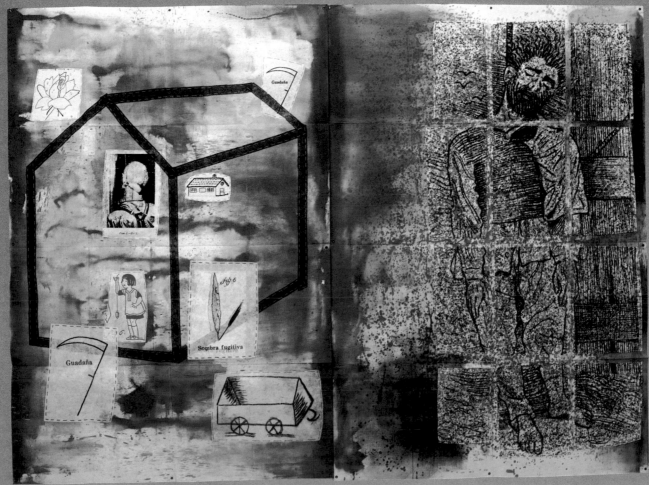

tance and change, difference and interpretation. In this way it is historical. This historical aspect of Dittborn's work is not simply in the content; the whole conception of the *Airmail Paintings* is founded in the distances – historical, geographic, temporal – that divide the metropolitan from the post-colonial, the American from the European; and which structure the 'transperiphery', the flow of image, art and communication between the areas of the work excluded from the self-assumed centrality of the West and its art capitals. The *Airmail Paintings* in their journeying perform a vast act of writing across the globe, a writing whose very ephemerality stitches them into the fabric of history. For there is a moment in any long-distance flight when you no longer think of what you have left behind or of what you will discover up ahead. For that fatal moment, suspended between heaven and earth like the engraving of the hanged *campesino* (*Campesino ahorcado por los latifundistas*) by Jose Guadeloupe Posada, which reappears in several of Dittborn's works, you are a traveller, neither at home nor abroad, but held entirely within the invisible avenues of the airways, cradled in the roar of the engines, indubitably alone but entirely dependent upon a work over which you have no control but which exists only to transport you. It is the space between, the time of difference, the vanishing point of geography, the lonely moment of the last instance that never comes and lasts forever. It is a kind of paradise.

Each work of Dittborn's endures this solitary eternity of the freight compartment, mailed from Santiago to scar the globe with the ashen trajectory of its passage. That stolen time becomes a mode of writing, as all writing is a record of time disappearing and an act which celebrates the sacrifice of time to the action of making. To travel is, for Dittborn, to mark the changes that distance traversed brings with it, to mark as surely as ink marks a paper. The mailing and journeying of the works is an act of making and an act of hope, since it presumes an arrival, a future. Like writing, like any 'graphy', it erases its own past as its procedes in order to assure the existence of a future. In this way, Dittborn's work denies the eternal present of Greenbergian Modernism in favour of the materialist Modernism of Benjamin, formed on the model of the present as only, always, the narrow gate through which the future (Benjamin's Messiah) must arrive.

At destination, the work is unwrapped, unfolded, hung where life is, again, though differently, denying its journeying but bringing, like a tattered postmark, the shrivelled evidence of that missing time spent in the Utopia of the aircraft's hold, a zone whose Utopian aspect is that it has no human attributes, although it is entirely ordered by human hands. It has passed through the unhuman to become more powerfully a stranger, an alien at its point of arrival. For these great pleated sheets are merely human. Packed with words, symbols and materials that insist on making sense, despite the problem of translating them, they hang softly but their words and faces, reproduced, murmur subversive messages to each other in forgotten tongues. Each mark, each piece of stitching, comments on and reinterprets its neighbours, just as each object caught here – faces found in prints and photographs or scribbled in dentists' waiting rooms, sketches from drawing manuals, engravings and texts, feathers and inks and textiles – reinterprets its own history in the new context of the painting. In the same way, each new gallery provides a new context for the reinterpretation of the work itself.

As a prolonged musing on the nature, the mystery and the ordinariness of our need to represent, these works promote an audience's reflections not simply on how to interpret this work, but on the very processes of interpretation themselves. What is it that allows us to make sense of a screened image, taken from a photograph reproduced in a magazine of the 1930s, and used to identify wanted criminals, at a point thousands of miles and 60 years away? Certainly, and without question, they tell us of the impossibility of knowing the person whose face somewhere, once, gathered the light about it that in all its journeys, has reached this retina at this hour. In that sense, certainly and without question, it tells me of the absence of a final knowledge, the unavoidable travail of interpreting that cannot come to the end of its exegesis. But it also speaks of many things that evoke, stimulate, require interpretation, just like any allegory. The faces, quotations and drawings cannot stand alone: they stand upon the work that we must do. Their distance is temporal as well as spatial, and is included in the movements they have made from medium to medium, audience to audience, to reach us.

For interpretation too is a journey, a travel along well-worn or alien paths, travelled hopefully, never, finally, to arrive. For a certain stand of European thought, interpretation, the mutual interpretations and misunderstandings of communities as they try, in an age without ethical or aesthetic norms, to come to an understanding is the very fabric of history. To speak, to listen, to dispute, is to be a part of history, to enter into its processes. But what can we begin to say of this communicative community in the age of globalisation?

Edward Said is not alone when he argues that the West defines itself (negatively) by drawing endless distinctions between Itself and its Others, the communities which it excludes or which

FROM ABOVE: Pietá (the Canvas, the Count and the Madison Square Garden), *Airmail Painting No 97, 1991-92, paint, charcoal, stitching and photsilkscreen on 2 sections on non-woven fabric, 210x280cm. Itinerary: 1992 Santiago (Chile), Seville (Spain) 1992-93 Paris (France); 1993 Cologne (Germany), Rotterdam (Holland); If Left to its Own Devices, Airmail Painting No 75, 1988-89, paint, embroidery, stitching and photosilkscreen on 2 sections on non-woven fabric, 203x280cm. Itinerary: 1989 Santiago (Chile), Sydney (Australia); 1990 Melbourne (Australia), Canberra (Australia), Adelaide (Australia); 1993 Rotterdam (Holland); 1994 Wellington (New Zealand)*

exclude it (indigenous peoples of colonised countries, Islam, black femininity . . .) The question, in one sense, is as banal and as fruitless as the question of translation: is it possible to read the poetry of a foreign tongue? But it is also a question of power, of the centrality of English to world power and global economics, of the necessity for English-speakers to hasten the inevitable break-up of their language, like Latin before it, into a thousand new tongues. Dittborn's use of English and Spanish texts together begins a simple, effective, inescapable dialectic, for there is no Chilean language as such: not since the colonists destroyed the indigenous Indians of Tierra del Fuego. In a conversation with Adriana Valdes, Dittborn argues that 'texts from Latin America cannot be translated. In them one is constantly burning what one has said and suggesting what will never be said', ('A Whiter Shade of Pale: Conversations between Adriana Valdes and Eugenio Dittborn', *Mapa: Airmail Paintings, Eugenio Dittborn, Pinturas Aeropostales,* ICA, London/ Witte de With, Rotterdam, 1993). What I think is at stake here is not a definition of identity, but a re-definition: a refusal of identities invented in the West, of even those identities that the Western eye might seek in texts originating in Latin America. There is no authenticating source at the origin of Dittborn's works which controls and defines what has to or can be said.

Dittborn's carefully chosen words to Valdes indicate that the place of the work is in the present: between the smouldering ruins of the past and a future that is, by definition, unknowable. In this sense, the works are work, actions undertaken in the only place where action can happen, in the present. Of us they demand an attention to the present as a moment, not of Greenbergian contemplation infinitely extensible into the future and the past; but of making, making art or making meaning. The thing that will never be said is indefinitely postponed, like the arrival of the *Airmail Paintings*, forever in the future. Like the identity anthropologists and tourists seek, that moment at which language and truth meet is not concealed, it simply does not exist – not, in any case, yet. This endless deferral provides some sense of what is at stake in the making of a global culture.

For the meeting of disparate communication patterns is never innocent, just as this writing and this special issue are not and cannot be innocent attempts to gather whole and disparate traditions around the mythological table of negotiation. Some of those present at any international meeting are more present than others. The problem of translation is also a political problem (if we take politics to be the domain of power) and an economic one, but it is also a question of time. Translation, whose

origins lie in the Latin words 'to carry over', is a matter of journeying, of removal from one space to another. In that journey, something unrepeatable is performed, something that cannot be undone, something belonging to life, which is unrepeatable, not theatre, which is. To think globally is a different process if undertaken in an ex-colonial regional capital or in a world-city like London, New York or Paris. In his work, Dittborn manages to act locally twice, once at the point of making and sending, and again at the point of arriving and interpreting. Locked into the work is the very difference that makes the translation both necessary and impossible, a translation from Santiago to London that is already part of the burnt-out past, a brief stay that denies the possibility of any complete knowledge, deferring it into the future. This translation is an expanse of time, and an experience of that time, as distance in the presence of the work.

The Posada engraving recycled in, among others, *If Left to Its Own Devices*,1989, is itself already translated from Mexico to Chile, a distance greater than that between London and New York, and across 70 years, the gap between us and, say, the Tatlin tower. This unkind death, brutal and unnecessary, is overlaid on a sheet of the non-woven material that Dittborn favours for his paintings, a white, porous, pressed fabric used to stiffen jackets. The material is itself marked with spots and dribbles of paint that have soaked into the fabric itself, colours not floating free, like Pollock's drip paintings, but colours that impregnate the ground. Posada's image, treated heavily, is cut into sections that are stitched onto the main sheet, itself stained, like the clothes of a man who has died, stained with the secretions of his life and his death. In the bottom corner, where his feet touch ground, another panel is stitched on where a little girl holds a plumb line. Suspended as his body is, the plumb line speaks of another world, a world of science, of building, of reason turned to the construction of homes, like the model bungalow embroidered on a further tacked-on panel. Other elements include a doodle of a pretty girl, scribbled out; a medical photo of a skull deformity with numerical annotation; another version of the Posada print, this time with shorter hair and beard (an 'earlier' view of the same figure, hair and beard having grown after death?). The memory of home, the erasure of sexuality, the medical specimen, the prospect of modernisation as memory is erased, and opposite, on another sheet, spattered with inks, a caricatural cow's skull by a cartoon cactus. Is this a repertoire of Western images of Latin America, a specimen of suffering and its forgetting, of a cartoon summing up the victimology and harmlessness of a continent? And then again, are the

crows over the hanged man's shoulder memories of Van Gogh's last cornfield, the splattered colours of the abstract expressionist search for manhood and selfhood? Is this a commentary on the deaths of the painters, Pollock and Van Gogh, the archetypes of the tragic artist? Is the hanging metaphor for the hung work pinned neatly over the alien walls? Are these stains the traces of a body, the painter's, that is no longer there, his art only the illusory life suggested by hair that keeps growing after death? What journey is necessary for this art to exist? The journey into death? Is the death of the artist the precondition for the life of art? And what of the viewer's mortality? Is that too the necessary premise of a representation of America as a lifeless and expiring desert?

I do not know. The things which I find in front of me are assembled, their iconography so dispersed and the links between them so limited to their encounters on this crumpled plane that I am driven to make up stories that will draw them into a whole. That, at least, is the critical tradition in which I have been raised: that interpretation is a matter of uncovering the hidden unities in a work of art. Yet these are not unities but dispersals, and though each element of the *Airmail Paintings* arrives in the same place, their journeys here can be thought of as threads entwining on their travels but still distinct, still bringing with them the specificities and distinctive qualities of photo, graphic, embroidery, doodle, engraving cartoon and stain. Nothing in the end stitches them together except the ways in which, because of their very distinctions, I am stitched, sutured into the fabric myself, forced to travel across its surface in pursuit of that unspeakable word which cannot be voiced, the truth that cannot be possessed, the identity that cannot be discovered. The death of the artist is also the death of the investigating critic, dissolved into the thread that stitches him into the fabric of the art, moving continually from broken-backed hypothesis to defeated reading, never being allowed the still point of concentration with which art in the West has so favoured us, as the pinnacle of aesthetic delight.

Dittborn's work is not an 'expression' of Latin identity or even of an experience of it. Its essence is displacement, not only of the work in geographical space, but of the suspension of identity between earth and sky, between going and coming, between body and picture, a perpetually unstill voyage. That this voyage is also the coming and going of the colonial world, a history of voyages from the conquistadors to Charles Darwin's Beagle, the pioneer flyers of the airmail service to the jetliners of the international elite, the to-ing and fro-ing of letters, gifts and dreams from one place and time to another, voyages never completed, circular trips that spiral endlessly outwards, and journeys from a periphery which is central to a centre which is itself decentred in the act of contemplating the Other that once secured its own identity.

In the series, *Histories of the Human Face*, the fragmentary evidence of the problem of identity is constant. Identikit and photofit invent the faces of criminals. Elsewhere, anthropological photos of the last Indians of Tierra del Fuego gaze impassively, proudly, warily, into the lens that captures their extinction. 1920s magazine images of wanted criminals with notes on their crimes glower. In counterpoint, Dittborn's daughter's rudimentary sketches of faces trap the moment at which we learn to represent even that most iconic, that most personal of visual symbols, the face. For all of these faces, the histories are not only of the face but of how it is represented, and how those representations build on an image not of their subjects but of the people looking on. Only the least recognisable, the least identifiable, are innocent; the ones in which the lineaments of their making is more intriguing than the pretence at capturing, in regimes of power, the identities presumed to be forever caught in our constructions. Displacement becomes escape, identities that were never single and unified fleeing in perpetuity all efforts to hold them still. Dittborn's work has enormous lessons for those who would wish to fix an identity on that vast population which is Latin America, lessons concerning the abuse of power and the limitations of its technologies. But even more, it has lessons too for the attempt to see, in the mirror of this practice, an identity which is ours, the identity of the unseen commentator gathering the Americas into the artifice of the European hegemony. This work, this travelling, can destroy the European mind.

To Return (RTM), *Airmail Painting No 103, 1993, paint, stitching and photosilkscreen on 6 sections of non-woven fabric, 420x420cm. Itinerary: 1993 Santiago (Chile), Rotterdam (Holland); 1994 Wellington (New Zealand)*

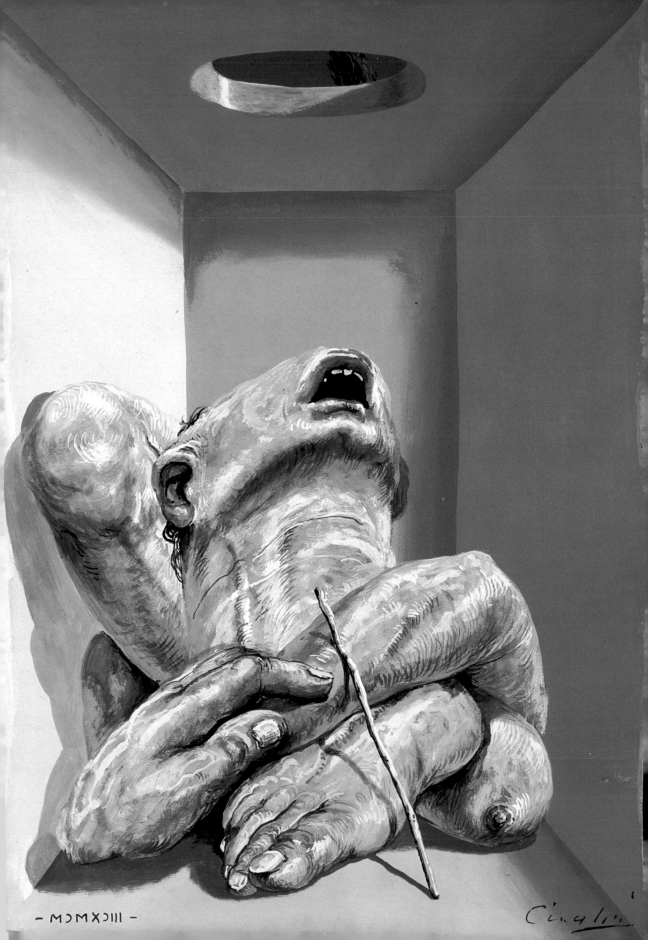

- MDMXDIII -

RICARDO CINALLI

EDWARD LUCIE-SMITH

Ricardo Cinalli is a young Argentine artist whose work offers a different and perhaps unfamiliar perspective on the Latin American sensibility. Critics have often been guilty of trying to impose preconceived stereotypes on the various art forms which have developed in Latin America. While admitting that these forms necessarily draw upon widely different cultural sources, European as well as indigenous, they have often, for example, tried to impose a norm based on a specifically Native American ethnicity. In other words, they have constantly sought roots in the various Pre-Colombian cultures which existed in the Americas before the arrival of European conquerors and settlers.

This tendency has been abetted by leading Latin American artists and in particular by the leaders of the Muralist Movement in Mexico. The irony here is the fact that the cult of the Indian, seen as the innocent and deeply-wronged possessor of a Pre-Hispanic Eden, is itself essentially a European invention – the product of the 18th-century Enlightenment in its second, more emotional and sentimental phase – the phase associated with the name of Jean-Jacques Rousseau rather than with that of Voltaire. The ethnocentric or indigenous model does have some plausibility in Mexico, in the Andean republics and perhaps in Brazil, but it seems inappropriate when it is applied to the art of other Latin American nations, especially Argentina, the vast majority of whose inhabitants descend from European stock.

Cinalli's extraordinary visual inventions read like a commentary on aspects of this situation, even though he has chosen to live and work in London, whilst making frequent forays to Latin America. The main building material for his compositions comes from the standard repertoire of classical forms. For example, two decorative compositions on a large scale, carried out for the headquarters of British Petroleum in Hemel Hempstead, feature tumbled antique fragments, heads and limbs of colossal Greco-Roman statues, fallen columns, antique sarcophagi and fragments of Cyclopean masonry. These are the materials which contributed to the *capriccio* landscapes of the 18th-century French painter Hubert Robert, and which were used in some of the most ambitious compositions by the Venetian draughtsman and engraver, Piranesi.

However, if one looks for a directly Argentine parallel, one can find it in literature rather than the visual arts: for example, in some of the stories of Jorge Luis Borges.

Perhaps because the murals just cited are a form of public statement, Cinalli's imagination is comparatively restrained in this field. The idea of fragmentation is pushed much further in works from his recent *Blue Box* series. In some of these, tumbled body-parts are seen heaped up in a kind of niche, which also functions as a stage (in the sense that it offers an area in which various roles can be enacted). In one especially striking work from this series, the body-parts just mentioned are accompanied by a dismembered Corpus Christi, which floats in mid-air with its back to the spectator.

Several comparisons can be made: to Salvador Dali (his Christ of *St John of the Cross* as well as the works of the mid-1930s); to Giorgio de Chirico; and also to Gericault's terrifying still lifes of dismembered limbs. The antique references which form the main theme of the murals are also present, but intermingled with others: from the Counter Reformation Catholicism which supplied some of the impetus for the Spanish conquest of the New World, to the wilder excesses of early 19th-century Romanticism. What one sees in this work is an embodiment of the cultural clashes so typical of Argentine intellectual life.

Argentina looks not to some mythic Pre-Colombian past, nor (however reluctantly) to the United States, but across the Atlantic to Europe, and specifically to European cultures which are descendants, in some way, of ancient Greece and Rome. Classicism is intimately part of the Argentine heritage.

On the other hand Argentine artists are also conscious – how could this be otherwise? – that they are part of a nation of immigrants, recent immigrants at that. The crucial decades in the creation of modern Argentina came at the beginning of the present century, when the population balance was transformed by a flood of new arrivals, most of whom crossed the Atlantic between 1905 and 1910.

Looked at in this light, the *Blue Box* paintings take on additional symbolic force. Here are specifically European fragments tumbled together in an alien and alienating setting. The

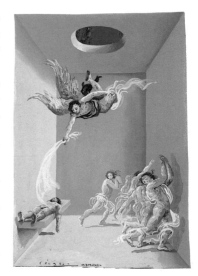

OPPOSITE: Blue Box *theme*, The Human Landscape, *1993, tempera on cardboard, 65x48cm; ABOVE:* Blue Box *theme*, Series I: Dreams, Wednesday, *tempera on cardboard, 65x49cm*

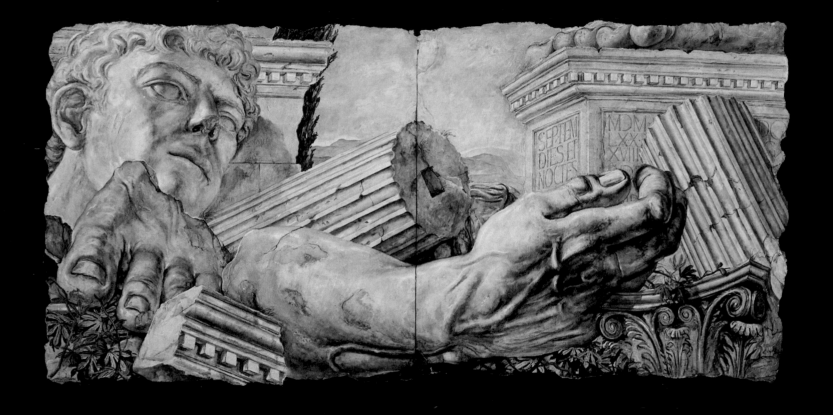

Corpus Christi, back deliberately turned, is a reminder of the strong influence of Catholicism; it also speaks of the fact that religion has nevertheless failed to heal the divisions in Argentine society. Christ looks down in pity at the mangled limbs heaped below, but is powerless to offer help. He Himself, the image tells us, is brutally divided.

The *Blue Box* series contains several groupings. In addition to a sequence showing dismembered limbs, one of which has just been described, there is another, entitled *Dreams*. In these the box, niche or stage-setting (in this case, the last of these seems the most appropri-

ate term) is filled, not with huge, out-of-scale forms, but with tiny figures. In *Dreams: Wednesday*, a male figure lies on a bed to the right of the stage, while a hovering angel pulls a sheet from his nude body. On the right-hand side, other male figures attempt to flee, hurling themselves against a wall.

Once more, there are insistent reminders of other, earlier art works – all of them European in origin. The agitated figures within a confined space suggest a comparison with De Chirico's *Gladiator* series of the 1920s. There are also much earlier sources, including Spanish 17th-century religious art, in which the ecstatic

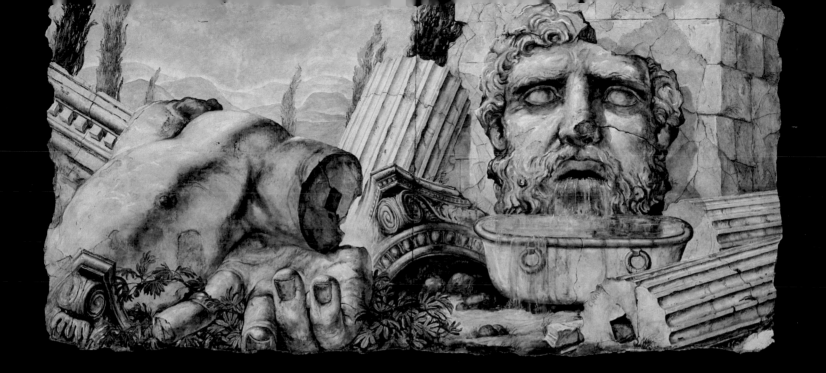

visions of the saints are a frequently attempted theme; the *Caprichos* and *Disparates* of Goya; and Jacopo Pontormo's *Joseph* series – the best-known painting from this is in the National Gallery, London.

Pontormo, who is the least obvious source, seems to me in some ways the most important. It is from him that Cinalli has derived not only the male figure type, but the feeling of unease which pervades the whole composition. The grotesque element one associates with Goya's prints is, by contrast, absent.

This is perhaps the moment to revert, yet again, to the notion, so insidiously planted by Andre Breton on his visit to Mexico, that Latin American art, where it is not indigenous, is 'naturally Surrealist'. Cinalli has not been able to escape the influence of Surrealism, which has affected several generations of artists in Latin America as much as elsewhere. In seeking comparisons for his work, I have cited the name of Salvador Dali, and also of Giorgio De Chirico whose *pittura metafysica* is often cited as Surrealism's most important predecessor – even more influential than the Dada of Marcel Duchamp and Francis Picabia. Nevertheless, other influences (pre-moderns ranging from Pontormo to Piranesi and Gericault) are of equal importance.

Untitled, *1991, fresco, oil on plaster, 600x300cm, for the British Petroleum Headquarters in Hemel Hempstead*

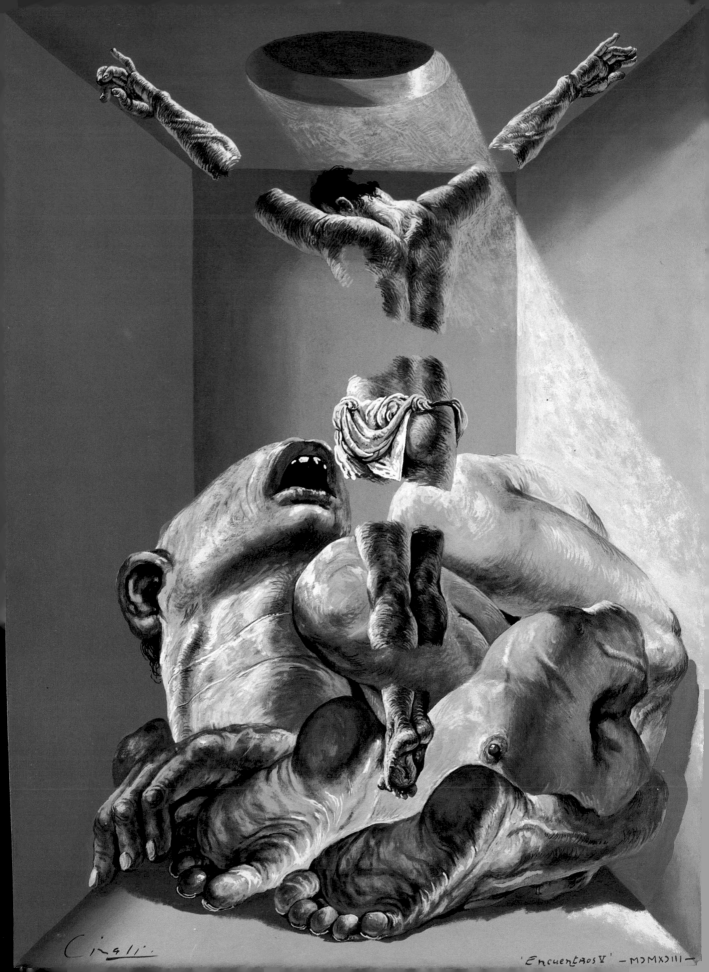

Cinalli embodies one of the most important, and it seems to me least noticed, characteristics of contemporary Latin American art, and this is one reason for choosing to write about him. I am speaking of its power to telescope accepted historical perspective.

If one pauses to consider the Latin American situation for a moment, one can see that this is absolutely logical. The transference of European culture to the New World is a textbook example of a violent *ruptura*, a break in historical sequence. In its present guise, Argentina is a very new nation – much younger, for instance, than the United States of America, whose constitution was formulated at the end of the 18th century. The successive waves of immigrants who created modern Argentina arrived, as all such immigrants do, with a load of cultural, as well as purely physical, baggage. This tumbled pell mell onto the shores of South America in addition to the possessions they had managed to bring with them. However, unlike the tangible objects which the immigrants had transported, their intellectual baggage was transformed by its passage across the ocean. For the first time it had to be defined and qualified with the adjective 'European', meaning that it was something from there, not something from here, the place where they now stood, and where they intended to make their lives. This newly sensed 'Europeaness' tended to take precedence over other characteristics which once might have seemed more important – in particular the sense that cultural ideas and events were arranged at fixed, well-understood intervals along a set line of development.

The ideas of the Counter Reformation, those of the 18th-century Enlightenment and those of nascent Modernism were suddenly jumbled together, fragmented by the accidents of the voyage and the stresses of settling in. Each was as vividly present as its neighbours; all were things to be clung to as continuing proofs of European identity.

It is this intellectual sea-change which Cinalli has seized upon, and which he now analyses and presents to his spectators with hallucinatory vividness. He has, like many Latin American artists of the past two decades, not been content with conventional formats, but has also done a considerable amount of installation work. There are a number of reasons, I think, why installations and environmental art in general have become such a typically Latin American means of expression in the course of the

past two decades. Among them is a certain innate theatricality. More important, however, is the sense that the truly effective artwork has both a public and a purely private identity. In environmental works, the balance is weighted towards the public aspect. Such works are essentially populist. They make the assumption that the work of art can be a public space, temporarily inhabited by those who come to visit it. The barrier between the work and the spectator is deliberately broken down – at least in a purely physical sense.

Cinalli's installations show his usual care for craftsmanship and are always beautifully thought thorough and calculated, showing a particular penchant for optical paradox. Thus, he often uses reflecting pools in order to present 'right way up' images, which in reality are upside down. In an installation of this type, the ghostly image in the pool, though at the mercy of any splash or ripple, seems more solid and 'real' than what has actually depicted. The work is, so to speak, demoted by the presence of its more easily read double, and it is itself read as merely a reflection, magically projected upwards from the shining surface of the pool.

If one considers for a moment, one can see that an installation of this type is a thoroughly Borgesian conception, an invitation to enter a visual labyrinth. Since the motifs Cinalli uses in these circumstances continue to be 'classical' – battered heads and gigantic fragmented limbs – the installation, for all its undoubted decorativeness, also acquires a moral dimension, in that it affirms the importance of the European past and then subverts it by suggesting not only that it is now in ruin, but that in reality, it is no more than a mirage.

A good reason for choosing to write about Cinalli – though perhaps at the moment an unfashionable one – is the seductive charm of his work, and the high degree of virtuoso skill displayed in it. Another, it must frankly be said, is the opportunity to strike at least a minor blow at the stereotypes which Europeans, North Americans and even some Latin Americans have recently tried to impose on Latin American artists, and perhaps through them on the whole of Latin American culture. The vastness, variety and vigour of Latin America all find a reflection in the contemporary visual arts. This art can be inventive and typically Latin American – an echo of situations peculiar to Latin America and not found elsewhere in the same form, without paying homage to indigenous shibboleths.

OPPOSITE: Blue Box *theme,* Untitled, *tempera on cardboard, 70x50cm; FROM ABOVE:* Inversion II, *1990, oil on wood, 350x350cm, steel plate polish 350x350cm;* Inversion III, Encuentros *theme, 1992, installation in artist's studio: fresco, 350x300cm and pool of water, 300x300cm*

M. FREIRE·75

PUTTING LATIN AMERICAN ART ON THE MAP

GABRIEL PEREZ-BARREIRO

The foundation in December 1993 of the University of Essex Collection of Latin American Art (UECLAA) marks the culmination of a growing interest in Latin American art in this country. The extraordinary success of UECLAA took even its organisers by surprise, the surest sign that it was time that Latin American art had a solid base in a public, university collection in Britain. As Dr Valerie Fraser, Executive Director and founder of UECLAA has pointed out, a mere couple of years ago the project would have seemed impossible.

In autumn 1993, Charles Cosac, a PhD student, donated an oil painting – *Memória*, by Siron Franco – to the University of Essex. This painting made the Collection of Latin American art a real possibility. Siron Franco is one of Brazil's most famous artists and as the founding donation, his work set the highest standard for subsequent donations. Siron Franco's association with Essex is to take a new step with the preparation of a major book on his work by Professor Dawn Ades, Director of UECLAA. *Memória* was the centrepiece of a ceremony to inaugurate the Collection in December.

The next step was a visit by Marcos Curi and Roque De Bonis from Argentina's Museo de Arte Contemporáneo (MAC). Within three days of first hearing of the project, four works arrived in London from the MAC by the artists Remo Bianchedi, Oscar Curtino and Luis Scafati. In many ways it was wholly appropriate that a link should have been set up with this museum in particular. Founded by the private initiative of Marcos Curi in 1977, the MAC has grown under his directorship and De Bonis's curatorship to be the finest collection of Argentine art from 1960 to the present day. Being a private museum, the MAC has steered clear of the monumental bureaucracy familiar to any visitor to Latin American museums, and has been able to conserve the coherence of a private collection. In 1973, Curi started to move away from his interests in European old masters and antiques and began to exchange what he had collected for Argentine works by artists of his generation. He converted an old chemical laboratory into his home and permanent display area, enjoying the experience of living amongst masterpieces by Jorge de la Vega, Ernesto Deira and other giants of Argentine art.

When they left London for Buenos Aires, Curi and De Bonis promised some 20 more works for the inauguration of the collection in December. Within a few weeks, 20 top quality works by some of Argentina's most important contemporary artists were waiting in Buenos Aires to be brought to Colchester. UECLAA's holding of contemporary Argentine works on paper is already one of the most complete anywhere outside Argentina, covering a broad range of tendencies and languages. The willingness of the MAC to cooperate with UECLAA shows a remarkable faith on the part of Curi and De Bonis, as at this stage the collection had no administrative structure to speak of, being financially generated fairly spontaneously.

Inspired by the scale of donations from the Museo de Arte Contemporáneo, Josefina Durini, owner of the Durini Gallery – London's only gallery specialising exclusively in Latin American art – dedicated her efforts to helping the collection. In the two months leading up to the formal inauguration of the collection, Mrs Durini's organisational abilities helped the collection to make contacts, attract donors and approach sponsors. The Durini Gallery donated 11 works to the collection, some from artists working with the gallery and some from Mrs Durini's private collection.

By now it was becoming clear that the original idea for the opening ceremony was fast becoming inadequate. A normal University opening was considered too modest for a project of this scope. It became evident that the collection was fast outgrowing its initial aims and thus needed a more glamorous launch.

Nicholas Elam, Head of Cultural Relations of the Foreign and Commonwealth Office (FCO) heard of the project by chance and his curiosity was awakened. A native of Colchester and long-standing fan of Latin American art, Elam returned to work the following day to arrange FCO sponsorship for the reception, pay for the transport of the works waiting in Buenos Aires and convince Mark Lennox-Boyd MP, Parliamentary Under-Secretary for Foreign and Commonwealth Affairs to inaugurate the collection at very short notice.

Meanwhile, University officials looked on in disbelief at the rapidly expanding collection, promises of financial help and the general

OPPOSITE: Maria Freire (Uruguay), Variante, *1975, acrylic on paper, 59x39cm, donated by the artist; ABOVE: Lygia Pape (Brazil),* Sculpture No 1 (Amazonino), *cellulose paint on sheet steel, 110x100x50cm, donated by Mr and Mrs M Naify*

feeling that this collection had greater potential than anyone could have expected. Several artists previously associated with Essex (Ofelia Rodriguez, Ana Placencia, Rita Bonfim and Ana Maria Pacheco) were invited to donate works and all responded with the best of their work, often, indeed, with the same pieces they had exhibited several months earlier at the University Gallery. A few more private donations and the collection had grown so rapidly that the decision was taken to close the doors, at least until more space could be found.

The collection was inaugurated with 46 works, of which not even half could be displayed in the University Gallery. Despite the inconvenience of the date falling too near the Christmas holidays, many people braved a winter night and the A12 motorway to travel to Colchester. Donors came from as far as Buenos Aires (Curi and De Bonis) and St Petersburg (Charles Cosac) for the occasion.

UECLAA now faces the challenge of capitalising on its initial success to win sponsorship to maintain the collection and achieve the ultimate aim – a purpose-built museum building with permanent display area, study facilities and administration. The collection will be intimately linked to the research activities in the University. The Department of Art History and Theory has long been aware of the difficulty of obtaining good quality reproductions of Latin American works of art, and the opportunity to have the works themselves on campus will help to confirm Essex as Europe's leading research centre in Latin American art.

Latin American Art in the UK

The University of Essex Collection owes its existence and success to the several initiatives, which over the past few years have done much to introduce Latin American art to a largely indifferent public. Broadly speaking, three main groups have been working in this area: academics, the artists themselves and a single commercial gallery.

In this country, art history has not been known for its openness to subjects outside the mainstream areas of Italy and Northern Europe. A symptom of this is the lack of art historians who can speak Spanish or Portuguese. In the United States and France, there has traditionally been more interest in Latin American art, in the former because of geographical and cultural proximity and in the latter because of the large expatriate artistic communities. The practical problems of dealing with Latin America are very considerable and it remains difficult to gain access to that most precious commodity, disinterested information. In many ways, it could be said that UECLAA was made possible through an unusual willingness to pool resources and exchange information. Within Latin America, museums and libraries are not all one would wish them to be and there has been relatively little art history written within the countries themselves. Where these histories exist, they are often written from an exclusively national viewpoint, and the lack of good colour illustrations is a problem. There is so little published material on the subject, especially on this side of the Atlantic, that there are few established models to guide whoever is interested in the subject. Partly as a result of these practical problems, it soon becomes clear to any student of the area that Latin American art involves a greater engagement with the artists, their context and the works of art than many other areas of art history. In fact, this is one of its most attractive challenges.

On another level, Latin American art can be very disconcerting to a British public accustomed to certain deep-rooted notions of cultural supremacy and linear 'progress'. Much Latin American art is too close to European languages for comfort. The argument that Latin American art is a mere emulation of European models (a view all too popular in certain Latin American countries), is soon contradicted by the freedom with which these languages and assumptions are consciously manipulated and often totally inverted. A serious look at Latin American art inevitably forces one to question the assumptions behind European art history. While North American art has fully conquered the discourse of Modernism, this has overshadowed the earlier flourishing of the avant-garde in Latin America (for example, Brazil and the River Plate from the 1920s).

The importance of Latin American culture has, however, been long recognised by a sector of British academics: the hispanists. Helped by a common language and the easier migration of the printed word in the world's second most widely-spoken language, Hispanic Studies has a very long and proud tradition in the UK. To pass from peninsular Spanish to Latin America needs no great leap of the imagination as much of the ground work already exists. The idea of a specialised collection of Latin American art raises less eyebrows amongst hispanists than amongst art historians. The exception to this is at the University of Essex due to the efforts of Dawn Ades and Valerie Fraser of the Department of Art History and Theory. Both experts in Latin American art, they have managed to fully integrate Latin American art into the University.

In this respect the University of Essex, founded in 1961, is unique. The University's first Vice-Chancellor, the hispanist Albert Sloman, laid out an innovative university structure responsive to the demands of the modern world. Sloman greatly emphasised the benefits to be gained from an interdisciplinary approach, especially

OPPOSITE: Oscar Curtino (Argentina), Cristobal Colon, 1966, ink on paper, 53x76cm, donated by Marcos Curi; FROM ABOVE: Eulises Niebla (Cuba), Verde y Rojo, 1993, metal tubing, 35.5x59x59cm and 35x38x62cm, donated by the Durini Gallery; Tunga (Brazil), Jardins de Mandâgoras, 1993, mixed media (iron, magnet, iron filings, dead frog, tooth etc), 52x40x6cm, donated by Charles Cosac

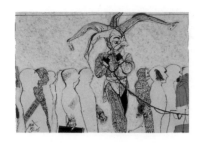

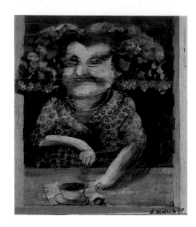

developing those areas at which traditional disciplines overlap. The notion of comparative studies is central to the Essex approach and thus the University was well prepared to introduce area studies. A Latin America Centre was provided for immediately grouping together people from different departments with an interest in Latin America. In other Universities with a Latin America Centre, it has tended to be an isolated centre concerned with its own teaching syllabus. As part of the innovative faculty structure at Essex, where subjects are arranged into Schools of Studies, it became a requirement that departments in the School of Comparative Studies include a Latin American element in their courses wherever possible, with two members of staff in each department.

Since its foundation, Latin American studies at Essex has flourished across all departments. Within the area of literature, Essex has had Jean Franco and Gordon Brotherston on its staff. Jean Franco's study, *Modern Culture of Latin America* (1967) has been hugely influential on Hispanic studies and her emphasis on the issue of social identity as a determining factor in the Latin American avant-garde has shaped a whole generation of academics. Most recently, we can see evidence of this approach in Oriana Baddeley and Valerie Fraser's (both Essex graduates) book on Latin American art, *Drawing the Line* (1989). Another example of the territory to be gained through an interdisciplinary approach is Dawn Ades and Gordon Brotherston's work on Pre-Colombian pictograms, a point at which literature and visual art are indistinguishable.

In 1989, Ades organised the exhibition 'Art in Latin America', at the Hayward Gallery (and subsequently Madrid and Stockholm). This was the first exhibition of its type in Europe, covering art from Independence to the 1970s. The accompanying catalogue has become the standard reference work for students of the subject. Since 1989, there have been several large exhibitions of Latin American art internationally, not least the one organised by the Museum of Modern Art in New York (1992-3). In October 1994, the Museum of Modern Art in Oxford is organising a major exhibition of art from Argentina, selected by its director, David Elliott.

Over several years, Ades has attracted many students to the University to study Latin American art. The concentration of expertise at Essex is what provided the opportunity for the unique creation of a permanent collection to be selected, curated and studied by its students. It was only natural that Ades should be named Director of the Essex Collection.

One of the essential steps in promoting Latin American art in Britain is to create a bibliography in English. There are precious few books on the subject published in Great Britain. Apart from Ades, Baddeley and Fraser's books, Guy Brett's catalogue *Transcontinental* (1990), contains important text on the issues of marginalisation seen through Latin American conceptual art. In 1993, Edward Lucie-Smith published *Latin American Art of the Twentieth Century* in the Thames and Hudson World of Art series. The fact that a book on the subject can now be mass-produced signals a greater public awareness of Latin American art outside the academic sphere. Nonetheless, there is still plenty more scope for publishing and UECLAA will hopefully be able to stimulate enough interest and pool the necessary resources to run a series of publications on various aspects of its collection.

The Durini Gallery

In elegant South Kensington, far removed from rural Essex, the Durini Gallery has been introducing colourful Latin American art to an otherwise grey art world over the past three years. The establishment of the Durini Gallery is a remarkable story in its own right. An 'outsider' to the exclusive world of London galleries, Josefina Durini trained as an architect in Buenos Aires. After moving to London to study decorative and fine arts, she opened her gallery in 1990, with no previous experience in the area and with no established client list. Since then, Durini has braved the recession and the challenges of single-handedly introducing Latin American artists into the world of London galleries.

The Durini Gallery has been working exclusively with Latin American artists for the past three years. The annual programme tries to keep a fair geographical balance – for practical reasons this always poses a problem as some countries have more developed communications and larger cultural budgets than others. In order to survive the current economic climate, Josefina Durini sees her job as a balancing act between artistic quality and commercial appeal to the British public. At present, the Gallery's most successful artists are the Argentine Miguel D'Arienzo and the Colombian Ramiro Arango. In 1994 artists of the same calibre as Siron Franco and Fernando de Syszlo are being included in the exhibitions.

Josefina Durini attributes the rise in interest in Latin American art to economic factors. During the 1980s, many Latin American countries (with the possible exception of Chile) experienced severe economic crises. This made it a very unattractive area for foreign investment and many companies and banks lost large amounts of money. The adoption of monetarist policies by several countries in the early 1990s reversed this trend and provided the stability required by foreign investment, albeit at a large social cost. The reversal of Argentina's economic situation under President Menem, banishing hyper-infla-

tion almost overnight, is a clear illustration of these policies. The concentration on privatisation has attracted those foreign investors who previously would have been wary. The effect of this in London, the centre of many of these investment houses, has made money available for individuals and corporations to concentrate on Latin American art.

Despite this concentration of foreign capital, most clients of Latin American art are not British but German or North American. Josefina Durini calculates that only some 30 per cent of her clients are British. Latin American art needs an independent institutional base in this country as several private initiatives to establish a permanent collection have failed in the past. A University guarantees the type of stability and independence thirsted for by many Latin American artists. It also provides a 'passport to credibility', in the words of Josefina Durini.

Artists and other activities in Britain

While having nothing like the number of Latin American artists that Paris or Madrid have, some Latin American artists have nonetheless chosen England as their home. Against all odds, three artists in particular have managed to establish themselves here: Ricardo Cinalli (Argentina), Ana Maria Pacheco (Brazil) and Ofelia Rodriguez (Colombia).

Latin American artists in the UK have been greatly helped by the efforts of the Ecuadorian artist Ana Placencia and her association LATOF (Latin America The Other Face). As the name implies, LATOF has been concerned above all with dispelling the myths about Latin America and presenting art which challenges the stereotypes surrounding Latin America. Ana Placencia's own work is a fascinating mixture of conceptual art with musical parallels which refuses to be classified in traditional categories. Placencia has built up a large number of contacts with British institutions which made the festival Latin America Ya! possible in 1993, a mixture of exhibitions, installations and lectures all over London.

The first of this type of association to promote Latin American art is the Latin American Arts Association, run by Sylvia Condylis from Canning House. The activities of the LAAA are not limited to the visual arts but to all art forms such as music and drama. The LAAA has managed to promote many events with a very tight budget over the years. Canning House is home to the Hispanic and Luso Brazilian Council, which organises many cultural events over the year. Like the LAAA, its activities are broad in scope, covering literature, music and the visual arts.

Most Latin American embassies in London have a cultural section which varies in size and importance, depending on the country. Traditionally, the strongest countries have been Brazil, Mexico, Venezuela and, more recently, Argentina. However, political instability in some countries and the lack of a serious cultural budget have hampered the type of long-term planning necessary for any cultural programme.

In 1990, The Association of Cultural Attaches of Latin America and Spain (ACALAS) was created to 'promote the culture of the continent through seminars, concerts, exhibitions and other events'. While this type of cooperation is an excellent idea and its potential is great, the implicit danger is of an excessive eclecticism. In 1993, the Bolivar Hall of the Venezuelan Embassy was used as the venue for a show of artists from all over Latin America. The lack of curatorial criteria or overall control was unfortunately evident in this case.

With the prospect of academic criteria, institutional continuity and prestige, the University of Essex Collection of Latin American art is perfectly placed to capitalise on the efforts of all these organisations in the common aim of bringing an awareness of the art of Latin America to the British public. The independence of an academic institution has proved most attractive to donors and sponsors, who can rely on a proven tradition of academic and curatorial skills. Hopefully, UECLAA will be used as a focus for Latin American visual arts in the UK, and by extension, the rest of Europe.

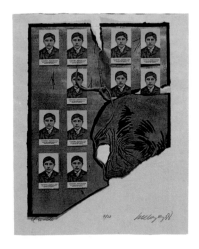

Hilda Paz (Argentina), El Santito, 1988, embossed collage, 65x50cm, donated by the Museo de Arte Contemporáneo, Buenos Aires

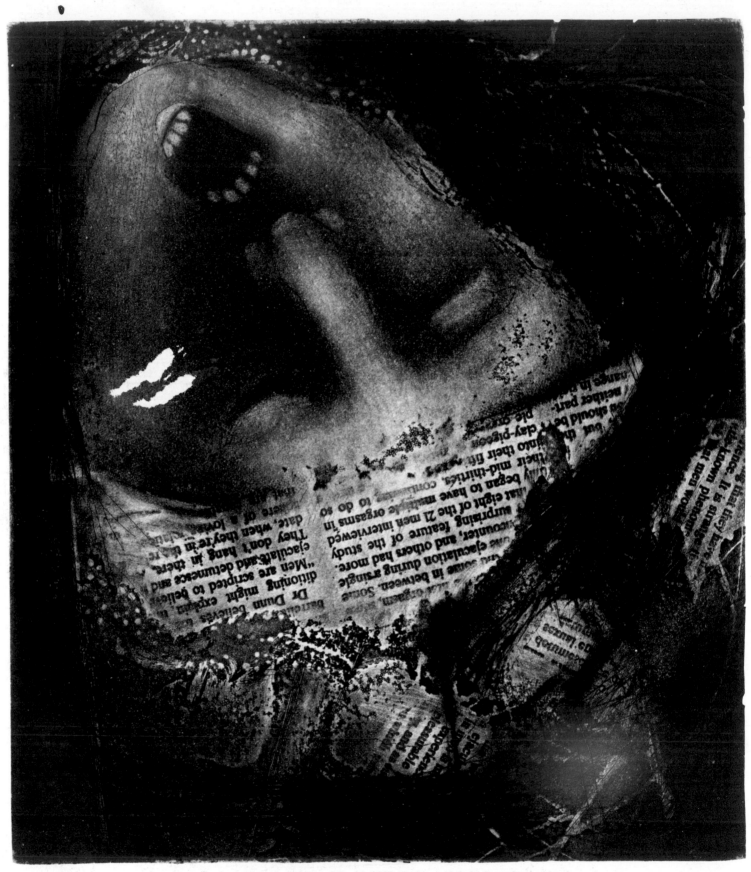

Ana Maria Pacheco (Brazil), Rehearsal No 10, 1990, Etching, 18.8x16.5cm, donated by the artist